essential skills
digital photography
in available light

third edition

mark galer

ELSEVIER

AMSTERDAM • BOSTON • HEIDELBERG • LONDON • NEW YORK • OXFORD
PARIS • SAN DIEGO • SAN FRANCISCO • SINGAPORE • SYDNEY • TOKYO
Focal Press is an imprint of Elsevier

Focal Press

Focal Press is an imprint of Elsevier
Linacre House, Jordan Hill, Oxford OX2 8DP, UK
30 Corporate Drive, Suite 400, Burlington, MA 01803, USA

First edition as Location Photography: Essential Skills 1999
Reprinted 2000
Second edition 2002
Third edition 2006
Reprinted 2007

British Library Cataloguing in Publication Data
A catalogue record for this book is available from the British Library

Library of Congress Cataloging-in-Publication Data
A catalog record for this book is available from the Library of Congress

ISBN–13: 978-0-240-52013-1
ISBN–10: 0-240-52013-0

For information on all Focal Press publications
visit our website at www.focalpress.com

Printed and bound in *Italy*

07 08 09 10 10 9 8 7 6 5 4 3 2

Acknowledgements

Philip Andrews would like to thank Karen, Adrian and Ellie and the great guys at Kaidan and Realviz for their support.

I would like to pay special thanks to Philip Andrews, John Child, Andrew Fildes and Michael E. Stern for their editorial input and to Orien Harvey for many of the wonderful images used to illustrate the text. I would also like to thank the students of RMIT University and PSC Melbourne who have also kindly supported this project with their images. I would also like to pay special thanks to my wife Dorothy - without whom this book would never have seen the light of day. Thank you.

mark galer

Picture Credits

Ansel Adams (Ansel Adams Publishing Rights Trust/Corbis), Paul Allister, Shane Bell, John Blakemore, Ricky Bond, Dorothy Connop, Tamas Elliot, Walker Evans (Walker Evans Archive, The Metropolitan Museum of Art) , Andrew Goldie, Andy Goldsworthy, Orien Harvey, John Hay, Wil Hennesy, Itti Karuson, Sean Killen, Dorothea Lange, Jana Liebenstein, Michael Mullan, James Newman, Kim Noakes, Matthew Orchard, Ann Ouchterlony, Rod Owen, Stephen Rooke, Michael Wennrich, Amber Williams.

All other images by the authors.

contents

foreword

Creative, successful professionals are highly motivated to improve their skills by engaging in continuous learning activities. Whether through the formal setting of a classroom, workshops, seminars, on-line learning, or just picking up a book, we are always searching for information on the complex issues of our chosen profession.

When it comes to photography (especially during the past ten years), the amount of information we seek has been compounded by the sheer speed at which innovations are brought to market.

Cameras, sensors, resolution, lens factor, exposure latitude, noise, compression artifacts, RAW, chromatic aberrations, AWB, and so on, are some of the topics and skills that have had to be learned as brand new concepts or re-learned from the digital perspective. The speed at which "new and improved" tools and concepts are being introduced makes everyone seem expert but in fact misinformation is as abundant as poorly crafted digital captures.

How do I put into words my appreciation for a book like this? As a professional photographer for more than 25 years and an educator for 19 years, building a reference library for my studio is an on-going task.

This book is one of the best I've ever read due to the depth and breadth of topics covered and will find a prominent place in my collection. I particularly appreciate that the author addresses the dynamic changes in the field of digital capture whilst remembering photography's timeless qualities.

Hooray for Mark, for he is speaking to us all with the single-minded goal of disseminating clear and thoughtful information.

Thank you Mark, from all of us.

Michael E. Stern
Adjunct Faculty
Brooks Institute of Photography
& www.CyberStern.com

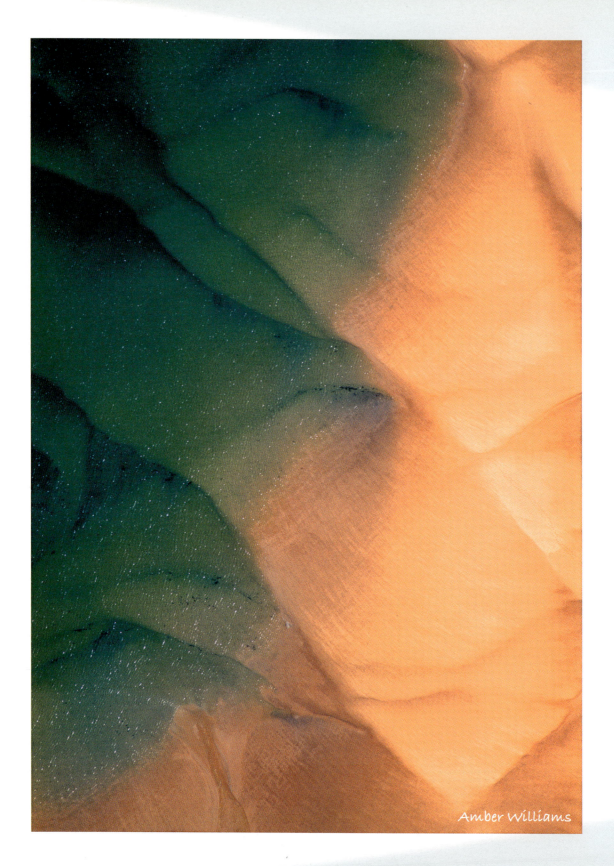

Amber Williams

introduction

Location photography covers a wide range of disciplines. From the captured image of a fleeting moment using existing light to the highly structured and preconceived advertising image using introduced lighting. This book is intended for photographers working on location using primarily the existing or 'available' light source. The information, activities and assignments provide the essential skills for creative and competent photography. The chapters offer a comprehensive and highly structured learning approach, giving support and guidance in a logical and sequential manner. Basic theoretical information is included along with practical advice gathered from numerous professional photographers. An emphasis on useful (essential) practical advice maximizes the opportunities for creative photography.

Acquisition of technique

This book is designed to help you learn both the technical and creative aspects of photography. The initial chapters provide the framework for the assignment briefs that follow. The chapters will help you acquire the essential skills required to confidently undertake a broad range of location work using ambient light. Terminology is kept as simple as possible using only those terms in common usage by practising professionals. The emphasis has been placed upon a practical approach to the subject and the application of the essential skills.

Application of technique

The book concludes with several chapters devoted to the practical application of the skills acquired in the earlier chapters of the book. Assignments can be undertaken in each of the three areas allowing the photographer to express themselves and their ideas through the appropriate application of design and technique. This book offers a structured learning approach that will give the photographer a framework and solid foundation for working independently and confidently on assignment.

The essential skills

To acquire the essential skills required to become a professional photographer takes time and motivation. The skills covered should be practised repeatedly so that they become practical working knowledge rather than just basic understanding. Practice the skills obtained in one chapter and apply them to each of the following activities or assignments where appropriate. Eventually the technical and creative skills can be applied intuitively or instinctively and you will be able to communicate with clarity and creativity.

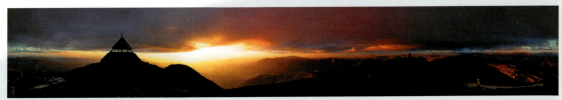

photo by Ricky Bond

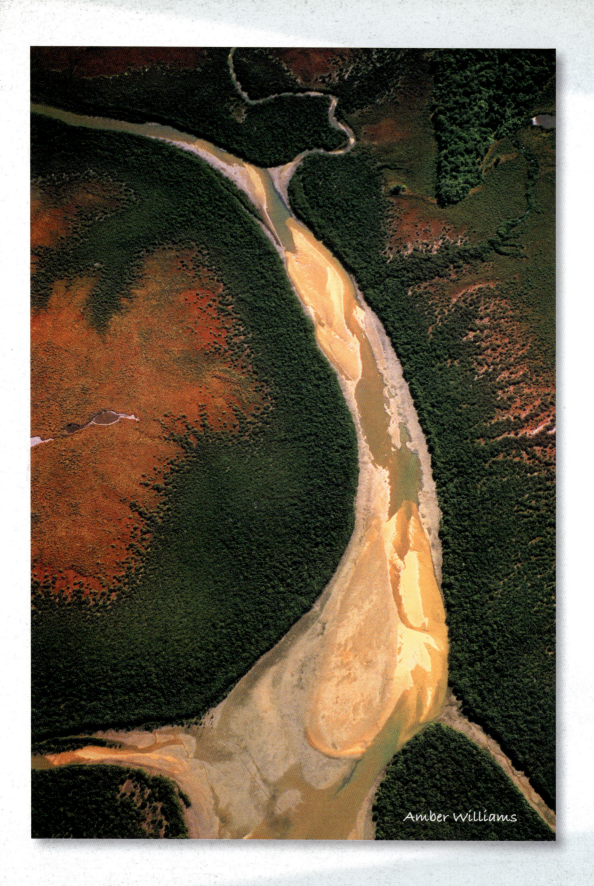

Amber Williams

digital cameras

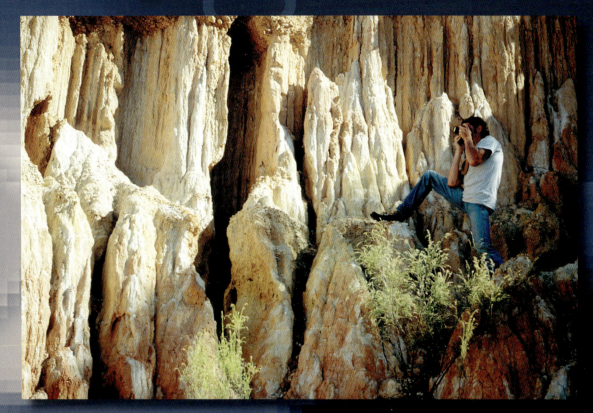

Mark Galer

essential skills

~ Understand the differences between various types of digital cameras.

~ Compare specifications and isolate features important to your personal workflow.

~ Appreciate the limitations of various systems and their impact on image capture and quality.

Introduction

Choosing a digital camera that will meet your imaging needs (and not blow a hole in your budget) can seem as difficult and confusing as choosing a new mobile phone plan or setting your neighbors DVD recorder to record their favorite TV show in two days' time. If we focus on the key differences between the digital cameras currently available the choice can be somewhat clarified, and the range of models that will fulfil your requirements can be narrowed considerably. If you need to go shopping it can be a useful exercise to create a 'must have' list after considering the implications of the various features that digital cameras do, or do not, offer. As the numbers of makes and models of digital cameras are immense this chapter focuses its attention on a few significant cameras (significant in their respective genres) to enable direct comparisons.

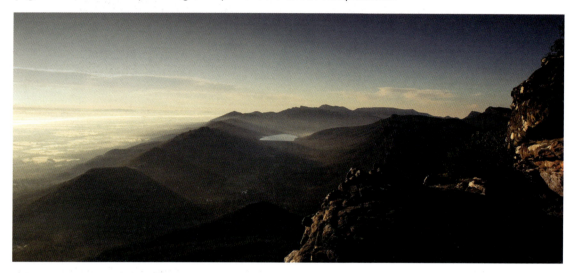

Boroka lookout, The Grampians. Sony R1

Megapixels

Top of most people's 'things to consider' list is usually 'megapixels' – how many do I want, how many do I need? 12 or 14 megapixels is great if you like cropping your images a lot or have a constant need to cover double-page spreads in magazines at a commercial resolution or create large exhibition prints.

Many high quality 8-megapixel cameras can however create digital files that can be grown to meet these requirements if the need arises. If the ISO is kept low digital files from many cameras can be 'grown' with minimal quality loss. Choose the 'Bicubic Smoother' interpolation method in the 'Image Size' dialog box when increasing the pixel dimensions of an image to ensure maximum quality is achieved.

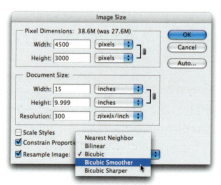

Image Size dialog box - Photoshop CS2

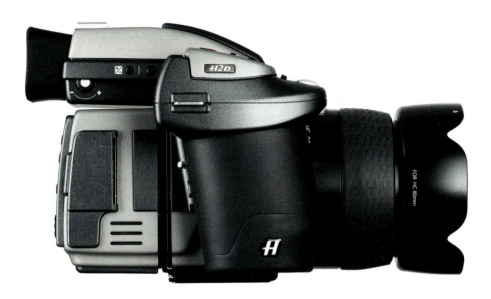

The Hasselblad H2D - who could want for anything more?
Ultimate 22-megapixel SLR or resolution overkill?

22-megapixel medium format capture may sound like something everyone would want to aspire to or own (and for some commercial photographers it is the only option) but you have to weigh up the implications of capturing such large files. A 22-megapixel file will place an increased burden on the hardware and software - slowing systems considerably if they do not have the performance to cope with the heavy traffic that multiple 22-megapixel files can impose. Many photographers in this period of transition from analogue to digital make the mistake of replacing like with what they perceive to be like, e.g. an analogue medium format camera such as a Hasselblad or Mamiya 645 or RZ67 with what they believe to be the equivalent digital medium format camera. It is worth noting however that the quality that can be achieved with a high end digital SLR, such as the Canon 1Ds Mark II, can match the image quality of a medium format analogue camera using a fine-grain film. A digital medium format camera, one could safely assume, is knocking on the quality door of 5 x 4 film and surpasses the quality that is available from medium format film. The price differential between a Hasselblad medium format digital camera and the Canon 1Ds Mark II is considerable and for many photographers the DSLR would outperform the Hasselblad in terms of speed and ease of handling.

ENOUGH IS ENOUGH

Now that most of the more recent prosumer fixed lens and DSLR cameras sport at least 8-megapixels the need for more is a timely question. An 8-megapixel file will easily cover a full page in your average magazine at commercial resolution. If you need more then you also need to consider whether the need for speed is greater than the need for size. Having both can be a costly venture.

The Canon EOS 1D Mark II and Nikon D2Hs - 8 frames per second and bursts in excess of 20 RAW files before the buffer is full. The Canon EOS 1D Mark II should not be confused with the EOS 1Ds Mark II (you may want to read that again and note the little 's' difference) which is the full-frame state of the art quality DSLR

The need for speed

The issue of speed can arise in many stages of a digital workflow. Many of the issues that were connected to the issue of speed that proved problematic in digital cameras only a few years ago have largely been removed from the equation. Delays between switching the camera on and being able to take your first image, achieving focus and the delay between pressing the shutter release and the camera actually capturing the image (called shutter lag) have now been mostly relegated to the digital compacts. After capturing the image the camera then has to write the file to the memory card. The issue of speed here usually only becomes problematic if the photographer is shooting in the RAW format. Camera manufacturers resolve this issue of write speed by placing a 'buffer' that can store multiple images before the camera has to write the files to the card. If an unfolding action requires the photographer to shoot bursts of images in rapid succession then the size of the buffer is an important issue if the photographer needs to capture in the RAW format. Fast shooting whilst using the camera RAW format is usually the preserve of photographers using higher quality DSLRs. If the photographer is capturing images faster than the camera can write them to the memory card the camera will be unable to capture additional images until the buffer has more available memory. If the camera is continually 'locking up' whilst the camera's processor writes the images to the card the photographer must make the choice to shoot in shorter bursts, switch to the JPEG format or upgrade to a camera with a larger buffer and faster write speed.

Note > If the camera you are looking at is not an SLR it is advised that you test the amount of shutter lag prior to making a purchase. Lag is reduced significantly in the budget digital cameras if the shutter release is already half pressed prior to capturing the image, i.e. focus and exposure are already set.

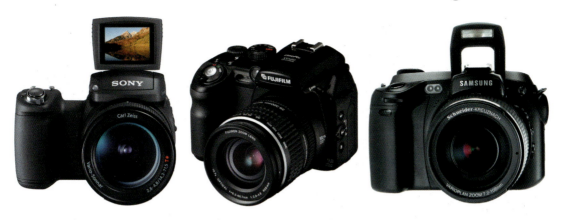

The Sony DSC-R1, Fuji s9500 and Samsung Pro 815

Prosumer digicams - closing the gap?

The release of three new fixed lens digital cameras (the Sony DSC-R1, Fuji s9500 and Samsung Pro 815) and the dropping prices (and sizes) of budget digital SLRs has revived a dilemma that has been growing steadily for photographic enthusiasts or 'prosumers' seeking professional quality images at an affordable price. Which camera is the right one for me? The dilemma has never been more difficult for the consumer than it is today. Sony have added further fuel to the fire with the revolutionary new R1 which is one of the most significant new digital cameras released in 2005 (together with the Canon EOS 5D DSLR and Nikon D200).

A HISTORICAL SNAPSHOT OF DIFFERENCES OF OPINION

It seems photographers are destined always to fall into two different camps or 'modus operandi'. If we take a brief look at history there were those who followed and promoted Daguerreotypes and then there were those who saw the advantages of Fox Talbot's Caloptypes (two distinctly different ways of creating images), then followed wet plate vs. dry plate, sheet film vs. roll film and then of course analogue vs. digital. The digital revolution began an argument in the 1990s between the relative merits between film and digital. The push to digital capture has not so much been driven by quality however as by the dollar. Consumers embraced the digital revolution as soon as prices for these new electronic wonder toys dropped below a thousand dollars and early adopters to the digital revolution have either been oblivious to the quality issues or have decided to compromise quality for speed and convenience. With film manufacturers rapidly shutting up shop and cameras that sport 8 megapixel sensors now an affordable reality, the argument of whether the photographic enthusiast captures with a film camera or digital camera is pretty much dead in the water. Now the consumer is getting fussy - we like small, we like fast and we like quick - we want it all and we want it now! The battle that is now raging is whether the photographic enthusiast buys a fixed lens feature-rich 'Prosumer' camera or a digital SLR (DSLR) camera.

Fixed lens digital cameras are sometimes referred to as 'Digicams', 'Prosumer cameras', 'Bridge cameras' or 'EVFs' (an acronym for 'Electronic ViewFinders'). There is no traditional name because this is an entirely new breed of camera where typical examples in the genre are neither compact nor feature the mirror and pentaprism mechanisms to enable them to be called an SLR. The quality and list of professional features that these cameras boast has been growing over the last few years and the spec sheets have raised more than a few eyebrows amongst professional photographers. Although the size of these cameras has been growing (largely in response to the huge optical zooms that are integral to most of the models on offer) their price point has pretty much remained the same.

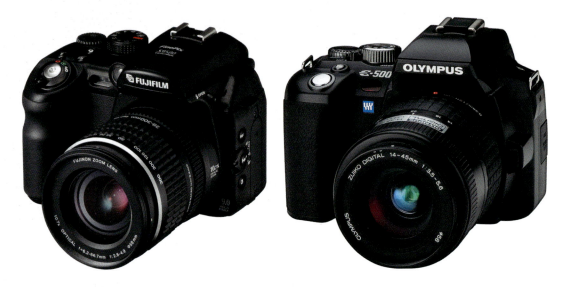

Let's play spot the DSLR - The Fuji s9500 and Olympus E-500

Comparing features

The new Fuji s9500 now has a 9 megapixel sensor and a 10.7x optical zoom range via a twist-barrel (rather than electronic) zoom control whilst the Samsung Pro 815 has an 8 megapixel sensor and boasts a whopping 15x optical zoom spanning a colossal 28mm to 420mm zoom range (35mm equivalent). With the arrival of these impressive lenses the need to change a lens (which is obviously not possible if the lens is fixed) has been rendered a non-issue. In fact the inability to change the lens can be viewed a positive point when you consider that the 'dust on the sensor' issue* has always been a non-issue for the fixed lens digicams. The one thing you cannot describe these prosumer level digicams as, is 'compact'. The three prosumer digicams mentioned here are either about the same physical size and weight as some of the lighter DSLRs (Olympus E-500, Pentax ist and Canon EOS 350D Rebel - to name but a few) or, as is the case with the Sony R1, even heavier.

*** Only Olympus have addressed the problem of dust on the sensor to date. Olympus DSLR cameras use a 'Supersonic wave filter' that vibrates the dust off the sensor when the camera is powered up.**

A kangaroo inspecting the impressive Carl Zeiss lens (as fitted to the Sony DSC-R1)

The new Sony R1 has raised the bar in the 'tubby' stakes with the camera weighing in at a couple of grams short of a kilo. A kilo in old money is about the same as a Nikon F90/F100 SLR film camera with batteries and 50mm lens. The Sony R1 is about the same physical size as a DSLR sporting a 70-210 telephoto zoom lens - from back to front it's deep, very deep! Whilst I had this camera out on location recently some digital photographers on a photographic workshop (and shooting with a broad range of DSLRs) spied the R1 and thought I was working with a digital medium format camera! This mistake came about by the fact that the R1 looks very well endowed up top. Sony has moved the ingenious 'pop-up-and-rotate-me-in-any-direction' LCD screen to sit just behind the pop-up flash which moves forward to give adequate coverage for the wide 24mm coverage (35mm equivalent) that the Carl Zeiss lens offers. You can definitely not describe the porky R1 as 'compact'. Having said this I had both the Fuji s9500 and Sony R1 sitting comfortably in my kit bag that is normally reserved for a single DSLR system (one camera and three lenses). If you factor in the additional lenses that DSLR owners typically carry around in their kit bags then the 'kit' could still be called compact even if the prosumer digicams themselves no longer deserve or warrant this tag. With physical mass no longer a point of difference between DSLRs and prosumer digicams what exactly is it that distinguishes these two types of cameras?

Note > When comparing the weight of prosumer cameras against the specifications of a DSLR you must factor in the weight of the lens that you intend to use with the DSLR.

Choosing a system

The two major differences between the prosumer digicams and DSLRs is the size of the sensor and the type of view that we see through the viewfinder of each type of camera. The size of the sensor leads to the issue of image quality whilst the type of viewfinder image leads to an operational or handling issue. First we will look at the issue of size, i.e. does size really matter?

A case of try before you buy - the shop assistant from Ted's shot with the Fuji FinePix s9500, ISO 200. 9 megapixels of detail with minimal noise

Sensor size

Sensors in the prosumer cameras have always been small, whilst in DSLRs the sensor size is comparatively much larger (more than double the dimensions and quadruple the surface area). The use of small sensors in prosumer digicams usually leads to increased levels of noise when compared to the images captured with an average DSLR camera at the same ISO - especially when comparisons are made at higher ISO settings. Larger sensor sites typically lead to less problems with noise. If money is not an issue then you can play find the noise with images captured with Canon's full size sensors found in the EOS 1Ds Mark II and new EOS 5D. The fifth generation Super CCD sensor used in the new Fuji s9500 digicam however is a marked improvement from previous sensors found in your average digicam. At ISO 80, 100 and 200 the level of noise is effectively suppressed and can match the levels of noise found in some of the budget DSLRs using CCD sensors.

If we examine the detail (zooming in to 200 or 300% on screen) from an image captured at ISO 400 on the Fuji s9500 in low light we will discover posterization and lumpy tones. These are evident as a result of in-camera processing in an attempt to suppress the noise that is inherent in files captured with the small sensors found in prosumer digicams.

The small sensor of the s9500 pushes its luck at 400 ISO - image magnified to 300% (see inset)

This image processing makes the image look as if we are viewing the file through distorted glass. Quality is starting to be compromised. If we view a RAW file from a file that has been captured at 400 ISO without noise suppression then the smudged detail is replaced with luminance and color noise that is reminiscent of images captured with high-speed color film. Fuji, I feel, have been a little over zealous with the noise suppression in the new s9500 when the ISO moves over 200. I would personally still like to see the color noise suppressed but would have been happy to see a little luminance noise at 400 ISO rather than lose the crispness of the image in the attempt to remove all noise. There is no option for noise suppression when using the JPEG format, and switching to RAW mode in the Fuji is not a very quick affair. The RAW option is buried deep in a submenu instead of being conveniently accessed via one of the main camera switches as is the case with many other high-end cameras. I feel Fuji is underestimating the number of photographers who will want to frequently switch between JPEG snapshots and the RAW format for their personal folio images.

Note > Although the image artefacts that are starting to appear at 400 ISO, they are barely noticeable in a 4 x 6 inch print or 17 inch screen preview of the entire image.

The digicam is used to photograph in unfamiliar territory. Fuji FinePix s9500, 80 ISO, 1-second exposure
The Fuji again tries to suppress the excessive noise generated using the 1-second exposure leading to ragged lines
and posterization (stepping of tones). The noise starts to build in the Sony image but image quality remains high
Photographs by Ricky Bond

Long exposures

When the ISO of prosumer digicams is raised differences become more obvious and the digicams start to lose any comparison with an image produced from a DSLR at the same ISO setting. It is not just the matter of raising the ISO that wakens the sleeping monster called noise. Duration of exposure also leads to increased noise. At normal hand-held shutter speeds this is never a problem, it is only when the camera is mounted on a tripod and the photographer is photographing in low light that noise again becomes an issue. The Fuji s9500, Sony DSC-R1 and a Canon EOS 20D were tested using shutter speeds between 1 and 5 seconds and this served to highlight the relative merits of the different sensors. The Fuji FinePix s9500 is equipped with a PC sync terminal and cable-release socket to aid studio-based photography whilst the Sony is equipped with neither (the Sony R1 gives you quick access to a self-timer but a threaded cable release would have also been useful). When using the Fuji s9500 at exposure times of a second, even at the base 80 ISO setting, image quality begins to suffer.

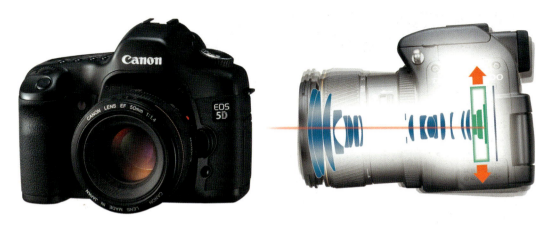

Say goodbye to noise - with the impressive EOS 5D
Whilst image stabilization defers the need to raise the ISO in the prosumer cameras - Konica Minolta A2

Image stabilization

Many prosumer cameras now offer some form of 'image stabilization' or 'anti-shake' technology. This allows hand-held shots in low light or at the limit of telephoto extension, up to 420mm in some models where you would normally use a combination of high ISO, fast shutter speed and wide aperture. Others such as FujiFilm offer an anti-blur scene mode instead with similar settings to a sports mode but with increased ISO. Image stabilization is not unique to prosumer digicams - professional DSLRs also feature this technology and while Konica Minolta build 'Anti-Shake' into the camera body, Canon's IS system (image stabilization) and Nikon's VR system (vibration reduction) are designed into their pro-grade lenses. If you intend to use a camera for classic telephoto purposes such as wildlife or sports, this may be important to you. It is also useful for hand-held portrait shots in available light. However it is worth remembering that image stabilization may only remove the shake in your own hands and if the subject is not absolutely motionless, then shooting at 200mm and 1/125 second may still result in motion blur.

Alternatives to image stabilization

To retain maximum quality when using a prosumer digicam it is still important to keep the ISO low and when the shutter speed slows to a point where movement blur rears its ugly head, mount the camera on a tripod rather than raise the ISO. When the subject moves in low levels of light the DSLR owner has a distinct advantage - the ability to increase the ISO and yet retain acceptable quality. This is especially noticeable in DSLR cameras such as the canon EOS 5D, EOS 1Ds Mark II, but price puts these professional cameras out of reach of most enthusiasts. The DSLR ISO advantage might be lost if the DSLR owner then uses a lens with a maximum aperture that is less than impressive, e.g. f4 or f5.6. The consumer who chooses to buy a DSLR over a prosumer digicam must factor in a lens with a respectable maximum aperture when comparing prices. If a digicam owner is using a maximum aperture or f2.8 and a DSLR owner is using a lens with a maximum aperture of f4 then the playing field called 'noise' may be levelled.

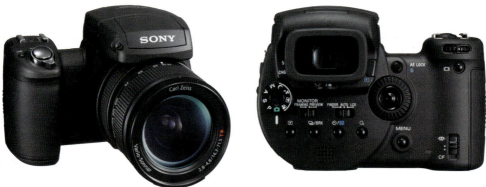

The Sony DSC-R1- a camera with an identity crisis or a new breed?

Large sensors in prosumer digicams

The quality that can be achieved with the Sony DSC-R1, unlike other prosumer cameras, is not compromised by its sensor size. The larger CMOS sensor means that you can raise the ISO comfortably to 400 without noise becoming a huge issue. Noise starts to become apparent at around 800 ISO but can be suppressed reasonably effectively with Photoshop's new 'Reduce Noise' filter. At 1600 quality is unduly compromised and 3200 is just plain wishful thinking on Sony's part. In the test conducted in the studio the Sony R1 was able to take the prolonged exposures (one second and over) in its stride but the results were not quite a match for the superior quality captured by the Canon CMOS sensor used in the EOS 20D. Again it is important to note that these differences in quality are only likely to be seen if the final print size is large.

Larger sensors and increased dynamic range

Another advantage that any prosumer digicam equipped with a larger sensor will enjoy over other prosumer digicams is the fact that larger sensors are able to record a broader dynamic range, i.e. the ability of the sensor to record information in a high contrast scene. Add a white dress, a black suit and a little sunshine and most digicams have met their match as the scene easily exceeds the subject brightness range that most digicams can handle.

The S3 Pro uses the SuperCCD SR sensor that uses two photodiodes located at each photosite. The 'S' pixel has normal sensitivity whilst the 'R' pixel is smaller and captures information beyond the range of the 'S' pixel, The camera's processor combines the information from the two photodiodes to create an image file with an extended dynamic range

Using a DSLR to record the same high contrast scene has typically only been an advantage when capturing in the RAW format and the photographer is skilled enough to be able to extract the additional detail using the camera RAW interface (Fuji S3 excepted as it uses a specialized 'SR' sensor). Sony have admirably handled the issue of high subject contrast by implementing an automatic gamma control in an attempt to pass on the advantages of the broader dynamic range of a larger sensor to the JPEG file.

The 3:2 format revival

The Sony R1, together with a small handful of other prosumer cameras, captures images in the longer 3:2 format instead of the squarer 4:3 format that is typical with most prosumer and DSLR cameras. Only the Canon EOS 5D and EOS 1Ds DSLR cameras capture images using the 'full-frame' 3:2 format that replicates the format of 35mm film (the Fuji s9500 surprisingly has a 3:2 format option in the 'Photo Mode' or 'F' menu). This may not sound like a big deal but for landscape photographers looking to create the 'wider look', the 3:2 format saves them from having to crop away 10% of the pixels that would normally be surplus to requirement if captured using an overly square 4:3 format. Given the fact that screens are going wide-screen this is an excellent feature.

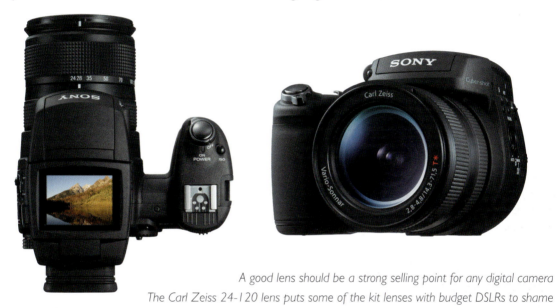

A good lens should be a strong selling point for any digital camera
The Carl Zeiss 24-120 lens puts some of the kit lenses with budget DSLRs to shame

Lens quality

One of the factors that really should to be taken into account when comparing prices of the R1 with a typical budget DSLR is the lens that the Sony R1 comes equipped with. A high quality 24 to 120 zoom lens with a maximum aperture of f2.8 would represent a significant purchase for any DSLR owner. Most budget DSLR cameras come equipped with lenses that are not in the same ballpark as the lens that is standard on the Sony R1. At the wide range of the zoom, a very impressive 24mm (35mm equivalent), the maximum aperture is a healthy f2.8. Unfortunately this drops to f4 by the time you pass 50mm - I have to admit that I found this slightly disappointing as the predecessor to this camera (the Sony DSC-F828) has a 1-stop advantage across the zoom range to the DSC-R1 (the larger CMOS sensor may have presented Sony with a different problem). Although not as bright as its predecessor it still has a significant advantage when compared to the typical zoom lens provided with a budget DSLR kit.

If the size of the R1 is not a deterrent and you have no need for a long zoom then the difference between the R1 and a DSLR (with a good lens) is reduced to just one factor - the preview. The type of preview that these fixed lens prosumer digicams offer is probably the single most important factor that will decide which system you buy into.

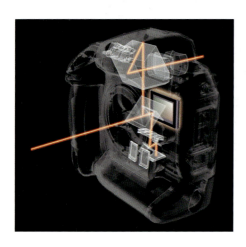

The pentaprism is an integral part of the creation of the optical view in an SLR camera
The LCD screen of a DSLR is used to 'review' rather than 'preview' the image

Viewfinders and LCDs

Single Lens Reflex (SLR) cameras use a mirror and pentaprism design to display an optical view of your subject in the viewfinder prior to capture. The view is typically bright (especially if you have a wide aperture lens fitted) and detailed so that you can focus the image easily and quickly if you have to switch to manual rather than auto focus. The image is not a 'what-you-see-is-what-you-get' image as feedback on issues such as how the sensor will handle the subject contrast together with the effects of your choice of exposure and depth of field are not being previewed. A depth of field preview button is available on some DSLR cameras that allows you to preview the image with the aperture stopped down to the one that will be used to capture the image rather than the widest aperture which is normally used to provide the optical view. Although useful in some instances the subject can appear very dark in the viewfinder making precise depth of field difficult to determine. This information is now more easily viewed on the LCD screen and not in the viewfinder after the image has been captured. The prosumer digicam on the other hand has no mirror, pentaprism and usually no optical viewfinder.*

*** Ricoh's GR Digital uses an optional optical finder to overcome the shortcomings of EVF technology. Leica has been developing a digital rangefinder camera to supplement its range of prosumer digicams, but at the time of going to press this camera has not materialized. Although this camera would offer a significant choice in the digicam range it is important to note that the view from a rangefinder camera does not mirror exactly what the sensor sees and at close range there are the typical issues of 'parallax error' that is inherent with all rangefinder cameras. Allowances have to be made at close range to readjust the framing from the view that is displayed in the viewfinder.**

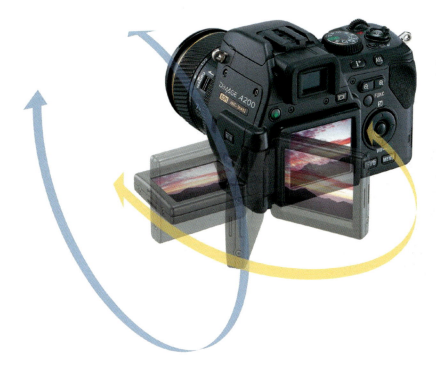

Live preview and adjustable LCDs are the plus points for prosumer digicams

The prosumer digicams use a video display instead of an optical display of the subject. This view is available via the LCD screen or from an electronic viewfinder (EVF). This preview is low-resolution live preview of what the sensor will record when the shutter release is pressed. A real-time live histogram is often an option in many of the prosumer digicams to guide your exposure choice and warn you of excessive contrast. Current advances in LCD technology have made available large bright screens that have a good viewing angle and on many models can be tilted to make low-angle or high-angle shooting a breeze. The Sony R1 has a high quality 2 inch flip-up and twist screen that is interestingly mounted on top of the camera rather than on the back of the camera. This can be rotated on a vertical axis through 270° and angled 100° on a horizontal axis. When not in use it can be closed with its screen facing in towards the camera body (a very nice touch for those users who do not handle cameras with kid gloves or those considering a long-term commitment to the camera). High-end DSLR cameras such as the D2x offer a tempered glass coating to protect the surface of the LCD screen

MAKING MOVIES

An interesting and attractive feature of most prosumer cameras (but not the Sony R1) is their ability to double-up as camcorders. Most of the prosumer digicams will now capture movies up to 640 x 480 pixels at 30 frames per second with sound. Load the camera with a 4 gigabyte memory card and the prosumer camera suddenly becomes capable of capturing the family's holiday movie.

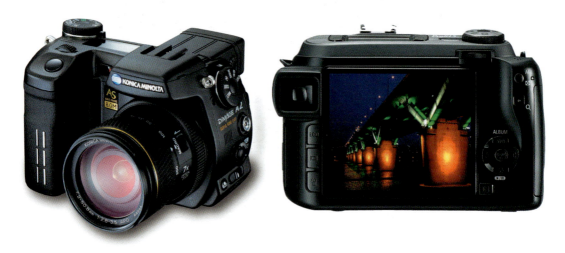

Konica Minolta A2 and the 'better-than-the-rest' 1-megapixel EVF
Samsung Pro 815 and the 'bigger-than-the-rest' 235,000 pixel 3.5 inch LCD

EVF resolution

When bright sunlight is falling on the LCD screen (making viewing the subject difficult or impossible even with the larger high-contrast LCD screens currently available) or when the photographer requires detailed information to focus, the prosumer digicam user may need to switch to viewing the scene via the EVF. Cameras such as the Konica Minolta DiMAGE A2 and the Sony DSC-R1 will automatically switch between the two using a proximity sensor that detects when you have put your eye to the viewfinder. The other prosumer cameras require a button to be pressed to switch between the LCD and the EVF. It's usually at this point where consumer satisfaction with the digicams starts to falter and wane. What the meticulous photographer would expect from the EVF is a bright high-resolution image with a fast refresh rate (reduced flickering). What we usually get is our subject rendered with a view that is all too often just 450 x 300 pixels (135,000 pixels) whilst the more expensive prosumer cameras now supply higher resolution 235,000 pixel EVFs on their flagship prosumer digicams such as the s9500 this is still no match for the information that can be seen when using an optical viewfinder. With dioptre adjustment available on most high-end prosumer digicams you can make the view pin sharp - sharp enough to count the pixels! If pixel counting sounds a little distressing and you feel you deserve more information then Konica Minolta offer one of the few alternatives. Konica Minolta set the benchmark, that the others have failed to live up to, when they released their impressive DiMAGE A2 by supplying an EVF with nearly one million pixels (922,000 pixels to be precise). A high gain mode (black and white) can be selected when the ambient light is low to reduce excessive noise and enable a relatively clear view to be maintained. Why manufacturers (other than Konica Minolta) have been slow to grasp the importance of the EVF to photographers is anyone's guess. The upshot is that manual focusing is problematic on most digicams. With this in mind it is worth checking that the auto focus options are quick and accurate throughout the zoom range and in low light conditions.

A simulation of an EVF view in low light
(central portion magnified to aid manual focusing)

Manual focus when using an EVF

Fuji offers a focus check that enlarges the central information so that you can get a clearer picture of the pixel-starved fuzz - not at all helpful. The depressingly dark EVF on the Sony R1 automatically switches to double magnification when you attempt to focus manually (automatically switching back to normal magnification when focusing is complete). These features would be highly appreciated if the manufacturers were then to quadruple the pixel count. Another feature that adds to the difficulty of focusing is that the manual focus rings on the digicams typically have no stops. They do not stop at infinity or the minimum focusing distance of the lens. Photographers using SLR lenses can, after practice, instinctively move the lens to the correct distance after appreciating the amount of twist they need to make from the stop. The lack of stops on the digicam lens precludes the use of this technique. The long and short of it is that focusing manually using a digicam is a tiresome affair that most users will hand over to the autofocus setting. With some mobile phones offering higher resolution LCD screens than the typical digicam EVF this is a situation I hope will be rectified in the not too distant future. It is perhaps the last real problem that is stopping the prosumer cameras making serious in-roads into the DSLR market.

Conclusion

Who then will be buying a high-end prosumer camera instead of a DSLR? They can be as expensive and as big as a small DSLR. The lack of an optical viewfinder or good EVF takes the shine off the experience of capturing images in some situations. They are slower when you need to capture bursts of images and can be noisier when you need to hand-hold images in low-light conditions. If on the other hand you are not adverse to using a tripod in low-light conditions and really can't be fussed with the whole 'lens-swapping, manual focusing, kit carrying' saga then you may be just the sort of person prosumer digicams have been designed for. These cameras will probably go from strength to strength over the coming years so if you are not quite ready to part company with traditional SLR technology just yet be sure to keep an eye on the high-end prosumer digicam market (or whatever they eventually become known as).

CHECK LIST OVERVIEW

Q. How many pixels do I need - how big do I want to print?
A. 6 megapixels for a full page and 10–12 for a double page.

Q. Do I need to shoot RAW files in rapid succession?
A. Investigate the buffer size and speed of DSLR cameras.

Q. Do I need to shoot hand-held in low light with raised ISO?
A. Choose a camera with a larger sensor, wide aperture lens and/or image stabilization and check out whether the budget DSLR comes with an option of upgrading to a better lens, brighter and with less barrel distortion at the wide-angle end of the zoom range.

Q. Would I prefer to work with a live preview or with an optical viewfinder?
A. Check out cameras with 2.5-inch LCD displays and the Konica Minolta EVF before you reach a decision on this one.

Q. Do I want or need movie capture, 3:2 format capture?
A. Only prosumer digicams offer movie capture and only a select few cameras offer the 3:2 format (some surprises in the prosumer digicam range).

Q. Can I change the ISO, image format setting, self-timer and white balance without referring to the manual or trawling through submenus?
A. Many cameras place all of the important settings within easy reach these days. Some manufacturers still need to talk with the photographers who use their cameras.

Q. Does the camera and lens come with useful features such as PC sync terminals, a threaded cable-release socket, protected LCD displays, lens-hood and twist-barrel zoom control, dual memory card slots and fast USB2 or Firewire data transfer?
A. Grab as many as you can on a single system. An individual feature is easy to overlook unless you are ticking them off a list.

Lake Wartook, Grampians National Park, Victoria - Fuji FinePix s9500

digital asset management

Mark Galer

essential skills

- ~ Implement fast and efficient systems for managing your image files.
- ~ Generate and apply metadata templates and keywords.
- ~ Batch rename and batch process images to alternative file formats.
- ~ Archive images.

Digital asset management

It does not seem so long ago that I was shuffling 35mm Kodachrome trannies around on a light box to edit and create narrative sequences. This was followed by the laborious process of labelling the trannie mounts with useful information of miniscule proportions, having inferior quality duplicates made and then creating file sheets to catalog and archive the work before it was lost to the undocumented subconscious of my brain. After sending the work via courier to the picture editor of a magazine, the inevitable long wait, the 'can you send us a copy we seem to have mislaid the first set', followed by the publication of the work, the trannies invariably came back damaged (hence the dupes) and it didn't matter how carefully you cross referenced your cataloging system you could never seem to lay your hands on a much needed trannie to complete an alternative edit or grouping to maximize the potential of your visual assets.

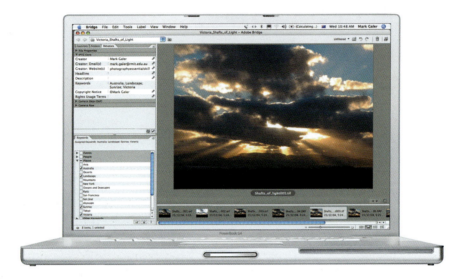

It has been a long time coming - but we now, finally, and after much gnashing of teeth, have an effective (and superior) digital equivalent to this analog asset management process. Many early adopters to digital capture (before Adobe camera RAW and Bridge became part of the collective bundle of joy) have understandably acquired some unusual (perhaps unique) workflow processes. The tools needed to complete the task logically, economically and efficiently were not part of Photoshop. Now we are able to adopt a digital asset management system into our daily workflow so that the cataloging task does not get bigger than Ben Hur.

> **Warning** > The danger of NOT integrating a systematic workflow is that hard drive space will quickly become eroded under the shear weight of digital data. You will, at short notice, backup your images to drives or discs (in a desperate attempt to free up hard drive space so that your computer does not grind to a halt). This will, in turn, prevent your computer's search engines, your Adobe software and your short-term memory from finding these files. Your files may be labelled with memorable names such as _B240100.ORF contained in folders with equally memorable names such as 116_Olympus. Your photographs will become lost in a sea of meaningless data.

Workflow sequence

1. Transfer images

It does not really matter which method you use to transfer your images to your computer (card reader, Image Tank or directly from the camera) so long as it uses a high-speed connection (USB 2 or Firewire) it is a relatively quick and painless process. The source of the images may be different but the destination should always be the same - a named folder in the 'Pictures/My Pictures' folder of your computer's hard drive. It is possible to move the image folder directly from the 'source' to the Pictures folder using no software, but in this 'auto/I can outsmart you/age' an application usually opens as soon as new images are detected at the other end of a USB or Firewire connection. These automated applications should be disabled unless they give you the option to save the files to a named folder in the Pictures folder of the hard drive.

On a Mac iPhoto is programmed to spring into life, but this can be a mixed blessing. iPhoto may be great for the family snaps (iPhoto 5 and 6 even manage the movie clips you captured on your digicam) but iPhoto has several drawbacks for professional quality digital asset management. iPhoto only supports a limited range of RAW files and does not embed 'keywords' directly into the file. Keywords are used to describe the image content and can be used to find a file when the file name has been forgotten - a bit like searching for a web page when you do not know the URL. This means that if you separate the images from the system the keywords are still with the system and not with the images. A different computer will be unable to search these files for a description of their content. Due to these limitations it is recommended that you disable iPhoto if you are using a Mac computer. You can disable iPhoto on a Mac by opening 'Image Capture' from the 'Applications' folder. In the 'Preferences' of Image Capture you can specify 'No Application'.

RAW AND JPEG

Many DSLR cameras provide the option of saving JPEG and RAW files during the capture process. If you are not in any great hurry to see your images then shooting only RAW files is recommended. Higher quality JPEGs can be generated from the RAW master files after you have had the opportunity of creating some settings in Adobe Camera RAW dialog box.

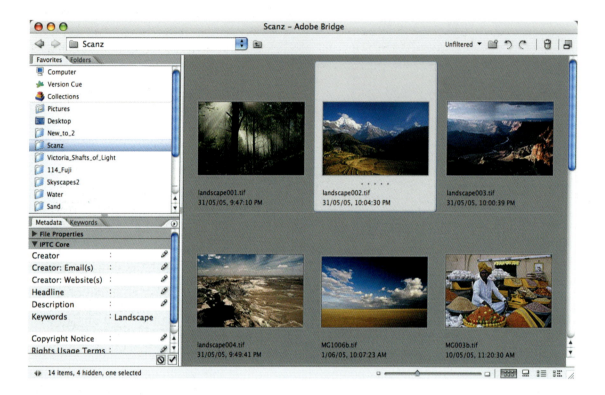

2. Select a workspace

After transferring your folder of images to the Pictures folder on your hard drive open Adobe Bridge (now a separate application) and spend a few moments familiarizing yourself with the interface (not too dissimilar from the File Browser that was shipped with Elements 3 and Photoshop CS). The tabs can be dragged and moved to new locations and the image windows can be made bigger or smaller.

WORKSPACES

Adobe have saved a series of workspaces in Bridge (go to Window > Workspaces) that will help you gain an idea of how some people may choose to sort and manage their image folders. You can also save your own workspaces that display the right amount of data and size of thumbnails/ previews that best suit your particular workflow or task in hand.

3. Build a cache

When a folder containing image files is opened in Bridge every photographer is practically biting their arm off to see the fruit of their creative labours. This impatience to see the glory, or experience the dejection, is why some photographers are not fans of Bridge. The problem is one of time - the software needs it - and you don't have it. Your relationship with a Digital Asset Management system is likely to be a lot more positive if at this stage you either GO AND MAKE YOURSELF A CUP OF COFFEE or switch to Adobe Photoshop to work on another image whilst Bridge is busy building thumbnails, reading the metadata and - its biggest task by far - building full screen previews of your images. The process that has to take place the first time you open a new folder of images is called 'building a cache'. Until this process is complete and the cache has been built you are not going to be able to interact with your images in real time in Bridge.

Unless you have a top of the range computer everything may appear to be covered in glue until the cache building is complete and it will likely annoy the socks off you if you attempt to move, open or organize your work in any way. Even after all of the thumbnails have appeared you must still allow the software time to create the larger previews. After this process is complete Adobe can quickly display the images each time you revisit the folder, as it will refer back to the cache it built the first time. The cache is a hidden treasure trove of all of the visual elements of your images required to make real time editing possible.

Note > Do not move or rename the folder once the image cache has been built without 'exporting the cache'. If the central cache thinks your images are new Adobe will start the task of building previews all over again. Exporting the cache (outlined in Step 10 of this workflow) to the image folder enables Adobe quick access to the previews and thumbnails wherever its new location. Choose 'Use Distributed Cache Files When Possible' from the Advanced options of the Preferences dialog box if you intend to keep all of your image folders in a separate location to your main computer. This will negate the need to continually export the cache for each and every image folder.

4. Select image files for processing

When your cache is complete you can start the editing process by clicking on any image thumbnail and dragging it to a new position to create a sequence or grouping. For fast editing you will need to select multiple images. Hold down the Shift key when you click on the first and last image in a sequence to select all of the images in that range. To select non-sequential images hold down the Ctrl key (PC) or Command key (Mac) and click on individual images. Ctrl/Command+A and Ctrl/Command+ Shift+A are the keyboard shortcuts for 'Select all' and 'Select none'.

You can choose whether you would like to view the thumbnails with information (the amount of information you would like to see is controlled by the Preferences) or the thumbnails only. Use the Keyboard shortcut Ctrl+T or Command+T to switch between information and thumbnails only view. Hide the panels by clicking on the icon in the bottom left-hand corner or by using the keyboard shortcut Ctrl+Alt+T (PC) Command+Option+T (Mac).

Note > Hide Photoshop's palettes by pressing the TAB key if working in File Browser.

24

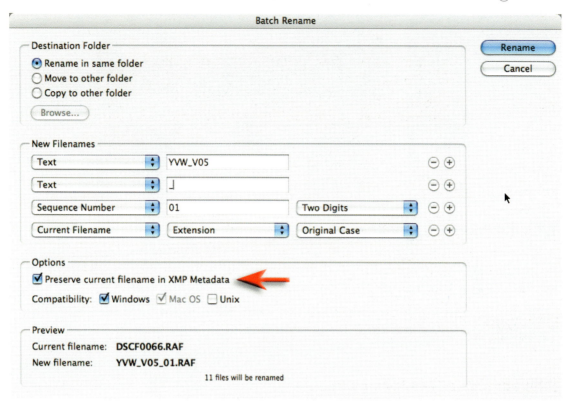

5. Batch rename

Go to 'Tools > Batch Rename' to change the name of your files. Do not use spaces or punctuation marks in the naming of files. Use underscores instead of spaces and initials instead of words to keep the file name short, e.g. YVW_V05 for Yarra Valley Winery, Victoria 2005. It is possible to add a full description to each of the files later using the images' metadata rather than the file name to describe the contents of the image (see step 9). Use the 'Preserve current file name in XMP metadata' option to retain the original file name in the metadata. This is a useful option when you want to retain the connection of PSD, TIFF or JPEG files to the master RAW files or when you are only renaming a selection of images from a shoot.

BATCH RENAMING IN FILE BROWSER

Users of File Browser in Photoshop 7 and CS were often confused with the default settings in the Batch Rename dialog box. The file extension, by default, appeared in the second field. This glitch by someone at Adobe prevented effective renaming of the files. The file extension should be consigned to at least the third field so each file can have the same name and a unique number (this requires at least two fields to be used before the file extension appears). This problem was rectified in Bridge.

6. Optimize the RAW previews

It is possible to open more than one image into the camera RAW dialog box. Opening the files in Bridge (Ctrl+R or Command+R) instead of Photoshop (Ctrl+O or Command+O) will allows you to process a batch of files in Bridge whilst working on another image in Photoshop.

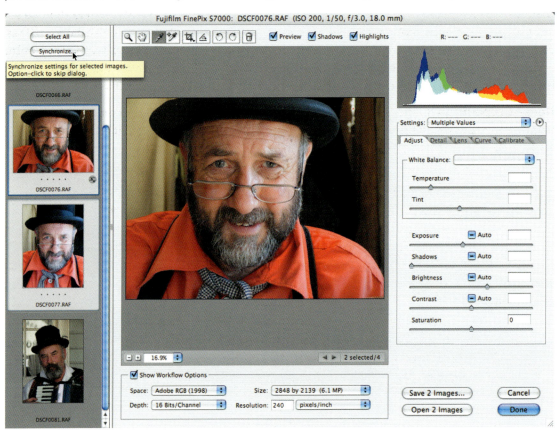

When images share the same lighting it is possible to synchronize the RAW settings. Images taken with a camera using the Auto White Balance setting will often display minor color variations which would benefit from being standardized in camera RAW.

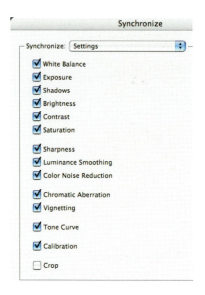

Start the synchronize procedure by optimizing one image (see Camera RAW) and then select the rest of the images that share the same lighting. Clicking on the synchronize button allows you to choose the precise RAW settings you would like to synchronize. The ability to synchronize selected settings allows you to standardize some components, such as color and tonality, whilst leaving other settings, such as crop and sharpness, specific to an individual image.

Note > Cropping an image in Camera RAW does not delete the pixels but merely hides them from view in the Bridge previews. The crop can be removed or altered at any time.

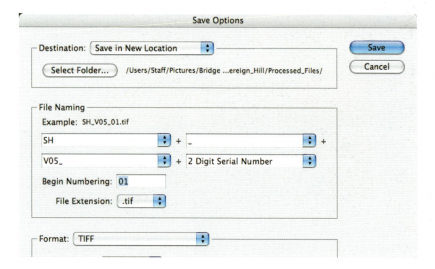

Select Done in the camera RAW dialog box to apply the changes or select 'Save' to process the files (convert them to PSD, TIFF or JPEG files with the settings applied). Saving multiple files can take a while but you can work in Photoshop on another image whilst this process is taking place (so long as the RAW files were opened in Bridge rather than in Photoshop).

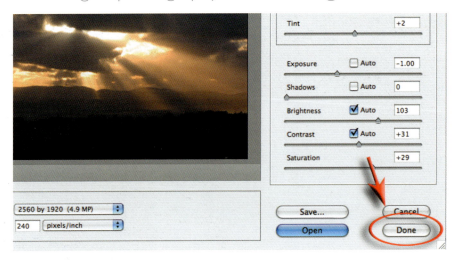

Opening all of the RAW files to optimize the color and tonality of the previews is not necessary. If you open up just one image in the camera RAW dialog box this can be used as a template to optimize the rest of the images in the image folder that share the same lighting and exposure. To share RAW settings between images displayed in Bridge double-click on a single RAW file thumbnail to open it into Adobe Camera RAW dialog box. Set the white balance, optimize the histogram and allocate noise reduction and sharpening settings that you would like a range of images to share.

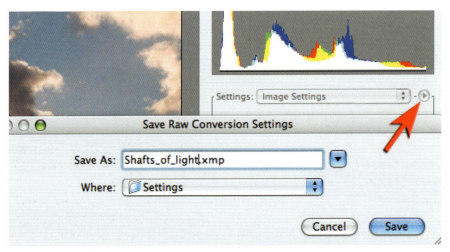

Either save these settings in the RAW dialog box using the option in the Image Settings menu or simply click Done to apply the settings to this single RAW image.

Note > Saving the settings is not so important as it was with File Browser because you now have the ability to 'copy' and 'paste' settings from the previews when working with Bridge. When the RAW processing is complete you do not need to open the image in the Photoshop editing space. Clicking on 'Done' in CS2 updates the settings without opening the file.

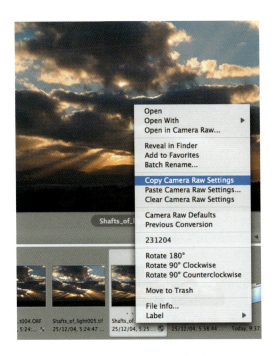

Apply your RAW settings to multiple files sharing the same light source and exposure. In Bridge you can also copy and paste settings as well as using the 'saved settings' or 'previous conversion' options to make the task easier.

Note > If using File Browser hold down the Alt (PC) or Option key (Mac) and click on the 'Update' button.

CAMERA RAW TIPS AND TECHNIQUES

Many photographers introduce a gray card or neutral tone in the image of the first shot on location to establish an effective tone for the 'white balance' tool inside the Adobe Camera RAW interface (eyedropper).

Every adjustment in camera RAW is global in nature – some adjustments are best left to Photoshop where they can be controlled in a localized way using adjustment layers and layer masks, e.g. localized sharpening, saturation adjustments etc. I typically set the noise reduction sliders to 0 when using a DSLR camera and a low ISO setting (see the chapter 'Camera RAW').

I mostly concentrate my efforts on making sure the histogram fits neatly between the goal posts on either side (these 'goal posts' will become level 0 and level 255 when the image is finally opened in Photoshop or Elements). Hold down the 'Alt' or 'Option' key as you drag the 'Exposure' and 'Shadows' sliders to view where and when clipping may occur. The 'Brightness' and 'Contrast' sliders are not destructive to the histogram once it has been set using the Exposure and Shadows sliders, so these controls share nothing in common with their namesakes inside Photoshop and Elements. The saturation slider, however, has to be treated with some caution because if this is moved too high clipping can be induced.

7. Image editing - natural selection by ranking or flagging

Digital capture has removed the cost factor that was previously associated with film, and this for many photographers has led to an increased number of images captured with each shoot. Instead of being very selective with the viewfinder of the camera many photographers now have an increased selection task in post-production. The ability to 'label', 'rate' or 'tag' files to indicate a preferred choice (choosing between the good, the bad and the downright ugly) makes this task a relatively quick and efficient process. I prefer to use the 'Filmstrip view' in Bridge for this process so that I can see a large preview of the image I must choose to promote or relegate. After the initial selection process is complete we can then proceed to the main options bar and switch to the filtered view. This shows us only the favorites that we have flagged or ranked.

Note > When you need to compare two images side-by-side to help the selection process it is possible to create a second window of the same folder of images (File > New Window). When selecting images some photographers prefer to adopt a system of lowering the rating of images rather than increasing the rating. To take this approach start by rating all of the images with 4 or more stars. Set the window to a filtered view of 'Show 4 or More Stars'. As you lower the rating of selected images they disappear from view but are not removed from the folder. Use the keyboard shortcuts (Ctrl+3 or Command+3) to lower the rating of selected images to hide them from view.

8. Metadata templates

Metadata starts with the information that was recorded by your camera into the image file such as aperture, shutter speed and ISO settings. You can add to this metadata to help protect your copyright, provide a client with additional information about the image and to help you keep track of your images when you either forget where you stored your images or (worse still) forget when and where the images were taken. Adobe allows us to add captions, user-friendly titles and information about us - the photographer. A certain portion of this added information is likely to be the same for each and every image we produce. This information can be quickly stamped into the files by appending the Metadata using a pre-prepared 'Metadata Template'. To prepare a metadata template in Bridge 1.0 create a 'New' image in Photoshop (File > New). Then from the File menu select 'File Info' to open the metadata dialog box. Add your content to the visible fields such as copyright information and your personal details. Save the Metadata under your personal name. Adobe allows you to create multiple templates so it is possible to record more than one photographer's details or to create different versions for different clients. When you have saved the template close the image and return to Bridge.

Note > You can quickly switch between Bridge and Photoshop by using the keyboard shortcut Ctrl+Alt+O (PC) or Command+Option+O (Mac).

To add your personal Metadata template first select a range of images using the keyboard shortcuts and then click on the Metadata options tag. Go to Append Metadata and then select the template you created earlier.

9. Add description and keywords

By adding Metadata that is unique to each file, or selected files, we can identify the image with something more descriptive or interesting than the file name (file names should be kept short and contain no punctuation or spaces if they are to live on servers for viewing, distribution or collection). Select one or more images in the folder and then enter a description in the Description field of the IPTC Core metadata.

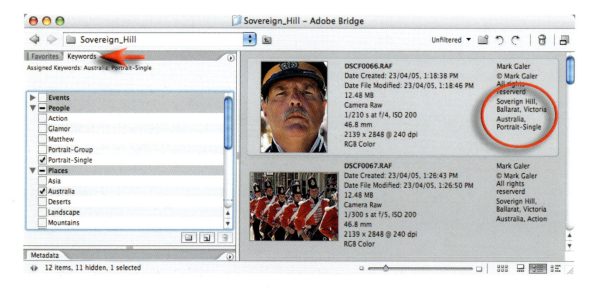

Adding keywords helps you to locate images long after the specific locations of individual images are forgotten. The use of keywords also allows you to gather images together from different shoots to create new collections and increase the potential for each individual image, e.g. gathering together a range of beach scenes at sunset from around the world to sell to a stock library years after they were captured.

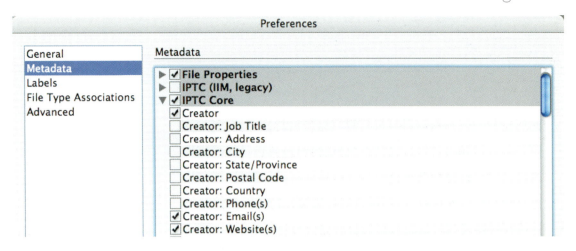

Unless you are a stock library you are not going to want to enter the amount of information that the IPTC* metadata supports. I have adopted an 'add them as I need them' approach, deleting the fields I do not require in Bridge's preferences. Keywords have a tabbed section all to themselves and cannot be added in the IPTC section of the Metadata tab. Keywords take a little thought and preparation if they are to be of any use. You will need to sit down and write a list of words that describes the sort of subjects you shoot and the sorts of words you would use to retrieve these subjects if lost. As I am primarily a travel/landscape photographer I have broken my work up into geographical regions (Asia, Europe, North America etc.) and topographical zones (Mountains, Rivers, Beaches, Deserts etc.). After you have established a library of useful keywords you can then start to select multiple files and click on the keywords to write the metadata to the files.

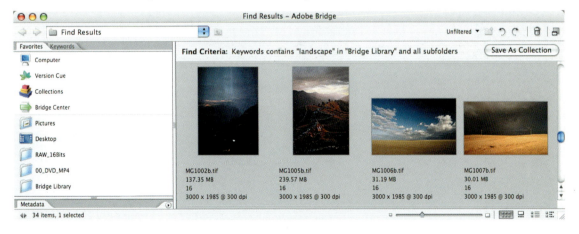

When Keywords have been assigned to your images you can search your drives by keyword (Edit > Find) as you would browse for a website where you are unsure of the URL. Use 'Batch Rename' for copying and renaming the files you find to a new folder or use the Save As Collection feature to create a collection of previews that link back to the original files.

***Useless information > IPTC stands for 'International Press and Telecommunications Council' - an organization of the worlds leading news agencies who were responsible for standardizing this part of the metadata information.**

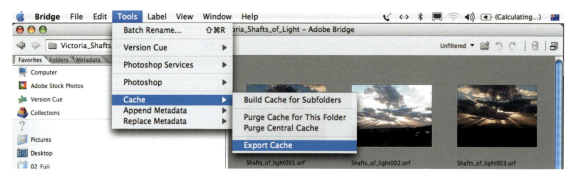

10. Archiving and backing up your work

Now that you are feeling organized and optimized you should back-up or archive your work onto a DVD or external hard drive. In fact it makes sense to back-up the work twice and keep one copy in a different location. These are your master files from which all of your future work will be generated. Before we start moving and burning however it is essential (in order to keep you caffeine intake down to something reasonable) to hit the command 'Export Cache' if you have not chosen the Distributed cache preference. An exported cache will sit in the image folder so that Bridge does not have to generate a new set of previews the next time you point your Adobe software at this folder (even if it is in a different location or being accessed by a different computer). If you are using 'File Browser' look under the 'File' menu in the Browser's dialog box. If you are using 'Bridge' go to 'Tools > Cache > Export Cache'.

Remember > Export a cache to avoid re-caching a folder.

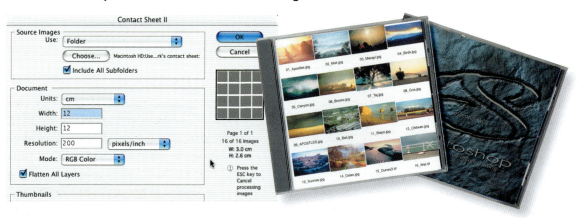

If you are backing up your image folder to a CD/DVD you can create a cover to help you locate the files quickly when your CD buries itself in amongst your collection of 549 other CDs. Make a selection of the images you want to back up and then proceed to the automated feature 'Contact Sheet II'. Specify a CD sized document size (12cm x 12cm) and a suitable printing resolution (200–300 ppi) and click OK - I feel another coffee coming on! I usually specify 16 thumbnails on a cover. When the first contact sheet is full, Photoshop automatically creates additional pages until all of the images in the folder are represented.

Image Processor

1 Select the images to process

Process files from Bridge only (6)

☐ Open first image to apply settings

2 Select location to save processed images

○ Save in Same Location

● (Select Folder...) ...hafts_of_Light/TIFF

3 File Type

☐ Save as JPEG ☐ Resize to Fit

Quality: 6 W: px

☐ Convert Profile to sRGB H: px

☐ Save as PSD ☐ Resize to Fit

☑ Maximize Compatibility W: px

H: px

☑ Save as TIFF ☐ Resize to Fit

☑ LZW Compression W: px

H: px

4 Preferences

☐ Run Action: Default Actions ▲▼ Automation works ▲▼

Copyright Info: []

☑ Include ICC Profile

[Run]
[Cancel]
[Load...]
[Save...]

11. Batch processing images to TIFFs, PSDs or JPEGs

If you are handing over your images to a client without further processing it is unlikely that they will thank you for handing over a folder of RAW files - even if they have an exported cache file. Photoshop now has an 'Image Processor' that makes light work of the task of converting all of the files to an appropriate format for your client's needs. It is possible to batch process in earlier versions of Photoshop by creating an 'Action' and then going to 'File > Automate > Batch'. A solution for the software impoverished (version 7 and CS) would be to go to www.russellbrown. com and download Russell's excellent script that was the inspiration for the Image Processor now found in Photoshop CS2.

Note > There is an option in the Image Processor for opening the first RAW image to apply the settings to the rest but if you have already completed this task earlier you can proceed in the secure knowledge that your resulting JPEG or TIFF files will be superior to the ones that would have been captured in-camera. You can also process the files from directly within the camera RAW dialog box by choosing the Save option. Depending on the size of your folder of images this might be another excuse to make a coffee especially if you then want to open the processed folder and build another cache.

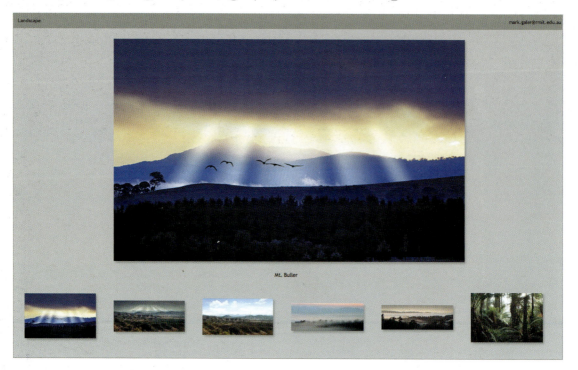

12. Create a web photo gallery

The creation of a web photo gallery is a great way for your client to make a selection online. With fast and easy navigation of the optimized images the client can quickly make a choice and then use the email link in the page. Although it is called a Web Photo Gallery it does not have to be online to be of any use. The gallery can be displayed in any web browser - online or offline and offers a quick and easy way of navigating your folder of images on your computer without launching Photoshop. To create a web gallery select a range of images and then go to Tools > Photoshop > Web Photo Gallery. Choose a gallery style and the options you require for both the thumbnails and large images and then choose whether you want to use the file's description that you may have added to the metadata earlier. Just remember that if the gallery is to be hosted on the Internet the folder name and file names must have short names (eight characters maximum for some servers) no spaces or punctuation marks. The resulting URL when uploaded to the web will be your main site URL, forward slash, folder name, forward slash, index.html or index.htm.

Note > The sequence of the images appearing in your gallery will follow a numerical and then alphabetical order. If you have used a two or three digit numbering system when you batch renamed the files then this will be the order of appearance in your gallery.

Conclusion

This workflow is not meant to be prescriptive and should be modified to meet your own needs. The important thing is that Adobe has now extended its focus beyond the post-production editing tools to embrace the complete workflow of a photographer. The digital workflow has now been embraced and our digital assets well and truly managed - a DAM good idea.

digital

exposure

Mark Galer

essential skills

~ Gain a knowledge and understanding of exposure and its relationship to light
 sensitive surfaces, depth of field and selective focus.

~ Understand the camera's TTL light meter.

~ Understand the relationship between subject brightness range and exposure.

~ Create images demonstrating an understanding of metering techniques.

Introduction

An understanding of exposure is without doubt the most critical part of the photographic process. Automatic exposure systems found in many sophisticated camera systems calculate and set the exposure for the photographer. This may lead some individuals to think there is only one correct exposure, when in reality there may be several. The exposure indicated by an automatic system, no matter how sophisticated, is an average. Creative photographers use the meter's indicated exposure reading for guidance only. Other photographers may interpret the same reading in different ways to create different images. It is essential the photographer understands how the illuminated subject is translated by exposure into a photographic image.

Exposure

Exposure is the action of subjecting a light-sensitive medium to light. Cameras and lenses control the intensity of light (aperture) and the duration of light (time) allowed to reach the image sensor. The intensity of light is determined by the size of the aperture in the lens and the duration of light is determined by the shutter.

Exposure is controlled by aperture and time - intensity and duration.

Too much light will result in overexposure. Too little light will result in underexposure. It makes no difference whether there is a large or a small amount of light, the image sensor still requires the same amount of light for an appropriate exposure at any given ISO setting.

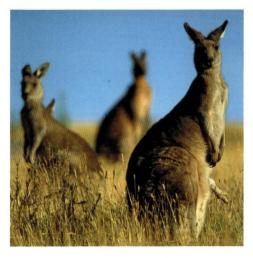
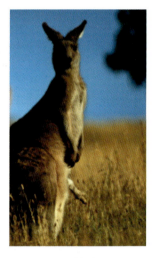

Overexposure *Correct exposure* *Underexposure*

Exposure must be adjusted to compensate for these changes in the brightness of the available light. This is achieved by adjusting either the intensity (**aperture**) or duration of light (**time**) or by adjusting the ISO on the camera. Increasing the size of the aperture gives more exposure, decreasing gives less. Decreasing the duration of the shutter speed reduces exposure, increasing gives more. Changing the ISO on the camera adjusts the sensitivity of the image sensor to the available light.

Measuring light

To calculate correct exposure the intensity or level of light has to be measured. Light is measured by a light meter. Understanding the types of metering used in most cameras is an important skill. All light meters inform the photographer of the amount of light available to obtain an appropriate exposure. This information can be used to set aperture and shutter speed settings in a variety of combinations. Each combination will give different visual outcomes whilst retaining the same overall exposure (depth of field and motion blur). Working in a creative medium such as photography '**correct exposure**' can sometimes be a very subjective opinion. The photographer may want the image to appear dark or light to create a specific mood.

Exposing for highlights - Mark Galer

Appropriate exposure

A light meter reading should only be viewed as a guide to exposure. Digital image sensors are unable to record the broad range of tones visible to the human eye. If the camera frames a subject with highlights and shadows the image sensor may only be able to capture the highlight tones or the shadow tones, not both. An extremely bright tone and an extremely dark tone cannot both record with detail and texture in the same framed image. Underexposure and overexposure in one image is therefore not only possible but common.

It is often necessary for the photographer to take more than one reading to decide on the most appropriate exposure. If a reading is taken of a highlight area the resulting exposure may underexpose the shadows. If a reading is taken of the shadows the resulting exposure may overexpose the highlights. The photographer must therefore decide whether highlight or shadow detail is the priority, change the lighting or reach a compromise. A clear understanding of exposure is essential if the photographer is to make an informed decision.

Intensity and duration

Intensity

Light intensity is controlled by the aperture in the lens. The aperture is a mechanical copy of the iris existing in the human eye. The human iris opens up in dim light and closes down in bright light to control the amount of light reaching the retina. The aperture of the camera lens must also be opened and closed in different brightness levels to control the amount or intensity of light reaching the image sensor. The right amount of light is required for correct exposure. Too much light and the image will be overexposed, not enough light and it will be underexposed.

As the aperture on a lens (as fitted to an SLR camera) is opened or closed a series of clicks may be felt. These clicks are called f-stops and are numbered. When the value of the f-stop **decreases** by one stop exactly **twice** as much light reaches the image sensor as the previous number. When the value of the f-stop **increases** by one stop **half** as much light reaches the image sensor as the previous number. This is called the 'halving and doubling principle'. The only confusing part is that maximum aperture is the f-stop with the smallest value and minimum aperture is the f-stop with the largest value. The larger the f-stop the smaller the aperture. From a small aperture of f22 to a wide aperture of f2.8 the stops are as follows (not all lenses have the range of stops indicated below):

<div align="center">

f22 f16 f11 f8 f5.6 f4 f2.8

</div>

<div align="center">

f16 f8 f4

</div>

Note > When using a command dial on the camera body to adjust the aperture you may find the aperture is opened or closed in 1/3 stop increments instead of 1 stop increments, e.g. the difference between f5.6 and f8 is one stop. The camera's LCD readout may however indicate values of 6.4 and 7.1 as the aperture is stopped down from f5.6 to f8.

ACTIVITY 1

Carefully remove the lens from a digital SLR camera if available.

Hold the lens in front of a white sheet of paper.

Look through the lens and notice how the size of the aperture changes as you alter the f-stop.

Record and discuss the relationship between the size of the aperture and the corresponding f-stop number displayed on the barrel of the lens.

Relationship between aperture and f-number

The reasoning behind the values given to the f-stops can be explained by the following example:

~ The diameter of a selected aperture on a standard 50mm lens for a full frame digital SLR such as the Canon 1Ds or Canon 5D measures 12.5mm.

~ This measurement divides into the focal length of the lens (50mm) exactly four times.

~ The aperture is therefore given the number f4.

~ The diameter of another selected aperture on the same lens measures 6.25mm.

~ This measurement can similarly be divided into the focal length of the lens to give an f-number of f8, thereby explaining why the higher f-numbers refer to the smaller apertures.

Mark Galer

The diameter of the same f-number may vary for different focal-length lenses but the intensity of light reaching the image plane remains constant. F4 on a long focal-length lens is physically much larger than the same aperture on a shorter focal length lens. The intensity of the light striking the image sensor is the same, however, due to the increased distance the light has to travel through the longer focal-length lens. See 'Inverse Square Law' on page 97.

ACTIVITY 2

Take exposure readings of a subject in bright sunlight and in deep shade.
Record all of the different combinations of exposure (shutter speed and aperture) for each lighting condition.

Duration

Light duration is controlled by the shutter. The time the image sensor is exposed to light is measured in whole and fractions of a second. This time is regulated by the shutter speed. Until the invention of the focal plane shutter, exposure time had been controlled by devices either attached to or within the lens itself. These shutters regulated the length of exposure. Early cameras had no shutter at all and relied upon the photographer removing and replacing a lens cap to facilitate correct exposure times. Other rudimentary shutters, very similar in appearance to miniature roller blinds, were tried but it was not until the invention of a reliable mechanical shutter that exposure times could be relied upon. As film emulsions became faster (increased sensitivity to light) so did the opportunity to make shorter exposures. Within a relatively brief period exposures were no longer in minutes but in fractions of a second.

Mark Galer

The shutter

The main types of shutter systems used in photography are the digital shutter, the leaf shutter and the focal plane shutter. The primary function of all systems is exposure. When the shutter is released it opens for the amount of time set on the shutter speed dial or LCD. These figures are in whole and fractions of seconds. The length of time the shutter is open controls the amount of light reaching the image plane. Each shutter speed doubles or halves the amount of light reaching the image sensor. Leaving the shutter open for a greater length of time will result in a slower shutter speed. Shutter speeds slower than 1/60 second, using a standard lens, can cause motion blur or camera shake unless you brace the camera, mount it on a tripod or use some form of image stabilization. Using a shutter speed faster than 1/250 or 1/500 second usually requires a wide aperture, more light or an image sensor of increased sensitivity (raised ISO). These measures are necessary to compensate for the reduced amount of light passing through a shutter open for a short period of time.

> **The same exposure or level of illumination can be achieved using different combinations of aperture and shutter speed. For example, an exposure of f11 @ 1/125 second = f8 @ 1/250 second = f16 @ 1/60 second and so forth.**

Digital shutter

The duration of the exposure can be controlled entirely by electronic means by switching on and switching off the image sensor for the prescribed amount of time. Many digital SLR cameras, however, use a hybrid system of digital and focal plane shutters.

Leaf shutter

Leaf shutters are situated in the lens assembly of most medium-format and all large-format cameras. They are constructed from a series of overlapping metal blades or leaves. When the shutter is released the blades swing fully open for the designated period of time.

Focal plane shutter

A focal plane shutter is situated in the camera body directly in front of the image plane (where the image is focused), hence the name. This system is used extensively in SLR cameras and a few medium-format cameras. The system can be likened to two curtains, one opening and one closing the shutter's aperture or window. When the faster shutter speeds are used the second curtain starts to close before the first has finished opening. A narrow slit is moved over the image plane at the fastest shutter speed. This precludes the use of high speed flash. If flash is used with the fast shutter speeds only part of the frame is exposed.

The advantages of a focal plane shutter over a leaf shutter are:

~ fast shutter speeds in excess of 1/1000 second;
~ lenses are comparatively cheaper because they do not require shutter systems.

The disadvantage is:

~ limited flash synchronization speeds.

Focal plane shutter firing faster than the fastest flash synchronization speed

ACTIVITY 3

Create exposures of a stationary subject at a variety of shutter speeds between 1/125 and 1/4 second whilst hand holding your camera.
Set the lens to 50 mm (or equivalent) and correct the exposure using the aperture each time the shutter speed is adjusted (use shutter priority [Tv] or manual mode).
At what shutter speed is the subject no longer sharp?

TTL light meters

TTL or 'through the lens' light meters, built into cameras, measure the level of reflected light prior to exposure. They measure only the reflected light from the subject matter within the framed image. The meter averages or mixes the differing amounts of reflected light within the framed image, and indicates an average level of reflected light. The light meter readings are translated by the camera's CPU and used to set aperture and/or shutter speed.

Centre-weighted and matrix metering

Centre-weighted and selective metering systems (matrix metering), common in many cameras, bias the information collected from the framed area in a variety of ways. Centre-weighted metering takes a greater percentage of the information from the central area of the viewfinder. The reading, no matter how sophisticated, is still an average - indicating one exposure value only. Any single tone recorded by the photographer using a TTL reading will reproduce as a midtone, no matter how dark or light the tone or level of illumination. This tone is the midpoint between black and white. If the photographer takes a photograph of a black or white wall and uses the indicated meter reading to set the exposure, the final image produced would show the wall as having a midtone (the same tone as a photographer's 18% gray card).

Centre-weighted TTL metering

Automatic TTL exposure modes

If the camera is set to fully automatic or program mode both the shutter speed and aperture will be set automatically, ensuring an average exposure in response to the level of light recorded by the meter. In low light the photographer using the program mode should be aware of the shutter speed being used to achieve this exposure. As the lens aperture reaches its widest setting the program mode will start to use shutter speeds slower than those usually recommended to avoid camera shake. Many cameras alert the photographer to this using an audible or visual signal. This should not be treated as a signal to stop taking photographs but to take precautions to avoid camera shake, such as bracing the camera or by using a tripod.

Semi-automatic

The disadvantage of a fully automatic or program mode is it can often take away the creative input the photographer can make to many of the shots. A camera set to fully automatic is programmed to make decisions not necessarily correct for every situation. If your camera is selecting both the aperture and shutter speed you will need to spend some time finding out how the camera can be switched to semi-automatic and manual operation.

Semi-automatic exposure control, whether aperture priority (Av) or shutter priority (Tv), allows creative input from the photographer (**depth of field** and **movement blur**) but still ensures the meter indicated exposure or 'MIE' is obtained automatically.

Aperture priority (aperture variable or Av)

This is a semi-automatic function where the photographer chooses the aperture and the camera selects the shutter speed to achieve 'MIE'. This is the most common semi-automatic function used by professional photographers as the depth of field is usually a primary consideration. The photographer using aperture priority needs to be aware of slow shutter speeds being selected by the automatic function of the camera when selecting small apertures in low-light conditions. To avoid camera shake and unintended blur the aperture has to be opened and the depth of field sacrificed (see the chapter 'Creative Controls').

Orien Harvey

Shutter priority (time variable or Tv)

This is a semi-automatic function where the photographer chooses the shutter speed and the camera selects the aperture to achieve correct exposure. In choosing a fast shutter speed the photographer needs to be aware of underexposure as light levels decrease. The fastest shutter speed possible is often limited by the maximum aperture of the lens. In choosing a slow shutter speed the photographer needs to be aware of overexposure when photographing brightly illuminated subject matter. Movement blur may not be possible when using an image sensor set to a high ISO in bright conditions.

Interpreting the meter reading

The information given by the light meter after taking a reading is referred to as the '**meter indicated exposure**' (**MIE**). This is a guide to exposure only. The light meter should not be perceived as having any intelligence or creative sensibilities. The light meter cannot distinguish between tones or subjects of interest or disinterest to the photographer. It is up to the photographer to decide on the most appropriate exposure to achieve the result required. A photographer with a different idea and outcome may choose to vary the exposure. It is the photographer's ability to interpret and vary the meter indicated exposure to suit the mood and communication of the image that separates their creative abilities from others.

If light or dark tones dominate, the indicated exposure will be greatly influenced by these dominant tones. Using the MIE will expose these dominant dark or light tones as midtones, whilst other tones may become overexposed or underexposed. If you consider that interest and visual impact within a photograph are created by the use of lighting and subject contrast (amongst many other things), the chances of all the elements within the frame being midtones are remote. The information, mood and communication of the final image can be altered through adjusting exposure from MIE.

Indian Market (average tones) MIE

Average tones

If a subject of average reflectance (a midtone) is framed together with dark and light tones in equal proportions (and all of the tones are lit equally by the same diffuse light source) the resulting meter reading will give correct exposure, i.e. the midtone will record as a midtone. If however a reading is taken from only the dark tones this exposure will render these dark tones as midtones and overexpose the mid- and light tones. An exposure using the reflected reading off only the lighter tones will render these lighter tones as midtones and underexpose the midtones and dark tones.

Dominant tones

If dark tones dominate the framed image the MIE will result in the dark tones being recorded as midtones. Midtones will be recorded as light tones and any light tones may be overexposed. If light tones dominate the framed image the meter indicated exposure will result in the light tones being recorded as midtones. Midtones will be recorded as dark tones and dark tones may be underexposed. If the midtones present in amongst these dominant dark or light tones are to be recorded accurately the exposure must be either reduced (for dominant dark tones) or increased (for dominant light tones) from the MIE.

Black swan (dominant dark tones) MIE

Decreased exposure

White wall (dominant light tones) MIE

Increased exposure

The amount the exposure needs to be reduced or increased is dictated by the level of dominance of these dark or light tones (see the chapter 'Light > Exposure compensation').

ACTIVITY 4

Photograph a subject requiring adjusted exposure from that indicated by the light meter. State how the dominant tones would have affected the light meter reading and how the image would have looked if you had not adjusted the exposure.

Reading exposure levels

The color information in a 24-bit RGB digital image file is separated into three 'channels' (8 bits per channel). Each color channel is capable of storing 256 levels of brightness between black (level 0) and white (level 255). When viewing all three color channels simultaneously each pixel is able to be rendered in any one of 16.7 million colors (256 x 256 x 256). These brightness levels can often be displayed as a simple graph or '**histogram**' in both the capture device and the image editing software. The horizontal axis displays the brightness values from left (darkest) to right (lightest). The vertical axis of the graph shows how much of the image is found at any particular brightness level. If the subject contrast or 'brightness range' exceeds the latitude of the capture device or the exposure is either too high or too low then tonality will be 'clipped' (shadow or highlight detail will be lost).

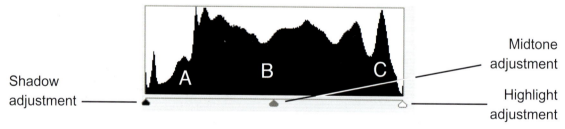

Shadow adjustment

Midtone adjustment

Highlight adjustment

Histograms

During the capture stage it is usually possible to check how the device has handled or interpreted the tonality and color of the subject. This useful information can often be displayed as a histogram on the LCD screen immediately after capture when using a DSLR or as part of the live preview when using a high quality prosumer digicam. The histogram displayed shows the brightness range of the subject in relation to the latitude or 'dynamic range' of your capture device's image sensor. Most digital camera sensors have a dynamic range similar to color transparency film (around five stops) when using the JPEG or TIFF file format and greater than seven stops when using the camera RAW format on a DSLR camera.

Note > When using the JPEG or TIFF file formats you should attempt to modify the brightness, contrast and color balance at the capture stage to obtain the best possible histogram before editing begins in the software.

Optimizing tonality

In a good histogram, one where a broad tonal range with full detail in the shadows and highlights is present, the information will extend all the way from the left to the right side of the histogram. The histogram below indicates missing information in the highlights (on the right) and a small amount of 'clipping' or loss of information in the shadows (on the left).

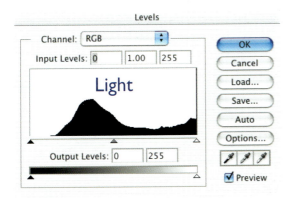
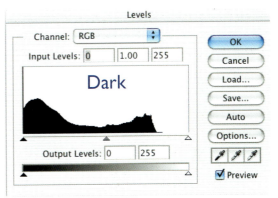

Histograms indicating image is either too light or too dark

Brightness

If the digital file is too light a tall peak will be seen to rise on the right side (level 255) of the histogram. If the digital file is too dark a tall peak will be seen to rise on the left side (level 0) of the histogram.

Solution: Decrease or increase the exposure/brightness in the capture device.

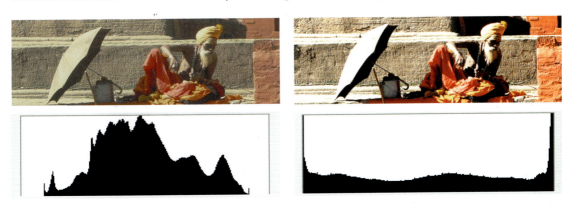

Histograms indicating image either has too much contrast or not enough

Contrast

If the contrast is too low the histogram will not extend to meet the sliders at either end.
If the contrast is too high a tall peak will be evident at both extremes of the histogram.

Solution: Increase or decrease the contrast of the light source used to light the subject. Using diffused lighting rather than direct sunlight or using fill-flash and/or reflectors will ensure that you start with an image with full detail. Alternatively adjust the contrast setting of the capture device or switch to shooting in Camera RAW if using a DSLR.

Optimizing a histogram in levels

The final histogram should show that pixels have been allocated to most, if not all, of the 256 levels. If the histogram indicates large gaps between the ends of the histogram and the sliders (indicating a low-contrast subject photographed in flat lighting) the relationship between the subject contrast and light quality could be reconsidered.

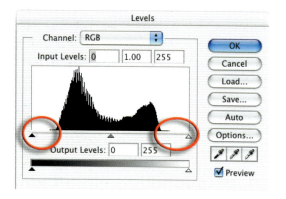 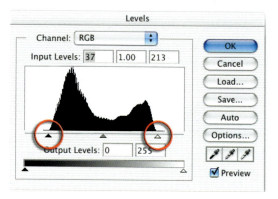

Small gaps at either end of the histogram can, however, be corrected in Photoshop by dragging the sliders in the 'Levels' adjustment dialog box to the start of the tonal information. Holding down the Alt key (Option key on a Mac) when dragging these sliders will indicate what, if any, information is being clipped. Note how the sliders have been moved beyond the short thin horizontal line at either end of the histogram. These low levels of pixel data are often not representative of the broader areas of shadows and highlights within the image and can usually be clipped (moved to 0 or 255).

Moving the 'Gamma' slider can modify the brightness of the midtones. If you select a Red, Green or Blue channel (from the Channel's pull-down menu) prior to moving the Gamma slider you can remove a color cast present in the image. For those unfamiliar with color correction the adjustment feature 'Variations' in Photoshop gives a quick and easy solution to the problem. After correcting the tonal range using the sliders click 'OK' in the top right-hand corner of the Levels dialog box.

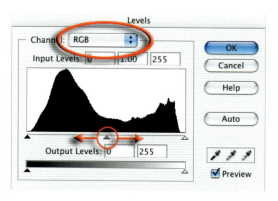

Note > Variations is not available for Photoshop users working in 16 Bits/Channel mode.

Color

Neutral tones in the image should appear desaturated on the monitor.

Solution: Select the correct white balance for your lighting or use a manual white balance setting to get the correct tone without any color cast or tints. Do not use the Auto white balance setting - that is best for one-off snapshots.

Accessing a broader dynamic range by using camera RAW

The histogram displayed on the back of a digital camera may not accurately reflect the precise range of tones that is being captured when the photographer elects to shoot in the camera RAW format. Most cameras provide information that is geared to the photographer capturing in the JPEG or TIFF format only. A photographer may therefore underestimate the dynamic range that is capable of being recorded by their camera. Instead of capturing a dynamic range of approximately five stops the RAW format may be capable of capturing images with a dynamic range that exceeds 7 or 8 stops when using a DSLR camera. The precise dynamic range will vary on the type of sensor being used as the smaller sensors fitted to the prosumer digicams do not enjoy the same dynamic range as the APS and full-frame sensors fitted to the DSLR cameras.

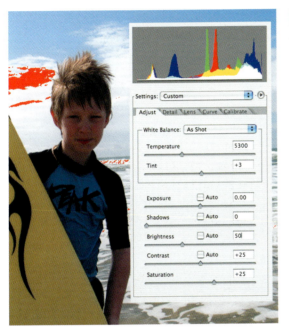 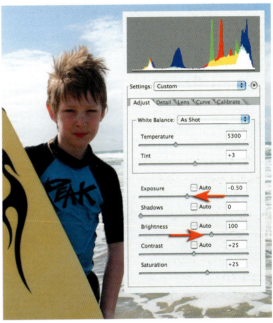

In the example above the highlights of the distant clouds were flashing when the image was reviewed in the camera (a common option on many digital cameras for indicating when overexposure has occurred). The histogram associated with the file clearly indicated that the highlights were being clipped. When the file was opened in camera RAW the exposure slider was moved to a value of −0.50 and usable detail (level 245) was returned to this area of the image. The brightness slider was raised to compensate for the negative exposure value. If the exposure had been lowered in camera the dark top that the boy is wearing would have required rescuing instead of the highlights. Most photographers find that it is preferable to rescue the highlights rather than the shadows (see the chapter 'Camera RAW') although due care must be taken not to allow the highlights to become completely overexposed. Taking two spot meter readings will enable the experienced photographer to ascertain the subject brightness range and assess whether this is compatible with the dynamic range of the sensor they are using.

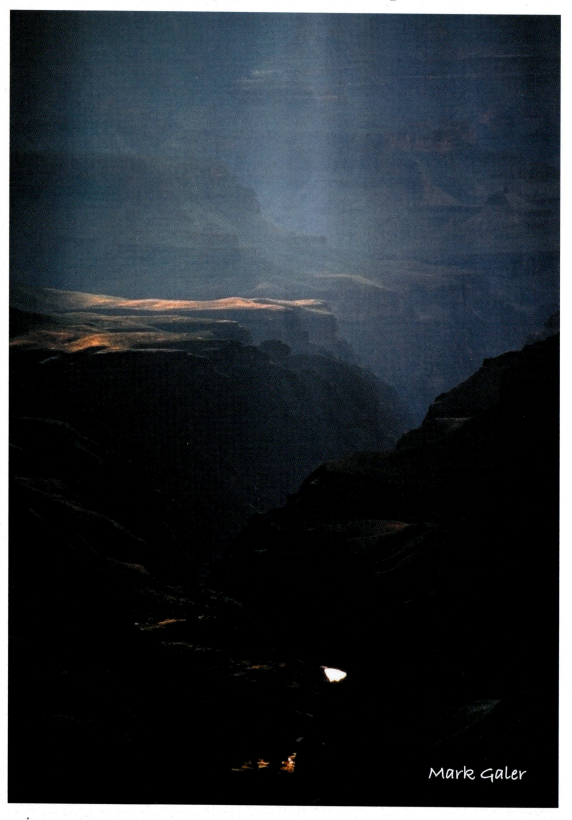

Mark Galer

camera RAW

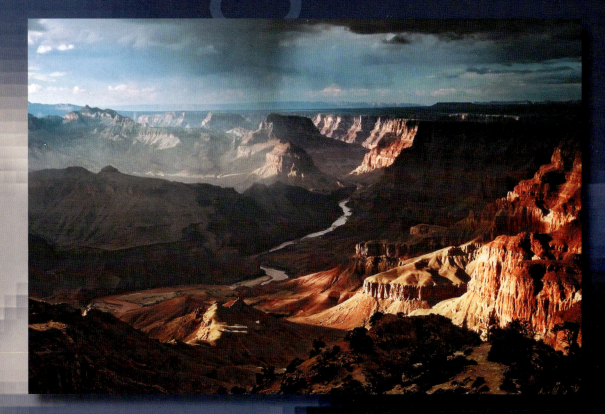

Mark Galer

essential skills

~ Capture high quality digital images as camera RAW files.

~ Process a camera RAW file to optimize color, tonality and sharpness.

~ Use camera RAW settings to batch process images for print and web viewing.

~ Convert RAW files to digital negatives for archival.

Introduction

One of the big topics of conversation since the release of Photoshop CS and Elements 3 has been the subject of 'RAW' files and 'Digital Negatives'. This chapter guides you through the advantages of choosing the RAW format and the steps you need to take to process a RAW file from your camera in order to optimize it for final editing in Adobe Elements or Photoshop CS/CS2.

All digital cameras capture in RAW but only Digital SLRs and the medium to high end 'Prosumer' cameras offer the user the option of saving the images in this RAW format. Selecting the RAW format in the camera instead of JPEG or TIFF stops the camera from processing the color data collected from the sensor. Digital cameras typically process the data collected by the sensor by applying the white balance, sharpening and contrast settings set by the user in the camera's menus. The camera then compresses the bit depth of the color data from 12 to 8 bits per channel before saving the file as a JPEG or TIFF file. Selecting the RAW format prevents this image processing taking place. The RAW data is what the sensor 'saw' before the camera processed the image, and many photographers have started to refer to this file as the 'Digital Negative'.

The sceptical amongst us would now start to juggle with the concept of paying for a 'state-of-the-art' camera to collect and process the data from the image sensor, only to stop the high-tech image processor from completing its 'raison d'être'. If you have to process the data some time to create a digital image why not do it in the camera? The idea of delaying certain decisions until they can be handled in the image-editing software is appealing to many photographers, but the real reason for choosing to shoot in camera RAW is QUALITY.

Processing RAW data

The unprocessed RAW data can be optimized by the latest image-editing software from Adobe. Variables such as bit depth, white balance, brightness, contrast, saturation and sharpness can all be assigned as part of the conversion process. Performing these image-editing tasks on the full high-bit RAW data (rather than making these changes after the file has been processed by the camera) enables the user to achieve a higher quality end-result. Double-clicking a RAW file opens the camera RAW dialog box where the user can prepare and optimize the file for final processing in the normal image-editing interface. If the user selects the 16 Bits/Channel option, the 12 bits per channel data from the image sensor is rounded up - each channel now capable of supporting 32,769 levels instead of the 256 we are used to working with in 8 bits per channel. When the file is opened into the image-editing workspace of your Adobe software the RAW file closes and remains in its RAW state, i.e. unaffected by the processing procedure.

Processing activity

Although the camera RAW dialog box appears a little daunting at first sight, it is reasonably intuitive and easy to master, and then RAW image processing is a quick and relatively painless procedure. The dialog box has been cleverly organized by Adobe so the user starts with the top slider and works their way down to the bottom control slider. If the image you are processing is one of a group of images shot in the same location, and with the same lighting, the settings used can be applied to the rest of the images as an automated procedure.

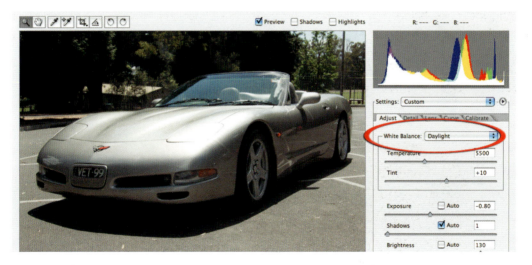

White balance - *Step 1*

The first task is to set the white balance by choosing one of the presets from the drop-down menu. If a white balance was performed in the camera the 'As Shot' option can be selected. If none of the presets adjust the color to your satisfaction you can manually adjust the 'Temperature' and 'Tint' sliders to remove any color cast present in the image. The 'Temperature' slider controls the blue/yellow color balance whilst the 'Tint' slider controls the green/magenta balance. Moving both the sliders in the same direction controls the red/cyan balance.

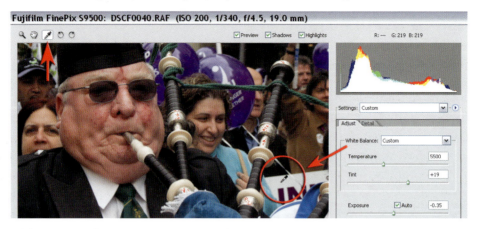

Alternatively you can simply click on the 'White Balance' eyedropper in the small tools palette (top left-hand corner of the dialog box) and then click on any neutral tone you can find in the image.

Note > Although it is a 'White Balance' you actually need to click on a tone that is not too bright. Clicking on a light or mid gray is preferable. A photographer looking to save a little time later may introduce a 'gray card' in the first frame of a shoot to simplify this task.

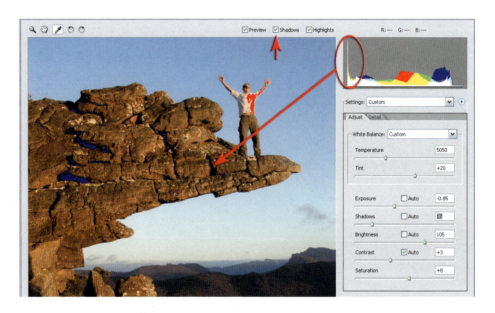

Tonal adjustments - *Step 2*

Set the tonal range of the image using the 'Exposure', 'Shadows' and 'Brightness' sliders. These sliders behave like the input sliders in the 'Levels' dialog box and will set the black and white points within the image. The 'Brightness' slider adjusts the midtone values in a similar way to the 'Gamma' slider when using 'Levels' dialog. When tall peaks appear at either end of the histogram you will lose shadow, highlight or color detail when you export the file to the main editing software. Careful adjustment of these sliders will allow you to get the best out of the dynamic range of your imaging sensor, thereby creating a tonally rich image with full detail.

Clipping information

Hold down the 'Alt/Option' key when adjusting either the 'Exposure' or 'Shadows' slider to view the point at which highlight or shadow clipping begins to occur (the point at which pixels lose detail in one or more channels). In Elements 3 you can check the 'Shadows' and 'Highlights' boxes underneath the main image window instead of holding down the Alt or Option key.

Note > If you hold down the 'Alt' or 'Option' key to view the clipping, the color that appears in the image window indicates the channel or channels where clipping is occurring (this only applies to the Alt/Option key technique). Color Saturation as well as overly dark shadows and overly bright highlights will also influence the amount of clipping that occurs. Clipping in a single channel (indicated by the red, green or blue warning colors) will not always lead to a loss of detail in the final image. When the secondary colors appear, however (cyan, magenta and yellow), you need to take note, as loss of information in two channels starts to get a little more serious. Loss of information in all three channels (indicated by black when adjusting the shadows and white when adjusting the exposure) should be avoided.

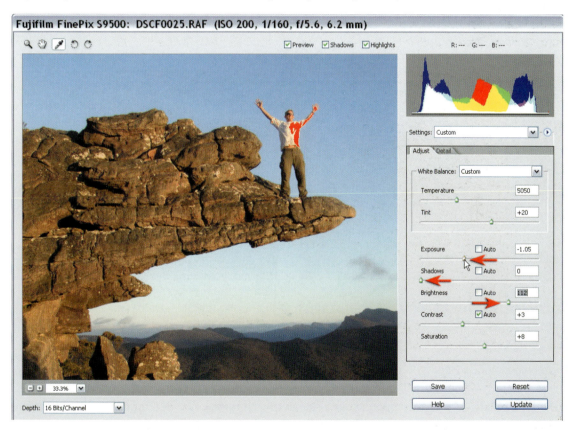

By moving the Exposure and Shadow sliders to the left, information is restored to the blue and red channels. The image is then made brighter using the Brightness slider.

Note > Large adjustments to the 'Brightness', 'Contrast' or 'Saturation' sliders may necessitate further 'tweaking' of the 'Exposure' and 'Shadows'.

Olympus E-300: _6180018.ORF (ISO 400, 1/200, f/4.7, 32 mm)

Noise reduction and sharpening - *Step 3*

Set the image to 100% and click on the Detail tab to access the sharpness and noise reduction controls. The Luminance Smoothing and Color Noise Reduction sliders (designed to tackle the camera noise that occurs when the image sensors' ISO is high) should only be raised from 0 if you notice image artifacts such as noise appearing in the image window.

In the image above the sensor was set to 400 ISO on a budget DSLR. Both luminance noise (left) and color noise (right) are evident when the image is set to 100%. With more expensive DSLR cameras set to 100 ISO it is common to leave all three sliders set to 0.

It is recommended that you only perform a gentle amount of sharpening in the RAW dialog box (less than 25) if you are using Photoshop Elements (see the chapter 'Post-production Editing'). Sharpening only affects the image preview as viewed in Bridge and not the image opened in the editing space when using the default settings of the full version of Photoshop.

Warning > The Luminance Smoothing and Color Noise Reduction sliders can remove subtle detail and color information that may go unnoticed if the photographer is not careful to pay attention to the effects of these sliders. Zoom in to take a closer look, and unless you can see either the little white speckles or the color artifacts set these sliders to 0.

Choosing a bit depth - *Step 4*

The only step that remains is to select the 'Depth' in the lower left-hand corner of the dialog box and then click 'OK'. If the user selects the 16 Bits/Channel option, the 12 bits per channel data from the image sensor is rounded up - each channel is now capable of supporting 32,769 levels. In order to produce the best quality digital image, it is essential to preserve as much information about the tonality and color of the subject as possible. If the digital image is edited further in 8 bits per channel the final quality will be compromised. If the digital image has been corrected sufficiently for the requirements of the output device in the RAW dialog box the file can be edited in 8-bit mode with no apparent loss in quality. Sixteen-bit editing, however, is invaluable if maximum quality is required from an original image file that requires further or localized editing of tonality and color after leaving the camera RAW dialog box.

Limitations with 8-bit editing

As an image file is edited extensively in 8 bits per channel mode (24-bit RGB) the histogram starts to 'break up', or become weaker. 'Spikes' or 'comb lines' may become evident in the resulting histogram after the file has been flattened.

Note > The least destructive 8-bit editing techniques make use of adjustment layers so that pixel values are altered only once, when the layers are flattened prior to printing.

Final histograms after editing the same image in 8 and 16 bits per channel mode

The problem with editing extensively in 8-bit mode is that there are only 256 levels or tones per channel to describe the full color range of the image. This is usually sufficient if the histogram looks healthy (few gaps) when we begin the editing process and the amount of editing required is limited. If many gaps start to appear in the histogram as a result of extensive adjustment of pixel values this can result in 'banding'. The smooth change between dark and light, or one color and another, may no longer be possible with the data supplied from a weak histogram. The result is a transition between color or tone that is visible as a series of steps in the final image.

Advantages and disadvantages of 16-bit editing

When the highest quality images are required there are major advantages to be gained by using Photoshop or Elements 3 to edit an image file in '16 bits per channel' mode. In 16 bits per channel there are trillions, instead of millions, of possible values for each pixel. Spikes or comb lines, which are quick to occur whilst editing in 8 bits per channel, rarely occur when editing in 16 bits per channel mode. Photoshop CS/CS2 has the ability to edit an image in 16 bits per channel mode using layers and all of the editing tools whilst Elements 3 supports only a single layer when editing in 16 bits per channel. The disadvantages of editing in 16 bits per channel are:

~ Not all digital cameras are capable of capturing in the RAW format.
~ File sizes are doubled compared to 8-bit images with the same pixel dimensions.
~ Many filters do not work in 16 bits per channel mode.
~ Only a small selection of file formats support the use of 16 bits per channel.

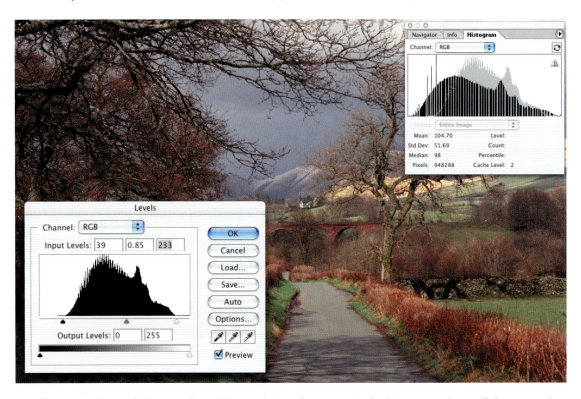

If you are editing in 16 bits per channel the comb lines that appear in the histogram palette will disappear when the uncached view is selected

Editing in 16 bits per channel

It is still preferable to make major changes in tonality or color in the RAW dialog box or in 16-bit mode before converting the file to 8-bit mode. Most of the better scanners that are now available (flatbed and film) now support 16 bits per channel image capture. Remember, you need twice as many megabytes as the equivalent 8-bit image, e.g. if you are used to working with 13 megabytes for a full-page image (8in x 10in @ 240ppi) you will require 26 megabytes to work with the same pixel dimensions in 16 bits per channel.

Choosing a color space - *Step 5*

Elements users do not get a choice in the RAW dialog box as to the color space the image will be opened in when OK is selected. The color space of the resulting image is determined by the Color Settings in the software preferences. If full Color Management has been selected the image will have the Adobe RGB color space embedded. If No Color Management or Limited Color Management is selected the image will acquire the sRGB color space. For images destined for print the preferred option is Full Color Management.

Photoshop CS/CS2 users can choose the profile that suits their current workflow. A new addition to the list is ProPhoto. This is a wide gamut color space and is the default editing space used by the camera RAW plug-in.

The wide gamut ProPhoto space (white) compared to the Adobe RGB 1998 space (color)

Note > The ProPhoto color space is suitable for users who are intending to stay in 16 Bits/ Channel for the entire editing process and who have access to a print output device with a broader color gamut than traditional CMYK devices are capable of offering.

Save or open - *Step 6*

When you have optimized the image you can either open the image into the main editing space of your Adobe software or save the image as a PSD, TIFF or JPEG with your optimized settings. The Save dialog box also gives the user access to Adobe's DNG (Digital NeGative) format which is a useful format for archiving your RAW files due to its lossless compression and its long term support by Adobe.

Additional information

Distribution of data

Most digital imaging sensors capture images using 12 bits of memory dedicated to each of the three color channels, resulting in 4096 tones between black and white. Most of the imaging sensors in digital cameras record a subject brightness range of approximately five to eight stops (five to eight f-stops between the brightest highlights with detail and the deepest shadow tones with detail).

Tonal distribution in 12-bit capture

Darkest Shadows	- 4 stops	- 3 stops	- 2 stops	-1 stop	Brightest Highlights
128 Levels	256	512	1024	2048	4096 Levels

Distribution of levels

One would think that with all of this extra data the problem of banding or image posterization due to insufficient levels of data (a common problem with 8-bit image editing) would be consigned to history. Although this is the case with midtones and highlights, shadows can still be subject to this problem. The reason for this is that the distribution of levels assigned to recording the range of tones in the image is far from equitable. The brightest tones of the image (the highlights) use the lion's share of the 4096 levels available whilst the shadows are comparatively starved of information.

An example of posterization or banding

Shadow management

CCD and CMOS chips are, however, linear devices. This linear process means that when the amount of light is halved, the electrical stimulation to each photoreceptor on the sensor is also halved. Each f-stop reduction in light intensity halves the amount of light that falls onto the receptors compared to the previous f-stop. Fewer levels are allocated by this linear process to recording the darker tones. Shadows are 'level starved' in comparison to the highlights that have a wealth of information dedicated to the brighter end of the tonal spectrum. So rather than an equal amount of tonal values distributed evenly across the dynamic range, we actually have the effect as shown above. The deepest shadows rendered within the scene often have fewer than 128 allocated levels, and when these tones are manipulated in post-production Photoshop editing there is still the possibility of banding or posterization.

Expose right and adjust left

'Expose right' and multiple exposures

This inequitable distribution of levels has given rise to the idea of 'exposing right'. This work practice encourages the user seeking maximum quality to increase the exposure of the shadows (without clipping the highlights) so that more levels are afforded to the shadow tones. This approach to make the shadows 'information rich' involves increasing the amount of fill light or lighting with less contrast in a studio environment. If the camera RAW file is then opened in the camera RAW dialog box the shadow values can then be reassigned their darker values to expand the contrast before opening it as a 16 Bit/Channel file. When the resulting shadow tones are edited and printed, the risk of visible banding in the shadow tones is greatly reduced.

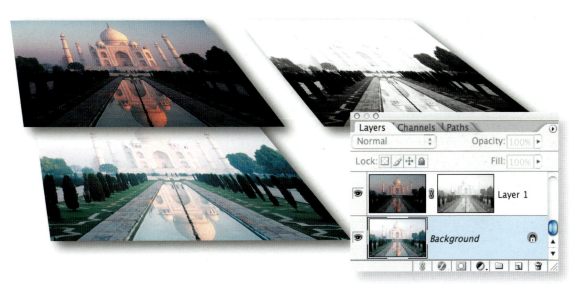

Separate exposures can be combined in image-editing in Photoshop or Elements

This approach is not possible when working with a subject with a fixed subject brightness range, e.g. a landscape, but in these instances there is often the option of bracketing the exposure and merging the highlights of one digital file with the shadows of a second. The example above shows the use of a layer mask used to hide the darker shadows in order to access the bit-rich shadows of the underlying layer and regain the full tonal range of the scene. See *Essential Skills: Photoshop CS2 or Photoshop Elements 4.0 Maximum Performance* for detailed post-production editing techniques.

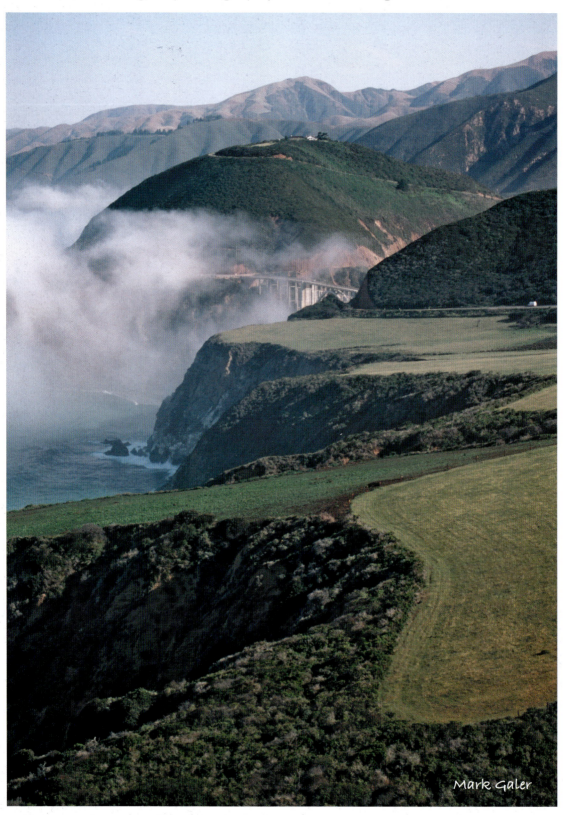

Mark Galer

framing the image

Mark Galer

essential skills

~ Develop an awareness of how a photographic image is a two-dimensional composition of lines, shapes and patterns.

~ Develop an understanding of how differing photographic techniques can affect both the emphasis and the meaning of the subject matter.

~ Look at the composition of different photographs and the design techniques used.

~ Create digital images through close observation and selection that demonstrate how the frame can create compositions of shape, line and pattern.

~ Document the progress and development of these skills.

Introduction

Capturing or creating strong images relies primarily on the photographer's ability to study the subject carefully, enthusiastically, imaginatively and sympathetically. The equipment can only help to craft the photographer's personal vision. Most people are too preoccupied to look at a subject for any great amount of time. Skilled observation by the photographer can release the extraordinary from the ordinary. The famous British photographer Bill Brandt in 1948 is quoted as saying:

> **'It is the photographer's job to see more intensely than most people do. He must keep in him something of the child who looks at the world for the first time or of the traveller who enters a strange country.'**

Framing techniques

The following techniques should be considered when the photographer wants to control the communication, impact and design of any image.

- ~ Communication and context
- ~ Format
- ~ Content
- ~ Balance
- ~ Subject placement
- ~ The decisive moment
- ~ Vantage point
- ~ Line
- ~ Depth

Communication and context

Photographs provide us with factual information. With this information we can make objective statements concerning the image. Objective statements are indisputable facts. Photographic images are an edited version of reality. With limited or conflicting information within the frame we are often unsure of what the photograph is really about. In these cases we may make subjective decisions about what the photograph is communicating to us personally. Subjective statements are what we think or feel about the image. Subjective opinion varies between individuals and may be greatly influenced by the caption that accompanies the image and/or our cultural or experiential background.

What do we know about this woman or her life other than what we can see in the photograph? Can we assume she is lonely as nobody else appears within the frame? Could the photographer have excluded her partner purchasing coffee to improve the composition or alter the meaning? Because we are unable to see the event or the surroundings that the photograph originated from we are seeing the subject out of context.

ACTIVITY 1

Read the following passage taken from the book *The Photographer's Eye* by John Szarkowski and answer the question below.

'To quote out of context is the essence of the photographer's craft. His central problem is a simple one: what shall he include, what shall he reject? The line of decision between in and out is the picture's edge. While the draughtsman starts with the middle of the sheet, the photographer starts with the frame.

The photograph's edge defines content. It isolates unexpected juxtapositions. By surrounding two facts, it creates a relationship. The edge of the photograph dissects familiar forms, and shows their unfamiliar fragment. It creates the shapes that surround objects.

The photographer edits the meanings and the patterns of the world through an imaginary frame. This frame is the beginning of his picture's geometry. It is to the photograph as the cushion is to the billiard table.'

Discuss what John Szarkowski means when he says that photographers are quoting 'out of context' when they make photographic pictures. Find one image that illustrates your discussion.

Format

Format refers to the size and shape of an image. A certain amount of confusion can surround this term. It applies to both '**camera format**' and '**image format**'. An image can be taken or cropped in the vertical or horizontal format using different format image sensors.

A vertical image (one that is tall and narrow) is described as '**portrait format**' even if the image is a natural landscape. A horizontal image is described as '**landscape format**' even if the subject is a portrait. The origins of this terminology date back to when traditional artists were a little more conservative with their intended use of the frame.

In editorial work photographers must ensure that images are taken using both vertical and horizontal formats. This gives the graphic artists the flexibility to design creative pages.

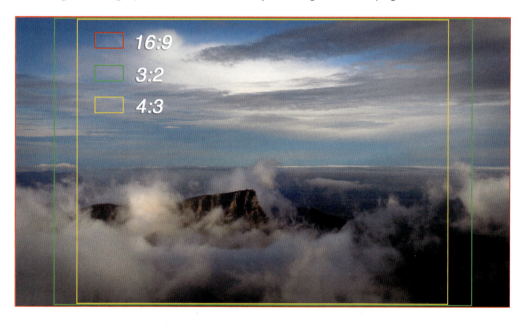

Most prosumer digicams and DSLRs currently available use sensors that have a 4:3 format or 'aspect ratio'. The aspect ratio is a numerical way of describing the shape of the frame. A 4:3 aspect ratio means that for every unit of height, the width is one and a third times wider. 4:3 is a numerical description of this ratio without using fractions. This format is the same as a standard computer screen, e.g. 1024 x 769 pixels. DSLRs that use full frame sensors such as the Canon 5D have an image sensor with a 3:2 aspect ratio that matches 35mm film (36mm x 24mm). This is a slightly wider format but not as wide as a wide-screen television that has a 16:9 aspect ratio. Some prosumer digicams now offer 3:2 as an alternative aspect ratio whilst cameras such as the Panasonic LX-1 and Leica D-LUX 2 use a CCD image sensor with a 16:9 format. The aspect ratio of a single page in this book is close to 4:3 whilst a double-page spread from this book is closer to the 3:2 aspect ratio. Care needs to be taken when framing images for editorial work. The photographer has to be prepared to lose some of the visible image in the viewfinder if an editor wants to produce either a full-page or double page image spread from an image captured in a different aspect ratio. Many photographers instinctively design full frame. This can later create difficulties when trying to crop the image to a different format.

The decisive moment

The famous photographer Henri Cartier-Bresson in 1954 described the visual climax to a scene which the photographer captures as being the 'decisive moment'.

The moment when the photographer chooses to release the shutter may be influenced by the visual climax to the action and the moment when the moving forms create the most pleasing design. In the flux of movement a photographer can sometimes intuitively feel when the changing forms and patterns achieve balance, clarity and order and when the image becomes for an instant a picture.

Orien Harvey

To capture decisive moments the photographer needs to be focused on, or receptive to, what is happening rather than the camera equipment they are holding. Just like driving a car it is possible to operate a camera without looking at the controls. The photographer must spend time with any piece of equipment so that they are able to operate it intuitively. When watching an event unfold the photographer can increase their chances of capturing the decisive moment by presetting the focus and exposure.

ACTIVITY 5

Create an image that captures the decisive moment of an action or interaction.
Discuss the balance or imbalance of your image.

Subject placement

Balance may be easily achieved by placing the subject in the middle of the frame. The resulting image does not encourage the viewer's eye to move around the image. This leads to a static composition, making little demand on the viewer.

The photographer should think carefully where the main subject is placed within the image, only choosing the central location after much consideration.

When the subject is framed the photographer should examine the image as if it was a flat surface. This action will help the photographer become aware of unnecessary distractions to the basic design. A common mistake made by photographers is to become preoccupied with the subject, forgetting to notice background detail. This can lead to the problem of previously unnoticed trees or lampposts apparently growing out of the top of people's heads when the final image is viewed.

The rule of thirds

Rules of composition can help photographers create harmonious images. The most common of these rules are the 'golden section' and the 'rule of thirds'. The golden section is the name given to a traditional system of dividing the frame into unequal parts which dates back to the time of Ancient Greece.

The rule of thirds

The rule of thirds is the simplified modern equivalent. Visualize the viewfinder as having a grid which divides the frame into three equal segments, both vertically and horizontally. Photographers often use these lines and their intersection points as key positions to place significant elements within the picture.

Breaking the rules

Designers who are aware of these rules often break them by deliberately placing the elements of the image closer to the edges of the frame. This can often be effective in creating dynamic tension where a more formal design is not needed.

ACTIVITY 4

1. Collect two examples of photographs that follow the rule of thirds and two that do not. Comment briefly on why and how you think the composition works.

2. Create an image that conforms to the rule of thirds. Discuss the key elements of the composition.

Balance

In addition to content a variety of visual elements such as line, color and tone often influence a photographer's framing of an image. The eye naturally or intuitively seeks to create a symmetry or a harmonious relationship between these elements within the frame. When this is achieved the image is said to have a sense of balance. The most dominant element of balance is visual weight created by the distribution of light and dark tones within the frame. To frame a large dark tone on one side of the image and not seek to place tones of equal visual weight on the other side will create imbalance in the image. An image that is not balanced may appear heavy on one side. Visual tension is created within an image that is not balanced. Balance, although calming to the eye, is not always necessary to create an effective image. Communication of harmony or tension is the deciding factor of whether balance is desirable in the image.

Itti Karuson

ACTIVITY 3

1. Collect one image where the photographer has placed the main subject off-centre and retained a sense of balance and one image where the photographer has placed the main subject off-centre and created a sense of imbalance.
Comment on the possible intentions of the photographer in creating each image.

2. Create an image where the focal point and/or visual weight is off-centre. Discuss the balance of this image.

Content

An essential skill of framing is to view the subject in relation to its background. This relationship between subject and background is often referred to as '**figure and ground**'. Many photographers stand too far away from the subject. In a desire to include all the subject their photographs become busy, unstructured and cluttered with unwanted background detail. This extra detail can distract from the primary subject matter. If a photographer moves closer, or chooses an alternative vantage point from which to take the image, distracting background can be reduced or eliminated. With fewer visual elements to be arranged the photographer has more control over composition. If background detail does not relate to the subject the photographer should consider removing it from the frame. Unless the photograph is to act as a factual record the need to include everything is unnecessary. William Albert Allard, a photographer for National Geographic, says:

> '**What's really important is to simplify. The work of most photographers would be improved immensely if they could do one thing: get rid of the extraneous. If you strive for simplicity, you are more likely to reach the viewer.**'

Matthew - Mark Galer

In the image above the protective hands provide all the information we need to understand the relationship between these people. In order to clarify this, the photographer could have moved further back. With increased background information the power of this portrait would have been lost. Photographers have the option however of taking more than one photograph to tell a story.

ACTIVITY 2

Create an image demonstrating how you can use a simple background to remove unwanted detail and help keep the emphasis or '**focal point**' on the subject.

Vantage point

A carefully chosen viewpoint or 'vantage point' can often reveal the subject as familiar and yet strange. In designing an effective photograph that will encourage the viewer to look more closely, and for longer, it is important to study your subject matter from all angles. The 'usual' or ordinary is often disregarded as having been 'seen before' so it is sometimes important to look for a fresh angle on a subject that will tell the viewer something new.

The use of a high or low vantage point can overcome a distracting background by removing unwanted subject matter, using the ground or the sky as an empty backdrop.

Mark Galer

ACTIVITY 6

1. Collect two examples of photographs where the photographer has used a different vantage point to improve the composition.

Comment on how this was achieved and how this has possibly improved the composition or interest of the image.

2. Create an image that makes use of an unusual or interesting vantage point. Discuss how you have sought to simplify the content by the choice of vantage point.

Line

The use of line is a major design tool that the photographer can use to structure the image. Line becomes apparent when the contrast between light and dark, color, texture or shape serves to define an edge. The eye will instinctively follow a line. Line in a photograph can be described by its length and angle in relation to the frame (itself constructed from lines).

Horizontal and vertical lines

Horizontal lines are easily read as we scan images from left to right comfortably. The horizon line is often the most dominant line within the photographic image. Horizontal lines within the image give the viewer a feeling of calm, stability and weight. The photographer must usually be careful to align a strong horizontal line with the edge of the frame. A sloping horizon line is usually immediately detectable by the viewer and the feeling of stability is lost.

Vertical lines can express strength and power. This attribute is again dependent on careful alignment with the edge of the frame. This strength is lost when the camera is tilted to accommodate information above or below eye level. The action of perspective causes parallel vertical lines to lean inwards as they recede into the distance.

Suggested and broken line

Line can be designed to flow through an image. Once the eye is moving it will pick up a direction of travel and move between points of interest. The photograph to the right is a good example of how the eye can move through an image. Viewers of this image will be guided towards the distant hills on the right side of the image. The lines created by the dry stone wall and the converging lines created by the ridges of the hills all serve to guide the viewer in this direction. A photographer can strategically frame an image and position the lines within the frame to aid this process (note the dry stone wall entering the image from the bottom left-hand corner). The use of simple and uncluttered backgrounds (without distracting detail) can also help to isolate focal points that use line as an important part of the design.

Mark Galer

Shane Bell

Diagonal lines

Whether real or suggested, these lines are more dynamic than horizontal or vertical lines. Whereas horizontal and vertical lines are stable, diagonal lines are seen as unstable (as if they are falling over) thus setting up a dynamic tension or sense of movement within the picture.

Curves

Curved line is very useful in drawing the viewer's eye through the image in an orderly way. The viewer often starts viewing the image at the top left-hand corner and many curves exploit this. Curves can be visually dynamic when the arc of the curve comes close to the edge of the frame or directs the eye out of the image.

ACTIVITY 7

1. Collect two examples of photographs where the photographer uses straight lines as an important feature in constructing the pictures' composition.
In addition find one example where the dominant line is either an arc or S-curve.
Comment briefly on the contribution of line to the composition of each example.

2. Create an image where the viewer is encouraged to navigate the image by the use of suggested line and broken line between different points of interest. Discuss the effectiveness of your design.

Depth

When we view a flat two-dimensional print which is a representation of a three-dimensional scene, we can often recreate this sense of depth in our mind's eye. Using any perspective present in the image and the scale of known objects we view the image as if it exists in layers at differing distances. Successful compositions often make use of this sense of depth by strategically placing points of interest in the foreground, the middle distance and the distance. Our eye can be led through such a composition as if we were walking through the photograph observing the points of interest on the way.

Mark Galer

In the image above our eyes are first drawn to the figure occupying the foreground by use of focus. Our attention moves along a sweeping arc through the bench to the people on the far left side of the frame and finally to the distant figures and tower.

A greater sense of depth can be achieved by making optimum use of depth of field, careful framing, use of line, tone and color. In this way the viewer's attention can be guided through an image rather than just being drawn immediately to the middle of the frame, the point of focus and the principal subject matter.

ACTIVITY 8

Create an image by placing subject matter in the foreground, the middle distance and the distance in an attempt either to fill the frame or draw our gaze into the image. Discuss the construction and design of your image.

Summary of basic design techniques

~ Simplify content.

~ Vary the use of horizontal and vertical formats.

~ Limit static compositions by placing the main subject off centre.

~ Create balance or tension by arrangement of tone within the frame.

~ Explore alternative vantage points from which to view the subject.

~ Arrange lines within the frame to reinforce or express feeling and to guide the viewer through the image.

Mark Galer

Orien Harvey

creative controls

Mark Galer

essential skills

~ Increase your knowledge and understanding about aperture, shutter speed and
 focal length and their combined effects on visual communication.
~ Increase your familiarity and fluency with your personal camera equipment.
~ Research professional photographic practice to demonstrate a visual
 understanding of applied camera technique.
~ Create images that demonstrate a working knowledge of depth of field, timed
 exposures and perspective.
~ Control communication and visual effect through considered use of focus, blur
 and perspective.

Introduction

In the chapter 'Framing the Image' we have looked at how the camera is a subjective recording medium that can communicate and express the ideas of individual photographers. We have seen how the choice of subject and the arrangement or design of this subject within the frame has enormous potential to control communication. This communication can be further enhanced by varying the way we use the equipment and its controls in order to create or capture images. The photographer is advised to consider the application of technical effects very carefully so that the resulting images are primarily about the communication of content and not technique. Technique should never be obtrusive. The principal techniques that enable photographers on location to communicate in controlled ways are:

~ Focus
~ Duration of exposure
~ Perspective

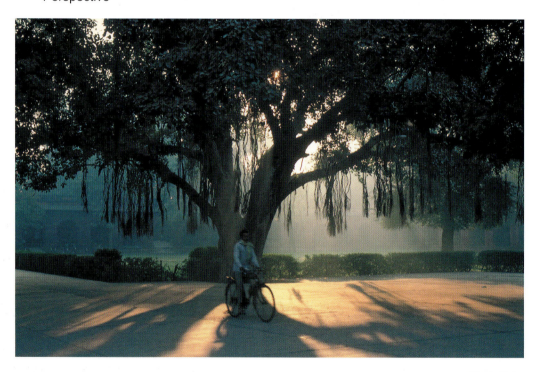

Mark Galer

Familiarity with equipment

Owning a large amount of equipment does not necessarily make us a better photographer. It is essential that you first become familiar with what you own before acquiring additional equipment. The camera must become an extension of the photographer so it can be operated with the minimum of fuss. The equipment must not interfere with the primary function of seeing.

The camera is a tool to communicate the vision of the photographer. Creative photography is essentially about seeing.

Focus

The word '**focus**' refers to either the point or plane at which an image is sharp or the 'centre of interest'. When an image is being framed the lens is focused on the subject which is of primary interest to the photographer. The viewer of an image is instinctively drawn to this point of focus or the area of the image which is the most sharp. This becomes the '**focal point**' of the image. In this way the photographer guides or influences the viewer to not only look at the same point of focus but also share the same point of interest.

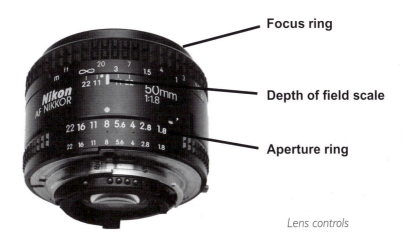

Focus ring

Depth of field scale

Aperture ring

Lens controls

Limitations of focus

When an object is made sharp by focusing the lens all other subjects at the same distance are equally sharp. Subjects nearer or further away are progressively less sharp.

On DSLR cameras the focusing ring on the lens can be rotated between two stops at which point it can no longer be turned to alter focus. As the subject moves closer to the lens a distance is reached where the subject can no longer be focused. The focusing ring will not turn further and reaches its stop (no stops may be present on the focusing ring of a prosumer digicam). This represents the '**closest point of focus**'. As the subject moves further away the focusing ring again reaches a point where it will not turn further. This distance is called '**infinity**' on the lens and is represented by the symbol ∞. At increasing distances from the camera the subject will continue to remain in focus. The closest point of focus and the point of infinity changes between different lenses. Prosumer digicams usually offer manual focusing as an option, but the absence of stops can make the process a little more time consuming.

ACTIVITY 1

Record the closest focusing distance of all your lenses. If you have a zoom lens check the closest focusing distance at the shortest and longest focal length.

Without using the macro mode or option of a prosumer digicam take two creatively designed images using the closest focusing distance of your lens.

Depth of field

In addition to choosing the focal point of the image the photographer can also control how much of the image appears sharp or 'in focus'. As the aperture of the lens is progressively reduced in size, subjects in front and behind the point of focus steadily begin to appear sharper. By choosing the aperture carefully the photographer may be able to single out one person in a crowd or the entire crowd to be in focus. In this way communication can be dramatically altered. The zone of acceptable sharp focus is described as the '**depth of field**'.

> **Depth of field can be described as the nearest to the furthest distances from the lens where the subject appears acceptably sharp.**

Aperture wide open *Aperture stopped down to f22*

Shallow depth of field (above left) is created using the wider aperture settings of the lens. Subject matter behind and in front of the point of focus appears progressivley out of focus. Due to the smaller sensors used in the prosumer digicams it is often difficult to achieve shallow depth of field unless you are working at the closest focusing distance of the lens, i.e. capturing an image using a prosumer camera using a small sensor will lead to greater depth of field than a DSLR using a lens set to the same aperture.

Maximum depth of field (above right) is created using the smaller aperture settings of the lens. Subject matter immediately in front of the lens and subject matter in the distance may appear acceptably sharp in the same image.

> **The widest apertures (f2, f4) give the least depth of field.**
> **The smallest apertures (f16, f22) give the greatest depth of field.**
> **The smaller the sensor the greater the depth of field at the same aperture.**

Depth of field preview

The changes to depth of field affected by aperture are not readily seen in most DSLR cameras. The subject is often viewed through the widest aperture that is held permanently open until the actual exposure is made. This is to give the photographer a bright image in the viewfinder. If the photographer wishes to check the depth of field at any given aperture they must use a '**depth of field preview**' or review the image using the camera's LCD screen. An advantage of using a prosumer digicam is that a live preview of the depth of field is available before the image is captured.

Contributory factors affecting depth of field

Depth of field is also affected by the distance the photographer is positioned from the subject and by the focal length of the lens being used.

Distance - As the photographer moves closer to the subject the depth of field becomes narrower. As the photographer moves further away the depth of field becomes greater.

Focal length - As the focal length of the lens increases (telephoto lenses) the depth of field becomes narrower. As the focal length of the lens decreases (wide angle lenses) the depth of field becomes greater.

> **The narrowest depth of field is achieved with the widest aperture on a telephoto lens whilst working at the lenses minimum focusing distance.**

Point of focus - Unless you are very close to your subject, you'll find that depth of field, your acceptable focus range, extends more behind the subject than in front. About twice the distance behind your point of focus will be in focus than in front of it.

Mark Galer

Practical application

All factors affecting depth of field are working simultaneously. Aperture remains the photographer's main control over depth of field as framing (usually a primary consideration) dictates the lens and working distance. For maximum control over depth of field the photographer is advised to select aperture priority or manual mode and use a DSLR camera. Firstly decide on the subject which is to be the focal point of the image. Second decide whether to draw attention to this subject, isolate the subject entirely or integrate the subject with its surroundings. Precisely focusing the lens is unnecessary when photographing in bright conditions with small apertures (f11, f16 and f22). Depth of field on a wide angle lens stopped down to f16 may extend from less than one metre to infinity.

Selective and overall focus

By selecting the quantity of information within the image to be sharp the photographer is said to be using '**selective focus**'. This is a powerful tool to control communication. The photographer is telling the viewer what is important and what is less important.

When the aperture is reduced ('stopped down') sufficiently, and the other contributory factors to great depth of field are favourable, it is possible to produce an image where the content of the entire frame is sharp. This effect is described as '**overall focus**'. Overall focus is often difficult to achieve. Unless the level of illumination is bright, or a tripod is available, the photographer runs the risk of '**camera shake**'. Small apertures, such as f16 or f22, often require the use of a very slow shutter speed.

Mark Galer

Maximizing depth of field

The photographer can maximize the depth of field and ensure overall focus by focusing approximately one third of the way into the subject. The infinity symbol should be placed on the appropriate mark using the depth of field scale on the lens.

ACTIVITY 2

Create an image using selective focus to control the communication.
Discuss the visual communication of the image.

Duration of exposure

All photographs are time exposures of shorter or longer duration, and each describes an individually distinct parcel of time. The photographer, by choosing the length of exposure, is capable of exploring moving subjects in a variety of ways.

By choosing long exposures moving objects will record as blurs. This effect is used to convey the impression or feeling of motion. Although describing the feeling of the subject in motion much of the information about the subject is sacrificed to effect. By selecting fast shutter speeds photographers can freeze movement. We can see the nature of an object in motion, at a particular moment in time, that the human eye is unable to isolate.

Fast shutter speeds

By freezing thin slices of time, it is possible to explore the beauty of form in motion. A fast shutter speed may freeze a moving subject yet leave others still blurred. This is dependent on the speed of the subject matter and the angle of movement in relation to the camera. For subject matter travelling across the camera's field of view, relatively fast shutter speeds are required, compared to the shutter speeds required to freeze the same subject travelling towards or away from the camera.

Mark Galer

Limitations of equipment

Wide apertures in combination with bright ambient light and/or high ISO allows the use of fast shutter speeds in order to freeze rapidly moving subject matter. Some telephoto and zoom lenses only open up to f4 or f5.6. If used with a low ISO there is usually insufficient light to use the fastest shutter speeds available on the camera.

Panning

Photographers can follow the moving subject with the camera in order to keep the subject within the frame. This technique called 'panning' allows the photographer to use a slower shutter speed than would otherwise have been required if the camera had been static. The ambient light is often insufficient to use the very fast shutter speeds making panning essential in many instances.

For successful panning the photographer must aim to track the subject before the shutter is released and follow through or continue to pan once the exposure has been made. The action should be one fluid movement without pausing to release the shutter. A successful pan may not provide adequate sharpness if the focus is not precise. In order to have precise focusing with a moving subject the photographer may need to use a fast predictive autofocus system or pre-focus on a location which the moving subject will pass through. Locking off a focus point and exposure setting by half pressing the shutter release button is especially important when using a prosumer digicam where the shutter lag may otherwise prevent the photographer from capturing the precise point in the action.

Jana Liebenstein

ACTIVITY 3

1. Create images of a running or jumping figure using fast shutter speeds (faster than 1/250 second). Vary the direction of travel in relation to the camera and attempt to fill the frame with the figure. Examine the image for any movement blur.

2. Take four images of the same moving subject using shutter speeds between 1/15 and 1/125 second. Pan the camera to follow the movement. The primary subject should again fill the frame. Comment on the visual effect of each image.

3. Create an image using the panning technique.

Slow shutter speeds

When the shutter speed is slowed down movement is no longer frozen but records as a streak across the image. This is called '**movement blur**'. Movement blur can be created with relatively slow moving subject matter. Speeds of 1/30, 1/15, 1/8 and 1/4 second can be used to create blur with a standard lens. If the camera is on a tripod the background will be sharp and the moving subject appear blurred. If the camera is panned successfully with the moving subject the background will provide most of the blur in the form of a streaking effect in the direction of the pan.

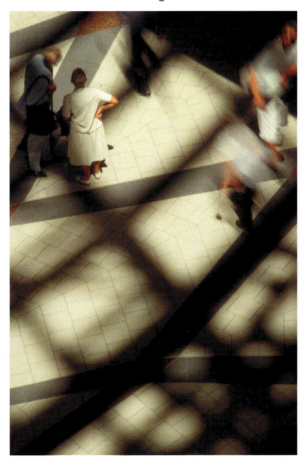

Mark Galer

Camera shake

Movement blur may also be picked up from camera movement as a result of small vibrations transmitted to the camera from the photographer's hands. This is called '**camera shake**'. To avoid camera shake a shutter speed roughly equal to the focal length of the lens is usually recommended, e.g. 1/30 second at 28mm, 1/60 second at 50mm and 1/125 at 135mm. Many cameras give an audible or visible signal when shutter speeds likely to give camera shake are being used. Using a camera with an image stabilizer or by carefully bracing the camera slower speeds than those recommended can be used with great success. When using slow shutter speeds the photographer can rest elbows on a nearby solid surface, breathe gently and release the shutter with a gentle squeeze rather than a stabbing action to ensure a shake-free image.

Extended shutter speeds

If the shutter speeds are further reduced information about the subject is eventually lost and the effect of movement may disappear. The technique of very long exposures is often explored in landscape photography where the photographer wants to record the passage of weather or water. For very long exposures the camera can be mounted on a tripod and the shutter fired using a cable release or via a shutter delay feature. Small apertures in combination with an image sensor set to a low ISO and light reducing filters such as a neutral density filter or polarizing filter will extend the shutter speed to seconds or even minutes.

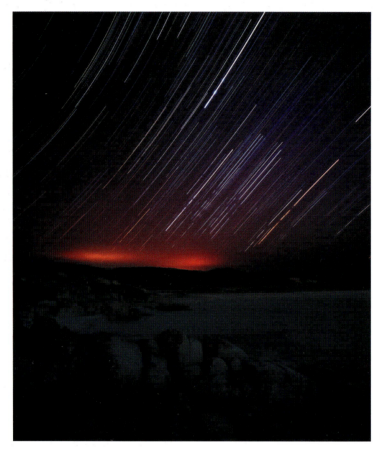

Orien Harvey

Increased noise

When using exposures of longer than one second increased levels of noise may become apparent with many image sensors (especially the smaller sensors fitted to most prosumer digicams). Test the digital camera you intend to use for any long exposures to establish acceptable levels of noise at extended exposures.

ACTIVITY 4

Create an image using shutter speeds longer than 1 second. The camera should be braced or secured on a tripod so that stationary subject matter is sharp.

A creative decision

The choice between depth of field and shutter speed is often a compromise. Choosing one effect impacts upon the other. The need for correct exposure requires the photographer to make one effect a priority over the other. When the photographer requires overall focus, movement blur is likely to occur from the use of a slow shutter speed. When the aperture is opened to achieve shallow depth of field the shutter speed is relatively fast. Movement blur is unlikely unless the photographer is photographing in subdued lighting conditions. Similarly when the photographer requires a reasonably fast shutter speed to avoid camera shake or freeze motion, shallow depth of field is often the result.

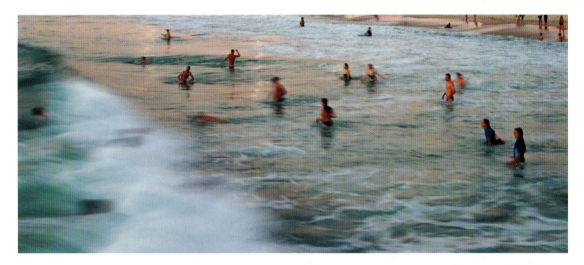

Orien Harvey

Limitations of semi-automatic

When selecting shutter priority mode on a built-in metering system the photographer must take care not to underexpose images. Excessively fast shutter speeds for the available light may require an aperture greater than that available on the lens.

When selecting aperture priority mode on a built-in metering system the photographer must take care not to overexpose images. Excessively wide apertures to create shallow depth of field in bright light may require shutter speeds faster than that available with the camera being used.

ACTIVITY 5

Record the widest aperture available on your lens or lenses when photographing in bright sunlight using an image sensor rated at 100 and 400 ISO that does not lead to overexposure.

Record the fastest shutter speeds available when photographing in a variety of interior locations using the existing light only.

Create an image that contains a mixture of solid (sharp) and fluid (blur) form.

Perspective

Visual '**perspective**' is the way we gain a sense of depth and distance in a two-dimensional print. Objects are seen to diminish in size as they move further away from the viewer. This is called '**diminishing perspective**'. Parallel lines converge as they recede towards the horizon. This is called '**converging perspective**'.

The human eye has a fixed focal length and a fixed field of vision. A photographer using a lens set to 50mm (or equivalent) can emulate the perspective perceived by human vision. Perspective can however be altered by changing the focal length of the lens together with the distance of the camera from the subject.

Steep perspective

Due to a close viewpoint a wide angle lens exaggerates distances and scale, creating 'steep perspective'. Subjects close to the lens look large in proportion to the surroundings. Distant subjects look much further away.

Taken with a wide angle lens, the woman in the foreground looks prominent and the city in the background looks distant. Viewers are drawn into the image via the steep perspective. The use of a wide angle lens in bright sunlight enables great depth of field whilst hand holding a camera.

Perspective compression

Due to a distant viewpoint a telephoto lens compresses, condenses and flattens three-dimensional space. Subject matter appears closer together. The viewer of an image taken with a telephoto lens often feels disconnected with the subject matter.

Taken with a telephoto lens, the perspective compression gives more emphasis to the distant city. It is easy to isolate the subject from the background using wide apertures on telephoto lenses. In overcast conditions or when photographing in the shade slow shutter speeds may cause camera shake.

ACTIVITY 6

Create an image using a non-standard focal length lens and viewpoint to alter the perspective. Comment briefly on the relationship between foreground and background and the perceived sense of depth in the image.

Summary of basic camera techniques

~ Select the focal point of the image and choose selective or overall focus.

~ Select the depth of field required using the aperture control.

~ Consider the combined effects of:
 – aperture
 – focal length
 – distance from the subject

~ To maximize depth of field focus one third of the way into the subject.

~ Use a depth of field preview, a depth of field scale or the camera's LCD display to calculate focus.

~ Consider the most appropriate choice of shutter speed to freeze or blur the subject.

~ Brace the camera when using slower shutter speeds to avoid camera shake.

~ Pan the camera to maximize sharpness of a moving subject.

~ Use predictive focus when panning a moving subject.

~ Allow for increased levels of noise with exposure times longer than one second.

~ Choose the desired perspective by considered use of focal length and viewpoint.

Michael Mullan

light

Mark Galer

essential skills

~ Gain an understanding of how light changes the character and mood of an image.

~ Develop an awareness of subject contrast and the dynamic range of image sensors.

~ Understand the relationship between lighting contrast, lighting ratios, subject contrast and subject brightness range.

~ Learn about exposure compensation and 'appropriate' exposure.

~ Learn how to manage difficult lighting conditions on location.

Introduction

Light is the essence of photography. Without light there is no photography. Light is the photographer's medium. The word photography is derived from the ancient Greek words, 'photos' and 'graph', meaning 'light writing'. To understand light the photographer must be fully conversant with its qualities and behaviour. In mastering the medium the photographer learns to take control over the creation of the final image. This takes knowledge, skill and craftsmanship. It can at first seem complex and sometimes confusing. However, with increased awareness and practical experience light becomes an invaluable tool to communication.

Seeing light

In order to manage a light source, we must first be aware of its presence. Often our preoccupation with content and framing can make us oblivious to the light falling on the subject and background. We naturally take light for granted. This can sometimes cause us to simply forget to 'see' the light. When light falls on a subject it creates a range of tones we can group into three main categories: highlights, midtones and shadows.

Each of these can be described by their level of illumination (how bright, how dark) and their distribution within the frame. These are in turn dictated by the relative position of subject, light source and camera.

Image 1 *Image 2*

ACTIVITY 1

Describe the above images in terms of highlights, midtones and shadows.
Draw diagrams to indicate the relative position of subject, light source and camera.

Light source

Ambient light is the existing available light present in any environment. Ambient light can be subdivided into four major categories:

~ Daylight
~ Tungsten
~ Fluorescent
~ Firelight.

Daylight - A mixture of sunlight and skylight. Sunlight is the dominant or main light. It is warm in color and creates highlights and shadows. Skylight is the secondary light. It is cool in color and fills the entire scene with soft diffused light. Without the action of skylight, shadows would be black and detail would not be visible.

Orien Harvey

Tungsten - A common type of electric light such as household bulbs/globes and photographic lamps. A tungsten element heats up and emits light. Tungsten light produces very warm tones when the white balance is set to daylight. Make sure you adjust the white balance to the dominant light source or capture in the RAW format and set the white balance in post production.

Fluorescent - Fluorescent light produces a strong green cast (not apparent to the human vision) if captured using a daylight white balance. If used as a primary light source the results are often unacceptable due to the broad flat light from above. Underexposure is again experienced when using this light source and the cast can be difficult to correct. Fluorescent light flickers and causes uneven exposure with focal plane shutters. To avoid this shutter speeds slower than 1/30 second should be considered.

Firelight - Light from naked flames can be very low in intensity. With very long exposures it can be used to create atmosphere and mood with its rich red tones.

Intensity

Light intensity is a description of the level of a light's brightness. The intensity of light falling on a subject can be measured using a light meter. This is called an 'incident reading'. A light meter built into a camera does not directly measure the intensity of light falling on the subject but the level of light reflected from it. This is called a 'reflected reading'.

Itti Karuson

Reflectance

Regardless of the intensity of the light falling on the subject, different levels of light will be reflected from the subject. The amount of light reflecting from a surface is called '**subject reflectance**'. The levels of reflectance vary according to the color, texture and angle of the light to the subject. A white shirt will reflect more light than a black dress. A sheet of rusty metal will reflect less light than a mirror. In all cases the level of reflectance is directly proportional to the viewpoint of the camera. If the viewpoint of the camera is equal to the angle of the light to the subject the reflectance level will be greater. The level of reflected light is therefore determined by:

~ Reflectance of the subject.
~ Intensity of the light source.
~ Angle of viewpoint and light to subject.
~ Distance of the light source from the subject.

Although the intensity of the light source may remain constant (such as on a sunny day) the level of reflected light may vary.

'Fall-off' and the Inverse Square Law

The way that light decreases as you move away from the light source is expressed scientifically by the Inverse Square Law, which states:

'When a surface is illuminated by a point source of light, the intensity of the light at the surface is inversely proportional to the square of the distance from the light source'.

Now, just before you panic this is really quite simple. It means that if your subject moves away from your camera's flash, there is a fall-off in the light that they receive. In fact, if they are now twice as far away, they do not receive half as much light but one quarter. Four times the distance, one sixteenth of the light! This does not happen in sunlight because we are all the same distance from that big point source in the sky, the sun. But it is essential that the Inverse Square Law is applied when dealing with flash, other artificial lights, reflected light or window light as the visual effect of subjects at differing distances to the light source is uneven illumination.

Orien Harvey

ACTIVITY 2

Using a floodlight or window light, illuminate two people standing at three feet and six feet from the light source.

Position the people six feet further away from the light source so that the people are now nine and 12 feet from the light source.

Does the difference in brightness between the two people illuminated by the light source increase or diminish as the light source moves further away from the subjects?

Quality

Light from a point light source such as an open flash or the sun is described as having a 'hard quality'. The directional shadows created by this type of light are dark with well-defined edges. The shadows created by the sun are dark but not totally devoid of illumination. This illumination is provided by reflected skylight. The earth's atmosphere scatters some of the shorter blue wavelengths of light and provides an umbrella of low-level light. Artificial point light sources create a much harsher light when used at night or away from the softening effects of skylight. The light from a point light source can also be diffused, spread or reflected off larger surface areas. Directional light maintains its 'hard quality' when reflected off a mirror surface but is scattered in different directions when reflected off a matte surface. This lowers the harshness of the light and the shadows now receive proportionally more light when compared to the highlights. The light is said to have a softer quality. The shadows are less dark (detail can be seen in them) and the edges are no longer clearly defined.

Harsh light

Soft light - Orien Harvey

The smaller the light source, the harder the light appears.
The larger the light source, the softer the light appears.

The control over quality of light is an essential skill when on location. Often the photographer will encounter scenes where the quality of the available light creates enormous difficulties for the latitude of the image sensor. The photographer must learn techniques to alter the quality of light or risk loss of detail and information. The quality of light, whether hard or soft, can be changed by diffusion and reflection.

Color

The visible spectrum of light consists of a range of wavelengths from 400 nanometers (nm) to 700nm. Below 400nm is UV radiation and X-rays and above 700nm is infrared (all capable of being recorded photographically). When the visible spectrum is viewed simultaneously we see 'white light'. This broad spectrum of colors creating white light can be divided into the three primary colors: **red, green and blue.** The precise mixture of primary colors in white light may vary from different sources. The light is described as cool when predominantly blue, and warm when predominantly red. Human vision adapts to different mixes of white light and will not pick up the fact a light source may be cool or warm unless compared directly with another in the same location.

The light from tungsten bulbs and firelight consists predominantly of light towards the red end of the spectrum. The light from tungsten lamps is also predominantly light towards the red end of the spectrum. The light from flash consists predominantly of light towards the blue end of the spectrum. Daylight is a mixture of cool skylight and warm sunlight. Image sensors balanced to 'Daylight' will give fairly neutral tones with noon summer sunlight. When the direct sunlight is obscured or diffused, however, the skylight can dominate and the tones record with a blue cast. As the sun gets lower in the sky the light gets progressively warmer and the tones will record with a yellow or orange cast. The color of light is measured by color temperature, usually described in terms of degrees Kelvin (K). This scale refers to a color's visual appearance (red - warm, blue - cold).

Color correction

When using a digital camera and saving to JPEG or TIFF color correction is achieved by adjusting the white balance to the dominant light source. Alternatively save to the camera RAW format and assign the white balance in post production.

Note > To avoid small inconsistencies of color reproduction it is NOT recommended to use Auto White Balance when using a print service provider to print from a batch of images captured using the same light source. Use a manual white balance setting or a specific white balance setting to create consistency of color temperature and tint.

ACTIVITY 3

Experiment by using a warm colored filter over a flash unit to capture a room lit with tungsten light (be sure to use an exposure that will record the available light present, e.g. a 'slow sync' flash setting). Take a second image without using the filter and compare the results.

Direction

The direction of light determines where shadows fall and their source can be described by their relative position to the subject. Shadows create texture, shape, form and perspective. Without shadows photographs can appear flat and visually dull. A subject lit from one side or behind will not only separate the subject from its background but also give it dimension. A front-lit subject may disappear into the background and lack form or texture. In nature the most interesting and dramatic lighting occurs early and late in the day.

Mark Galer

Early and late light

Many location photographs can look flat and uninteresting. Photographers arriving at a location when the sun is high find a flat, even illumination to the environment. The colors can look washed out and there is little or no light and shade to create modelling and texture. The mood and atmosphere of a location can be greatly enhanced by the realization that most successful location images are taken when the sun is low, dawn or dusk, or as it breaks through cloud cover to give uneven and directional illumination. When the sun is high or diffused by cloud cover the mood and the subject contrast usually remain constant. When the sun is low the photographer can often choose a variety of moods by controlling the quantity, quality and position of shadows within the image. Colors are often rich and intense and morning mists can increase the mood dramatically.

ACTIVITY 4

Visit the same location at dawn, midday and sunset.
Compare the color and quality of lighting effect and comment on the mood communicated.
Create an image that uses long shadows as an essential component of the final composition.

Contrast

The human eye simultaneously registers a wide range of light intensity. Due to their limited latitude image sensors are unable to do this. The difference in the level of light falling on or being reflected by a subject is called contrast. When harsh directional light strikes a subject the overall contrast increases. The highlights continue to reflect high percentages of the increased level of illumination whilst the shadows reflect little extra. Without contrast photographic images can appear dull and flat. It is contrast within the image that gives dimension, shape and form. Awareness and the ability to understand and control contrast is essential to work successfully in the varied and complex situations arising in photography.

Subject contrast

Different surfaces reflect different amounts of light. A white shirt reflects more light than black jeans. The greater the difference in the amount of light reflected the greater the subject contrast or 'reflectance range'. The reflectance range can only be measured when the subject is evenly lit. The difference between the lightest and darkest tones can be measured in stops. If the difference between the white shirt and the black jeans is three stops then eight times more light is being reflected by the shirt than by the jeans (a reflectance range of 8:1).

One stop = 2:1, two stops = 4:1, three stops = 8:1, four stops = 16:1

Paul Allister *Mark Galer*

A 'high-contrast' image is where the ratio between the lightest and darkest elements is 32:1 or greater.

A 'low-contrast' image is where the ratio between the lightest and darkest elements is less than 16:1.

Brightness range

Light is reflected unevenly off surfaces, light tones reflecting more light than dark tones. Each subject framed by the photographer will include a range of tones. The broader the range of tones the greater the contrast.

When harsh directional light such as sunlight strikes a subject the overall contrast of the scene increases. The tones facing the light source continue to reflect high percentages of the increased level of illumination whilst the shadows may reflect little extra. The overall contrast of the framed subject is called the **SBR** or '**subject brightness range**'.

SBR of approximately five stops (32:1) *SBR of approximately three stops (8:1)*

The SBR can be measured by taking a meter reading of the lightest and darkest tones. If the lightest tone reads f16 @ 1/125 second and the darkest tone reads f4 @ 1/125 second the difference is four stops or 16:1.

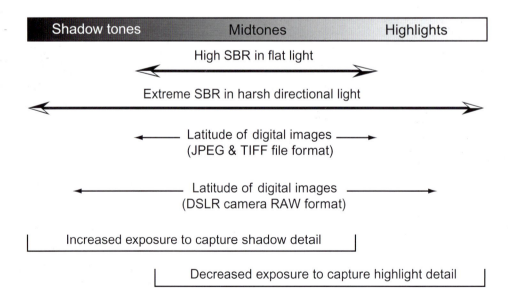

A subject with a high or extreme brightness range can exceed the latitude of the image sensor

Latitude

Image sensors are capable of recording a limited tonal range or brightness range. A subject photographed in high contrast lighting may exceed this recordable or 'dynamic range'. The ability for the image sensor to accommodate a brightness range is referred to as its '**latitude**'.

Digital image sensors capturing JPEG images typically capture a brightness range of only 32:1 or five stops. It is essential for digital photographers to understand that when capturing JPEG images with directional sunlight, shadow and highlight detail may be lost. The photographer capturing RAW files has increased flexibility to capture a broader range of tones and with careful exposure, post-production processing and printing techniques they can extend this range dramatically.

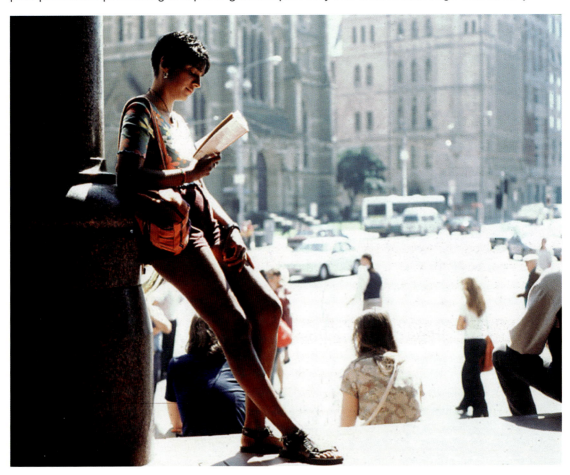

SBR exceeding the latitude of the image sensor

Previsualization

Awareness of the subject brightness range and the capability of the photographic medium to capture this range of tones, allows the photographer to previsualize or predict the outcome of the final image. When the brightness range exceeds the sensor's capabilities the photographer has the option to increase or decrease exposure to protect shadow or highlight detail that would otherwise not record or switch to RAW capture when using a DSLR. These scenes are described as '**extreme contrast**'.

Extreme contrast

In an attempt to previsualize the final outcome of a scene with a high brightness range, many photographers use the technique of squinting or narrowing the eyes to view the scene. This technique removes detail from shadows and makes the highlights stand out from the general scene. In this way the photographer is able to predict the contrast of the resulting image. If the photographer fails to take into account the image sensor's limited capabilities both shadow detail and highlight detail can be lost. It is usual for photographers to protect the highlight detail in the exposure and fill the shadow detail with additional lighting .

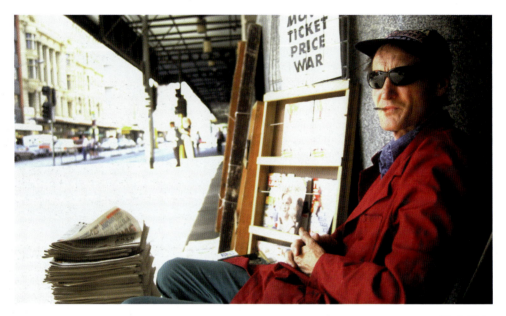

Mark Galer

In many instances when the photographer is expected to work quickly it is all the photographer can do to notice the extreme brightness range and make quick judgements from experience to alter the exposure. The least appropriate exposure in extreme contrast situations is often the exposure indicated by a camera's TTL meter. This average exposure may not be suitable if the subject or detail is located in the deep shadows or bright highlights. In these instances the photographer must override the exposure indicated by the meter and either open up (increase exposure) if shadow detail is required, or stop down (decrease exposure) if highlight detail is required.

In the photograph above the lighting contrast between the noon sun and the shadows was too great to record using the JPEG format. Increased exposure over the indicated meter reading was required to capture the shadow detail.

ACTIVITY 5

Create an image where the tonal range of the subject will exceed the tonal range that can be recorded onto the image sensor. Indicate whether the exposure has been increased or decreased from the TTL meter indicated exposure.

Exposure compensation

When working on location the lighting (sunlight) already exists. There is often little the photographer can do to lower the brightness range. In these instances exposure compensation is often necessary to protect either shadow or highlight detail. The results of exposure compensation are easily assessed via the camera's LCD monitor. The amount of compensation necessary will vary depending on the level of contrast present and what the photographer is trying to achieve. Compensation is usually made in 1/3 or 1/2 stop increments but when a subject is back lit and TTL metering is used the exposure may need increasing by two or more stops depending on the lighting contrast. Remember:

Increasing exposure will reveal more detail in the shadows and dark tones.
Decreasing exposure will reveal more detail in the highlights and bright tones.

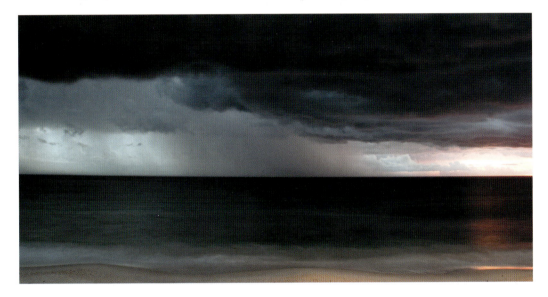

Orien Harvey

Exposure compensation adjustment

A compensation setting is required when the photographer wishes to continue working with an automatic metering system instead of manual controls. Using an automatic metering mode the photographer cannot simply adjust the exposure, from that indicated by the meter, using the aperture or shutter speed. The automatic mode will simply re-compensate for the adjustment in an attempt to record the overall tone of the framed subject matter as a midtone equal to the 18% gray card.

Assessing the degree of compensation

Photographers calculate the degree of compensation from MIE in a variety of different ways. The method chosen is often dictated by whether speed or accuracy is required.

Digital histogram - Most DSLR cameras and high-end prosumer digicams allow the user to view a 'histogram' of the exposure immediately after capture and/or indication of highlight clipping (overexposure). In the case of many of the prosumer cameras the histogram can be viewed live with the preview before capture takes place. This is now the most popular method for assessing whether exposure compensation is required when capturing images with digital cameras. It is worth noting however that DSLR cameras shooting in the RAW format are capable of capturing a broader dynamic range than the histogram may indicate (see the chapters 'Exposure' and 'Camera RAW'). Although this is a reliable method for assessing appropriate exposure compensation it does not replace some of the traditional methods where compensation must be immediate and reasonably accurate.

Bracketing - The photographer can estimate the necessary compensation by bracketing the exposures. To bracket the exposure the photographer must expose several frames, varying the exposure in 1/3 or 2/3 stop increments either side of the MIE.

18% Gray card - Photographers can use a midtone of known value from which to take a reflected light meter reading. A midtone of 18% reflectance is known as a 'gray card'. The gray card must be at the same distance from the light source as the subject. Care must be taken to ensure the shadow of neither the photographer nor the light meter is cast on the gray card when taking the reading. When capturing in JPEG make sure the indicated exposure is suitable for an SBR not exceeding 32:1. If highlight or shadow detail is required the exposure must be adjusted accordingly. When capturing RAW files the indicated exposure is suitable for an SBR of approximately 128:1 or greater.

Caucasian skin - A commonly used midtone is Caucasian skin. A reflected reading of Caucasian skin placed in the main light source (key light) is approximately one stop lighter than a midtone of 18% reflectance. Using this knowledge a photographer can take a reflected reading from their hand and increase the exposure by one stop to give an exposure equivalent to a reflected reading from an 18% gray card. Adjustments would be necessary for an SBR exceeding the latitude of the image sensor.

Re-framing - If the photographer is working quickly to record an unfolding event or activity the photographer may have little or no time to bracket or take an average midtone reading. In these circumstances the photographer may take a reading quickly from a scene of average reflectance close to the intended subject. This technique of re-framing may also include moving closer to the primary subject matter in order to remove the light source and the dominant light or dark tones from the framed area. Many modern cameras feature an exposure lock to enable the photographer to find a suitable exposure from the environment and lock off the metering system from new information as the camera is repositioned.

Judgement - The fastest technique for exposure compensation is that of judgement, gained from experience and knowledge. The photographer must previsualize the final image and estimate the degree of compensation required to produce the desired effect.

Compensation for back lighting

The most common instance requiring exposure compensation is 'back lighting' using a TTL meter. The metering system will be overly influenced by the light source and indicate a reduced exposure. As the light source occupies more and more of the central portion of the viewfinder so the indicated exposure is further reduced. The required exposure for the subject may be many times greater than the indicated exposure.

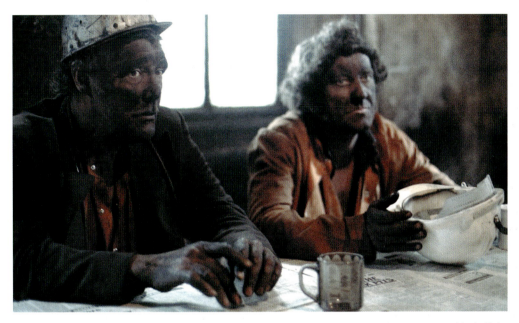

Mark Galer

If the camera is in manual mode or equipped with an exposure lock, the photographer can meter for the specific tonal range required and then re-frame the shot. An alternative used by many professionals is to adjust the exposure using the exposure compensation facility. Using this technique can avoid re-framing after first metering.

ACTIVITY 6

Choose four different lighting situations where the subject is back-lit.

Take a photograph of each subject with the 'meter indicated exposure' or MIE.

Do not reposition the frame. Make a record of the exposures.

Using your own judgement compensate the exposure using either the exposure compensation facility or adjusting ISO. Make a record of the exposures.

Take a meter reading for the shadow area and with the camera set to manual make one exposure at this reading. Make a record of the exposure.

Take a meter reading for the highlight area and with the camera set to manual make one exposure at this reading. Make a record of the exposure.

Review the images and name the image files accordingly.

Assess the results of your images using exposure compensation.

Filtration

The purpose of a filter is to selectively modify the light used for exposure. Filters are regularly used by professional photographers. They are an indispensable means of controlling the variations in light the photographer is likely to encounter. The range of filters used varies according to the range of situations likely to be encountered. However, when capturing RAW file images it is possible to undertake color correction in post production.

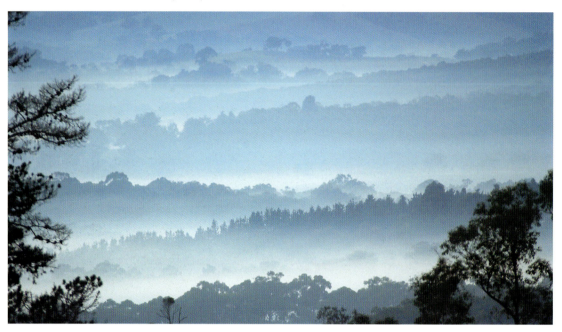

Mark Galer

UV filters

Ultraviolet (UV) radiation present in the spectrum of light is invisible to human vision but adds to the overall exposure of the image. It is most noticeable with landscape images taken at high altitude and seascapes. To ensure the problem is eliminated, UV filters can be attached to all lenses used on location. If the optical quality of the filter is good the filters may be left permanently attached to the lenses. The added benefit of this practice is the front lens element of each lens will be protected from scratching.

Neutral density filters

With manufacturers going to great lengths to create fast lenses with wide maximum apertures it may seem strange to find a range of filters available which reduce the amount of light at any given aperture. These are neutral density filters and are available in a range of densities. If only one is purchased the photographer should consider one that can reduce the light by at least two stops (four times less light). Neutral density filters are used for two reasons:

~ Reducing depth of field
~ Increasing duration of exposure.

Polarizing filters

Polarized light is the light reflected from non-metallic surfaces and parts of the blue sky. A polarizing filter can reduce this polarized light and the effects are visible when viewing the image in the camera.

A polarizing filter is gray in appearance and when sold for camera use consists of the actual filter mounted onto a second ring, thus allowing it to rotate when attached to the lens. The filter is simply turned until the desired effect is achieved.

The polarizing filter is used for the following reasons:

~ Reducing or removing reflections from surfaces
~ Darkening blue skies at a 90 degree angle to the sun
~ Increasing color saturation.

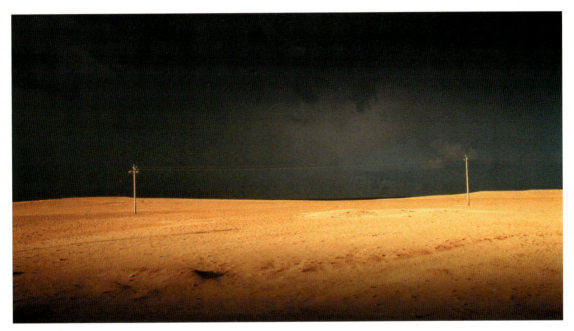

Mark Galer

Possible problems

The filter should be removed when the effect is not required. If not removed the photographer will lose two stops and reduce the ability to achieve overall focus.

When the polarizing filter is used in conjunction with a wide-angle lens, any filter already in place should be removed. This will eliminate the problem of tunnel vision or clipped corners in the final image. Photographing landscapes when the sun is lower in the sky can result in an unnatural gradation, ranging from a deep blue sky on one side of the frame to a lighter blue sky on the other.

ACTIVITY 7

Create an image on a sunny day eliminating polarized light and one without using the filter.

Try to remove reflections from a shop window using a polarizing filter.

How effective is the filter at eliminating these reflections?

Wil Hennesy

digital

lighting on location

Mark Galer

essential skills

~ Change the character and mood of subject matter using lighting.

~ Develop an awareness of overall subject contrast and how this is translated by the capture medium.

~ Develop skills in controlling introduced lighting on location.

~ Research a range of fill and flash lighting techniques.

~ Produce photographic images demonstrating how lighting techniques control communication.

Introduction

The lighting in a particular location at any given time may not be conducive to the effect the photographer wishes to capture and the mood they wish to communicate. In these instances the photographer has to introduce additional lighting to modify or manipulate the ambient light present. In some instances the ambient light becomes secondary to the introduced light, or plays little or no part in the overall illumination of the subject. The following conditions may lead a photographer towards selecting additional lighting:

~ The lighting may be too dull and the resulting slow shutter speeds would cause either camera shake or subject blur.
~ Color temperature of artificial lights causing undesired color casts.
~ The available light is leading to an unsuitable brightness range for the image sensor, e.g. the contrast is too high for the latitude of the capture medium and would lead to either overexposed highlights or underexposed shadows.
~ The direction of the primary light source is giving unsuitable modelling for the subject, e.g. overhead lighting creating unsuitable shadows on a model's face.

James Newman

ACTIVITY 1

Select two images created on location where you feel the photographer has used additional lighting to the ambient light present.
Discuss why you think the lighting has been changed to suit the communication.

Fill

In high and extreme contrast scenes where the subject brightness range exceeds the latitude of the imaging sensor, it is possible for the photographer to lower the overall lighting ratio by supplying additional fill-light. The two most popular techniques include using reflectors to bounce the harsh light source back towards the shadows or by the use of on-camera flash at reduced power output. Before the photographer jumps to the conclusion that all subjects illuminated by direct sunlight require fill, the photographer must first assess each scene for its actual brightness range. There can be no formula for assessing the degree of fill required when the subject is illuminated by direct sunlight. Formulas do not allow for random factors which are present in some situations but not in others. Photographers must, by experience, learn to judge a scene by its true tonal values and lighting intensity.

Mark Galer

The photograph above was taken in Morocco in harsh sunlight. The photographer could be mistaken for presuming this is a typical scene which would require fill-light. If the scene is read carefully however the photographer would realize that the shadows are not as dark as one would presume. Meter readings taken in the shadows and highlights would reveal that the shadows are being filled by reflected light from the brightly painted walls.

Reflectors

Fill-light can occur naturally by light bouncing off reflective surfaces within the scene. It can also be introduced by reflectors strategically placed by the photographer. This technique is often used to soften the harsh shadows cast on models in harsh sunlight.

The primary considerations for selecting a reflector are surface quality and size.

Natural fill - Mark Galer

Surface quality

Reflectors can be matt white, silver or gold depending on the characteristics and color of light required. A matt white surface provides diffused fill-light whilst shiny surfaces, such as silver or gold, provide harsher and brighter fill-light. Choosing a gold reflector will increase the warmth of the fill-light and remove the blue cast present in shadows created by sunlight.

Size

Large areas to be filled require large reflectors. The popular range of reflectors available for photographers are collapsible and can be transported to the location in a carrying bag. A reflector requires a photographer's assistant to position the reflector for maximum effect. Beyond a certain size (the assistant's ability to hold onto the reflector on a windy day) reflectors are often not practical on location.

ACTIVITY 2

1. Select two examples where fill-light has been used to soften the shadows created by a harsh direct light source. Comment on the likely source of the fill-light used in each image.

2. Create an image by experimenting with different reflectors to obtain different qualities of fill-light. Keep a record of the type of reflector used with each image and the distance of the reflector from the subject.

Flash

Flash is the term given for a pulse of very bright light of exceptionally short duration. The light emitted from a photographic flash unit is balanced to daylight and the duration of the flash is usually shorter than 1/500 second.

When the photographer requires additional light to supplement the daylight present flash is the most common source used by professional photographers. Although it can be used to great effect it is often seen as an incredibly difficult skill to master. It is perhaps the most common skill to remain elusive to photographers when working on location. Reviewing the image via the LCD screen will help the photographer master the skills more quickly. The flash is of such short duration that integrating flash with ambient light is a skill of previsualization and applied technique. The photographer is unable to make use of modelling lights that are used on studio flash units (modelling lights that can compete with the sun are not currently available). The skill is therefore mastered by a sound understanding of the characteristics of flashlight and experience through repeated application.

Shane Bell

Characteristics

Flash is a point light source used relatively close to the subject. The resulting light is very harsh and the effects of fall-off are often extreme (see page 97 'Light > Intensity > Fall-off'). One of the skills of mastering flash photography is dealing with and disguising these characteristics that are often seen as professionally unacceptable.

Choice of flash

Choosing a flash unit for use on location may be decided on the basis of degree of sophistication, power, size and cost.

Most commercially available flash units are able to read the reflected light from their own flash during exposure. This feature allows the unit to extinguish or 'quench' the flash by a 'thyristor' switch when the subject has been sufficiently exposed. When using a unit capable of quenching its flash, subject distance does not have to be accurate as the duration of the flash is altered to suit. This allows the subject distance to vary within a given range without the photographer having to change the aperture set on the camera lens or the flash output. These sophisticated units are described as either 'automatic' or 'dedicated'.

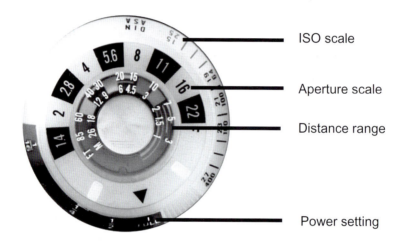

ISO scale

Aperture scale

Distance range

Power setting

Control panel of an older style automatic flash unit

Automatic

An automatic flash unit uses a photocell mounted on the front of the unit to read the reflected light and operate an on-off switch of the fast acting thyristor type. The metering system works independently of the camera's own metering system. If the flash unit is detached from the camera the photocell must remain pointing at the subject if the exposure is to be accurate.

Useful specifications

Perhaps the most important consideration when selecting an automatic flash unit is its ability to make use of a range of f-stops on the camera lens. Cheaper units may only have a choice of two f-stops whereas more sophisticated units will make use of at least four.

Ideally the output of a professional unit will have a high 'guide number' (an indication of the light output). The amount of time the unit takes to recharge is also a consideration. Many flash outfits have the option of being linked to a separate power pack so that the drain on the unit's smaller power supply (usually AA batteries) does not become a problem.

The flash head of a unit will ideally swivel and tilt, allowing the photographer to direct the flash at any white surface whilst still keeping the photocell pointed at the subject.

Dedicated

Dedicated flash units are often designed to work with specific cameras, e.g. Nikon 'speedlights' with Nikon cameras. The camera and flash communicate more information through additional electrical contacts in the mounting bracket of the unit. The TTL metering system of the camera is used to make the exposure reading instead of the photocell. In this way the exposure is more precise and allows the photographer the flexibility of using filters without having to alter the settings of the flash.

In addition to the TTL metering system the camera may communicate information such as the ISO of the capture medium and the focal length of the lens being used. This information may be automatically set, ensuring an accurate exposure and the correct spread of light.

Features such as automatic fill flash, slow sync, rear curtain slow sync, red eye reduction and strobe are common features of some sophisticated units. Often the manuals accompanying these units are as weighty as the manual for the camera which they are designed to work in conjunction with.

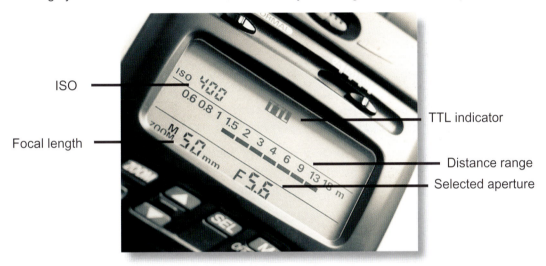

Control panel of a modern dedicated flash unit

Setting up a flash unit

Check that the ISO has been set on either the flash or flash meter and the camera.

Check that the flash is set to the same focal length as the lens. This may involve adjusting the head of the flash to ensure the correct spread of light.

Check that the shutter speed on the camera is set to the correct speed (often slower than 1/250 second on a DSLR camera using a focal plane shutter).

Check that the aperture on the camera lens matches that indicated on the flash unit. On dedicated units you may be required to set the aperture to an automatic position or the smallest aperture.

Check that the subject is within range of the flash. On dedicated and automatic units the flash will only illuminate the subject correctly if the subject is within the two given distances indicated on the flash unit. If the flash is set incorrectly the subject may be overexposed if too close and underexposed if too far away. Check the accuracy of the flash output using a flash meter (see 'Guide numbers' in this chapter).

Guide numbers

Portable flash units designed to be used with professional cameras are allocated a 'guide number' (GN) by the manufacturers and this guide number denotes its approximate power output (guide numbers are often optimistic or overstated). The guide number is an indication of the maximum distance at which the unit can be used from the subject to obtain an appropriate exposure. The guide number is usually rated at ISO 100 in metres/feet (ISO 100, m/ft.) using a designated focal length and an aperture of f1. Because an f1 lens is a collector's item and not a typical aperture available to photographers the actual maximum working distance is usually somewhat lower than the guide number would suggest.

A unit with a guide number of 56/184 (at 105mm) could correctly expose a subject at 46 feet using an aperture of f4 (184 divided by 4 = 46). If the lens was changed to one with a maximum aperture of f5.6, the maximum working distance would be reduced to just under 33 feet.

Gaining a rough idea of the maximum working distance of a flash unit is useful for the photographer who does not wish to get caught in a situation where they do not have enough light to illuminate their subject. Now that the digital photographer has the ability to review images immediately after capture using the camera's LCD screen the worry of underexposing or overexposing their subject whilst using unfamiliar equipment has largely been removed. It is worth mentioning that the amount of light reflected back from the subject matter will greatly influence the final exposure of the flash unit when using automated settings. Exposure compensation may be required when working with a subject with dominant light or dark tones.

Note > Bouncing the light from the flash or diffusing the flash light in an attempt to soften the harsh light from a portable flash unit will further reduce the working distance that the photographer is able to work from their subject matter (see page 120).

ACTIVITY 3

Test the guide number of a flash unit using a flash meter if available.

Turn the flash unit to manual operation and full power.

Stand a measured distance from the flash unit, e.g. 16 feet.

Attach a diffusing dome or 'invercone' to the flash meter's cell and set the ISO to 100.

Aim the flash meter at the unit and take an ambient reading of the flash (use a 'sync lead' or friend to manually trigger the flash using the test button).

Multiply the indicated aperture on the flash meter by the distance, e.g. if the subject stands sixteen feet from the flash and records a meter reading of f11 the guide number of the unit is 176.

Note > If no flash meter is available increase the distance between the flash and the subject at intervals of 3 feet. Choose the best exposure and then multiply the distance by the aperture used to find the guide number of the flash unit.

Flash as the primary light source

The direct use of flash as a professional light source is often seen as unacceptable due to its harsh qualities. The light creates dark shadows that border the subject, hot-spots in the image where the flash is directed back into the lens from reflective surfaces and 'red-eye'.

Red-eye

Red-eye is produced by illuminating the blood-filled retinas at the back of the subject's eyes with direct flash. The effect can be reduced by exposing the subject's eyes to a bright light prior to exposure ('red-eye reduction') or by increasing the angle between the subject, the camera lens and the flash unit. Red-eye is eliminated by moving closer or by increasing the distance of the flash unit from the camera lens. To do this the lens must be removed from the camera's hotshoe. This is called 'off-camera flash'. Red-eye can also be removed in post-production editing software.

Off-camera flash

Raising the flash unit above the camera has two advantages. The problem of red-eye is mostly eliminated. Shadows from the subject are also less noticeable.

When the flash unit is removed from the camera's hot shoe the flash is no longer synchronized with the opening of the shutter. In order for this synchronization to be maintained the camera and the flash need to be connected via a 'sync lead'.

For cameras that do not have a socket that will accept a sync lead a unit can be purchased which converts the hot shoe on the camera to a sync lead socket. If a dedicated flash unit is intended to be used in the dedicated mode a dedicated sync cable is required that communicates all the information between the flash and the camera. If this is unavailable the unit must be switched to either automatic or manual mode.

Keep the photocell of an automatic unit directed towards subject during exposure.

Hot-spots

When working with direct flash the photographer should be aware of highly polished surfaces such as glass, mirrors, polished metal and wood. Standing at right angles to these surfaces will cause the flash to be directed back towards the cameras lens, creating a hot-spot. Whenever such a surface is encountered the photographer should move so that the flash is angled away from the camera. It is a little like playing billiards with light.

ACTIVITY 4

Connect a flash unit to your camera via a sync lead and set the unit to automatic.

Position your subject with their back to a white wall (within half a metre).

Hold the flash above the camera and directed towards the subject.

Make exposures at varying distances from the subject. Keep a record of the position of the flash and distance from the subject.

Repeat the exercise with the unit mounted on-camera.

Discuss the results of the most favourable image, commenting on the light quality, shadows and the presence of red-eye.

Diffusion and bounce

If the subject is close or the output of the flash unit is high, the photographer has the option of diffusing or bouncing the flash. This technique will soften the quality of the light but lower the maximum working distance.

Diffusion

Diffusion is affected by placing tissue, frosted plastic or a handkerchief over the flash head. Intensity of light is lowered but the quality of light is improved.

The flash can be further diffused by directing the flash towards a large, white piece of card attached to the flash head. Purpose-built attachments can be purchased.

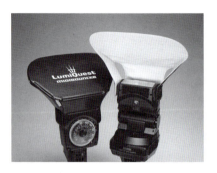

A LumiQuest MidiBouncer

Bounce flash

The most subtle use of flash is achieved by directing the flash to a much larger, white reflective surface such as a ceiling for overhead lighting, or nearby wall for side lighting. This is called bouncing the flash. To obtain this effect the flash unit must have the ability to tilt or swivel its flash head. If this is not possible the flash can be removed from the hot shoe and connected to the camera via a sync lead. If an automatic flash is being used the photographer must ensure that the photocell is facing the subject when the flash is fired.

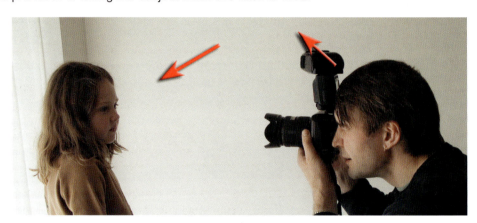

ACTIVITY 5

Create an image of a person using either diffused flash or bounce flash. For the bounce flash technique direct the flash towards a white ceiling or white reflector positioned to one side of the subject. Vary the distances of the reflector to the subject. Discuss and compare the quality of the light in your resulting image or images.

Note > Ensure the thyristor of the flash unit is directed towards your subject.
Alternatively use a flash meter to establish an appropriate exposure.

Fill-flash

Fill-flash can be a very useful way of lowering the brightness range. Often the photographer is unable to reposition the primary subject and the addition of fill-light from the camera's position is essential to the image's success.

The aim of fill-flash is to reveal detail in the dark shadows created by a harsh directional light source. The aim is not to overpower the existing ambient light and remove the shadows completely. If the power of the flash is too high the light will create its own shadows creating an unnatural effect. Because the ambient light is still regarded as the primary light source any exposure dictated by the flash unit must also be suitable for the ambient light.

Mount the flash unit on the camera's hot shoe and direct the flash towards the subject. To retain the effect of the primary (ambient) light source the flash is most commonly fired at half or quarter power. The ratio of ambient to flash light is therefore 2:1 or 4:1.

Manual - Select a smaller aperture on the camera from that indicated by the flash unit or flash meter, e.g. if the meter or unit indicates f5.6 select f8 or f11 on the camera.

Automatic - Many automatic flash units have the facility to fire at 1/2 or 1/4 power, making fill-flash a relatively simple procedure. If this facility is unavailable set the ISO on the flash unit to double or quadruple the actual speed of the ISO set in the camera to lower the output.

Dedicated - Many sophisticated cameras and dedicated flash units have a fill-flash option. This should be regarded as a starting point only and further adjustments are usually required to perfect the technique. Power often needs to be further lowered for a more subtle fill-in technique. The photographer may also wish to select a 'slow-sync' option on the camera, if available, to avoid underexposing the ambient light in some situations.

ACTIVITY 6

Create an image using the fill-flash technique.

Lower the lighting contrast of a portrait lit with harsh sunlight.

Experiment to see if you can lower the flash output on your unit to half or quarter power.

Discuss the light quality of the resulting image and the fill/ambient lighting ratio.

Flash as a key light

The main light in studio photography is often referred to as the '**key light**'. Using studio techniques on location is popular in advertising and corporate photography where mood is created rather than accepted. In this instance flash becomes the dominant light source and the ambient light serves only as the fill-light.

When the ambient light is flat, directional light can be provided by off-camera flash. This enables the photographer to create alternative moods. The use of off-camera flash requires either the use of a 'sync lead' or an infrared transmitting device on the camera.

Slave units

Some professional flash units come equipped with a light-sensitive trigger so that as soon as a flash connected to the camera is fired the unconnected flash or 'slave' unit responds. On location the slave unit can be fired by the use of a low powered on-camera flash.

Accessories

A tripod or assistant is required to either secure or direct the flash.

An umbrella or alternative means of diffusion for the flash may be considered.

Color compensating filters may also be considered for using over the flash head. A warming filter from the 81 series may be useful to create the warming effect of low sunlight.

Technique

- ~ Check the maximum working distance of the flash.
- ~ Ensure the key light is concealed within the image or out of frame.
- ~ Diffuse or bounce the key light where possible.
- ~ Consider the effects of fall-off.
- ~ Avoid positioning the key light too close.
- ~ Establish a lighting ratio between the key light and ambient light.
- ~ Consider the direction of shadows being cast from the key light.

When working at night the photographer may have the option of approaching the subject and firing a number of flashes manually during an extended exposure (recharging the unit each time). The photographer or assistant must take care not to illuminate themselves during this process.

ACTIVITY 7

Create an image using introduced light as a directional key light.

Record the lighting ratios between the key light and the ambient light present.

Discuss the effects of both the key and ambient light on your subject.

Slow-sync flash

Slow-sync flash is a technique where the freezing effect of the flash is mixed with a long ambient light exposure to create an image which is both sharp and blurred at the same time. Many modern cameras offer slow-sync flash as an option within the flash program but the effect can be achieved on any camera. The camera can be in semi-automatic or manual exposure mode. A shutter and aperture combination is needed that will result in subject blur and correct exposure of the ambient light and flash. To darken the background so that the frozen subject stands out more, the shutter speed can be increased over that recommended by the camera's light meter.

~ Set the camera to a low ISO setting.
~ Select a slow shutter speed to allow movement blur, e.g. 1/8 second.
~ Take an ambient light meter reading and select the correct aperture.
~ Set the flash unit to give a full exposure at the selected aperture.
~ Pan or jiggle the camera during the long exposure.

Mark Galer

Possible difficulties

Limited choice of apertures - less expensive automatic flash units have a limited choice of apertures leading to a difficulty in obtaining a suitable exposure. More sophisticated units allow a broader choice, making the task of matching both exposures much simpler.

Ambient light too bright - if the photographer is unable to slow the shutter speed down sufficiently to create blur, a slower ISO should be used or the image created when the level of light is lower.

ACTIVITY 8

Create an image using the technique slow-sync or flash-blur.

Choose a subject and background with good color or tonal contrast.

Pan the camera during the exposure.

Discuss the results.

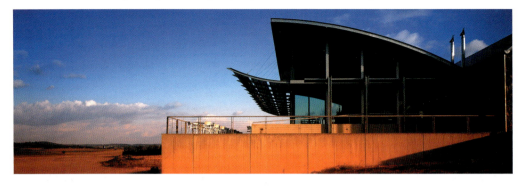

First exposure - exterior ambient light - exposure: MIE less 1/2 stop

Second exposure - total darkness - interior lights on - exposure: average highlights and shadows

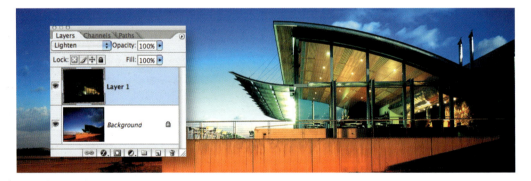

Combined exposure

Double exposures

A double exposure can be used to balance the bright ambient light and the comparatively dim interior lighting of a building. Some digital cameras allow for the multiple exposures, that are required to achieve this outcome, to be recorded in-camera. If the camera does not allow for multiple exposures to be made using a single image file, two separate exposures can be combined in post-production. To achieve this result the photographer must use a tripod and take care not to disturb the alignment whilst adjusting the camera to make the second exposure. If the camera's white balance is set to daylight the interior lighting will record as a different color temperature to the exterior daylight. If the images are combined in post-production the interior lighting is placed on a layer above the exterior lighting layer. Set the interior lighting layer to the Lighten blend mode.

John Hay

Orien Harvey

Orien Harvey

post-production editing

Mark Galer

essential skills

~ Enhance and optimize digital files for maximum impact.

~ Optimize the dynamic range of digital images.

~ Optimize image contrast and saturation.

~ Create localized adjustments to control communication and enhance design.

~ Target shadow and highlight tones for a specific output device.

~ Sharpen images using an adjustable Unsharp Mask layer.

~ Control the resulting tonal range of an image converted from RGB to black and white.

Overview

Every well-planned process has a beginning and an end. The post-production editing workflow is an involved process that needs to incorporate numerous procedures in a carefully considered, logical and progressive sequence. Only by following a logical sequence are we able to create highest quality images with the minimum of fuss. Each step in the sequence serves a purpose, but also has inherent pitfalls if performed badly or out of sequence. These three stages of image editing provide the photographer with an overview of a professional typical image-editing workflow. Although some of the steps could feasibly be repositioned in the workflow sequence it is recommended that you follow the steps in the pages that follow until you are comfortable with the process.

GLOBAL ADJUSTMENTS - STAGE 1

1. Optimize histogram, reduce noise, straighten and clean image
2. Global contrast
3. Global saturation

Global Adjustments 1 - 3

LOCAL ADJUSTMENTS - STAGE 2

4. Local adjustments
5. Gradients
6. Dodge and Burn

FINAL ADJUSTMENTS - STAGE 3

7. Target levels
8. Unsharp Mask
9. Stroke

Local

4

Local Adjustments 4 - 6

Gradients

5

Dodge & Burn

6

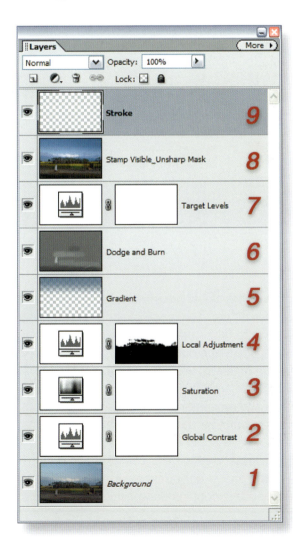

Layers

Normal | Opacity: 100%

Lock:

9 Stroke

8 Stamp Visible_Unsharp Mask

7 Target Levels

6 Dodge and Burn

5 Gradient

4 Local Adjustment

3 Saturation

2 Global Contrast

1 *Background*

Target

7

UNSHARP MASK

8

Stroke (if required)

9

Final Adjustments 7 - 9

Sequential editing

This example of a typical editing task, designed to enhance and optimize the image, aims to present a user-friendly guide to the editing process and present a brief overview of each step in the sequence. If you have been wondering where sharpening, or perhaps noise reduction, fits into the sequence of post-production editing then this guide should offer a little clarity.

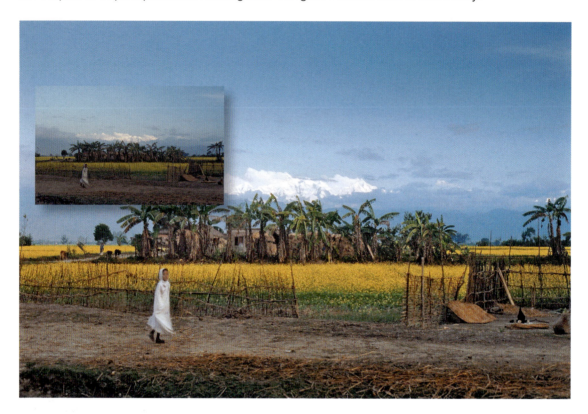

Stage 1 - Global adjustments

In the first stage of the editing process we need to make the global adjustments - those that are made to the entire image and are essentially objective in nature. These adjustments are required to correct minor errors and optimize the image file prior to future editing work, e.g. straighten a crooked image, remove any dust marks, suppress any noise and optimize the dynamic range of the image. They are adjustments that do not require a great deal of aesthetic judgement and serve to present the image in its optimum state prior to further editing. Viewing the image in its optimum state allows us to make decisions about whether the image requires any further editing in order to extract a particular mood or feeling that we may wish to communicate. These global adjustments can be carried out in Photoshop's main editing space, or to some extent in the Camera RAW space, where the objective is to optimize the image preview and set a base level of image settings prior to any localized editing in the second stage of the image editing process. The first stage of image editing is about as interesting as doing the housework but is essential in preparing the image files for the creative second stage of editing.

Step 1a - Levels and white point

The first step is a critical step and needs to be performed with due care and attention before rushing on to the creative enhancements. It's classified as a single step as the changes are all being made to either the Background layer in the main editing space or the sliders found in the camera RAW dialog box (see chapter 'Camera RAW').

The process begins with optimization of the histogram. In the Levels dialog box the black and white sliders (directly beneath the histogram) are moved in to touch the information recorded by the image sensor. This procedure sets the black and white points within the image. Holding down the Alt or Option key as you drag these sliders will help you locate the darkest and brightest pixels within the image. The overall brightness of the image can be adjusted by moving the central gamma slider to the left or right without upsetting either the black or white point in the image (see chapter 'Exposure' page 37).

Note > The Brightness/Contrast feature in the main editing space does not respect the black and white points when making its adjustment and will more than likely lead to clipping if used. The Brightness and Contrast sliders in the camera RAW dialog box do not share the same destructive nature as their namesakes in the main editing space.

Correct the color or white balance of the image if required by moving the gamma slider in either the Red, Green or Blue channels or by simply clicking the Set Gray Point eyedropper and then clicking on a tone in the image that should not have any color, e.g. a black jacket, gray hair or white shirt. This is usually quick and easy but can prove problematic if the tone you are clicking on has a reflective surface or is being illuminated with very cool or warm lighting, e.g. late afternoon sun. When the dynamic range, brightness and white balance has been adjusted click OK to apply the changes. You can apply these changes directly to the background layer if you are working in 16 Bits/Channel or by using an adjustment layer if working on an 8 Bits/Channel image.

Step 1b - Reduce noise and sharpen

There should be no need to use the Reduce Noise filter or noise sliders in the camera RAW dialog box if you have been using a DSLR, a low ISO setting and bright ambient light. The Reduce Noise filter suddenly becomes an essential filter in the photographer's post-production arsenal however when the ISO is raised (especially when using a prosumer digicam). Color noise and luminance noise can be reduced independently (see chapter 'Camera RAW' page 53).

It is important to zoom in to 100% (Actual Pixels) on screen to check if there is any excessive noise that may be due to working with a higher ISO setting or long exposures in low light. Use the minimum strength setting required to produce the smoother tones that you would like to work with. Be aware that excessive noise reduction will also lead to a loss of fine detail. Noise should be removed before any sharpening takes place. Photographers find advice on 'when' and 'how much' to sharpen digital images is often conflicting or confusing. My own advice would be a little or none at the start and the rest at the end. Sharpening too early in the post-production workflow can create image artifacts which can then be exaggerated by subsequent editing processes.

Note > In the default settings of Photoshop CS2 sharpening in camera RAW affects the preview image only and not the actual image when it is opened in the editing space.

Step 1c - Straighten and remove dust if present

Before moving on with the more subjective side of image enhancement it is important to straighten the image and check for any dust if using image files from a DSLR (Olympus DSLR owners are somewhat immune from the dust issue as Olympus' 'Sonic Wave Filter' takes care of this pesky problem). Strong diagonal lines in an image can look very dramatic. A 1 or 2 degree slope on a horizon line does not fit into this category. Although not disturbing for everyone a horizon line that looks like a ski slope is best straightened. If in doubt check that it is running parallel to the image frame.

Use the new Straighten tool if using Elements 4.0 for a super-speedy solution to the straightening issue or rotate the crop marquee if using Elements 3.0. If using Photoshop CS or CS2 use the Measure Tool to draw a line along the horizon and then proceed to Image > Rotate Canvas > Arbitrary. The precise number of degrees required to straighten the image is entered into the rotate field automatically.

For dust removal zoom in to 100% (Actual Pixels) and use the Healing Brush Tool or Spot Healing Brush Tool for a quick and effective clean-up job.

Note > Zooming in to anything less than 100% is not effective for spotting the dust that may, or may not, be lurking in your file.

Step 2 - Contrast

An 'S' curve in the Curves dialog box raises the contrast when using the full version of Photoshop. The fastest and least destructive way to increase contrast globally when using Elements is to create an adjustment layer and set the blending mode of this adjustment layer to Soft Light (if you are editing in 16 Bits/Channel in Elements you will need to drop the Bit Depth to 8 Bits/Channel - Image > Mode > 8 Bits/Channel). There is no requirement to make any adjustment in the adjustment layer dialog box, as the blend mode of the layer is all that is needed to increase the contrast. Lower the opacity of the adjustment layer to lower the contrast until you strike the correct visual effect you are looking for.

Step 3 - Saturation

Raising the level of contrast globally via a Curves layer or Soft Light layer will also increase the overall level of color saturation. A second Hue/Saturation adjustment layer can fine-tune the precise level of saturation you are looking for. If you are working in camera RAW the saturation can be adjusted in this interface but not to the degree of control that can be achieved in the main editing space. If you are looking to modify just a single color in the main editing space then this can be selected via the edit menu and the saturation of a limited range of colors can be adjusted to your liking. In the example above the intensity of the yellow flowers in the field is raised independently of the blues and reds.

Note > The range of colors adjusted can be further modified by dragging the sliders between the two color ramps, e.g. dragging the right two sliders to the left when editing the Yellows will further limit the effect of the increased saturation to prevent the greens from being adjusted.

Stage 2 - Local adjustments

There is a limit to how far you can edit a file without making adjustments to localized areas of the image file. These localized adjustments are relatively subjective in nature (no two photographers would necessarily make the same adjustments) and can control what, and how, the image communicates with the viewer. Many of these changes could be used to restore the image to how the photographer remembered the scene rather than how the camera and image sensor interpreted the scene. These changes or modifications could also be used to change the mood of the subject matter into something new or altogether different. As these changes are subjective these adjustments should be non-destructive in nature. Each adjustment should be placed on its own layer to enable the photographer to reinterpret or change the nature of this stage of the editing process at a later date.

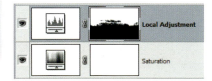

Step 4 - Local adjustment layers

Each adjustment layer is supported with a layer mask. Painting or dragging gradients into these layer masks will restrict any adjustment to a localized area of the image. For those with a little more time on their hands you may want to make a selection prior to creating an adjustment layer. In this tutorial image deselecting the Contiguous box in the options bar enabled the Magic Wand to select the sky between the branches of the trees. If you are using the Magic Wand Tool to create a selection you will then need to feather this selection (soften the edge) by going to the Select menu and choosing the 'Feather' command. A 1 or 2 pixel feather is usually enough to hide the saw-toothed edge that could result from an unfeathered selection. An active selection present when an adjustment layer is created will lead to the creation of a layer mask. The gamma slider can then be moved to the right to darken the sky significantly. The masked pixels remain unaffected by the adjustment.

Note > For those with less time on their hands choose the 'Gradient Tool' and select the Black, White gradient and the Linear option in the Options bar. Dragging a gradient from a short distance below the horizon to a short distance above the horizon line will also restrict the adjustment to the sky in a slightly less precise way (the tips of the trees and the distant snow-capped mountains may be darkened also).

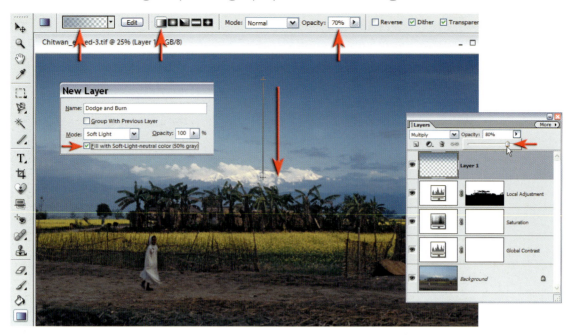

Step 5 - Gradients

The use of Gradients to control tonality and color is another helpful technique in post-production image editing. Darkening the sky or the corners of the image will help draw the viewer's attention to the main focal point within the image. Hold down the Alt key and click on the Create New Layer icon in the Layers palette. In the New Layer dialog box set the mode to Multiply and then select OK. Use the Eyedropper tool to click on a deep blue color in the distant hills. This sampled color will appear in the Foreground color swatch in the Tools palette. Select the Gradient Tool in the Tools palette and choose the Foreground to Transparent gradient from the Options bar. Check that you have the Linear and Transparency options selected and then lower the opacity to approximately 70%. Drag a gradient from the top of the image window to the distant snow capped mountains to create the effect of a more dramatic polarized sky. Fine-tune the darkened sky by lowering the opacity of this Gradient layer.

Note > It is common practice for many photographers to add a second gradient from the base of the image towards the middle of the image to darken the immediate foreground. Alternatively a subtle vignette can lower the luminance values towards the corners of the image that many find useful for restoring or creating depth to the image.

To prevent the gradient from causing a posterized effect (when bands of tone rather than a continuous tone is evident) it is important to add a small amount of noise to the gradient layer (Filter > Noise > Add Noise). Selecting the Monochromatic option with the amount set to 1 or 2% is usually sufficient to reduce or eliminate any banding that may otherwise occur.

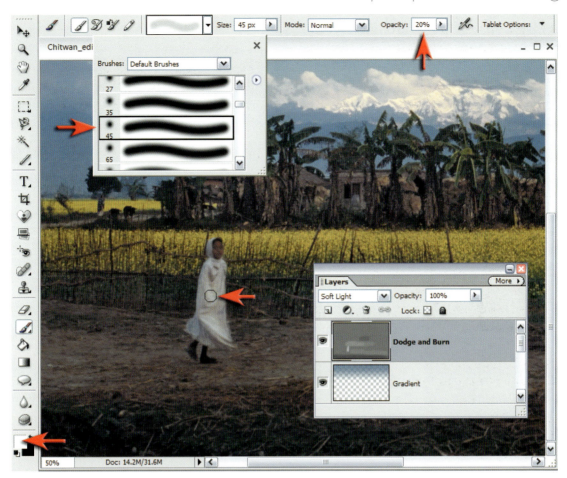

Step 6 - Dodge and Burn

Although there are the 'Dodge' and 'Burn' tools in the Tools palette (traditional darkroom terms for lightening and darkening localized areas of an image) it would be a destructive approach to start working directly on the background layer of the image. The same effects can be achieved in a non-destructive way by working on a Dodge and Burn layer and using the Paintbrush Tool instead. To create a Dodge and Burn layer hold down the Alt key and click on the Create a New Layer icon in the Layers palette. Set the mode to Overlay or Soft Light and check the Fill with neutral color (50% Gray) box. 50% Gray is invisible when the layer mode is in Overlay of Soft Light but when the pixels on this layer are made darker or lighter the underlying pixels are in turn made darker or lighter. In the tutorial image the little girl is made lighter by choosing white as the foreground color and painting into this layer using a soft-edged paintbrush set to 20% opacity. The road she is running along is also lightened to further separate it from the immediate foreground. Switching to Black as the foreground color will allow you to darken various parts of the image. With the local adjustments complete all that remains is to optimize the image for the intended output device.

Note > It is worth working with the Information palette open to help guide you as to how much lightening or darkening is appropriate.

Stage 3 - Final adjustments

The final stage in the image editing process is objective rather than subjective. The aim in making these final adjustments is to optimize the image for the intended output device. If the image is to be displayed on screen it is very much a case of 'what-you-see-is-what-you-get' and the uniformity of the image's appearance is handled by the profile embedded in the image file. Problems arise if the work is displayed on monitors that have not been correctly calibrated and profiled or in web browsers that are not designed to read profiles embedded in image files. All the photographer can reasonably be expected to do is to ensure their own monitor has been correctly calibrated and profiled before undertaking any image editing work. When images are destined to be printed an additional step needs to be taken to optimize the image for a specific output device.

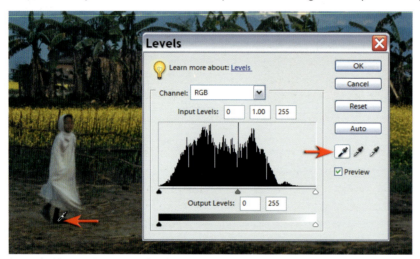

Step 7 - Target levels

If the image is to be printed we need to ascertain the range of tones that can be accommodated by the specific output device when using a specific type of paper. Commercial printing presses can typically print a range of tones between level 20 and level 245 when printing on coated paper. Shadow detail that is visible between 10 and 20 on your computer's monitor may not print with detail when reproduced in a magazine, so it is important to target the brightest highlights and deepest shadows with detail in your image so this detail is not lost when your image is reproduced (inkjet printers can easily exceed this range when printing on high quality photo papers). Targeting your darkest shadow detail and brightest highlight detail can be achieved using the Eyedropper tools in the Levels dialog box. The default values of the Set Black Point and Set White Point eyedroppers can be reassigned values that will effectively target your shadows and highlights instead of assigning black and white points. Double click on each eyedropper in turn and type in a new brightness value. Note the corresponding levels in the RGB fields. Then click on the darkest and brightest areas of your image to assign these as your new output values.

Note > The color balance of your image may be upset by this process if your shadow tones and highlight tones are not neutral or desaturated. You can either use the Set Gray Point eyedropper to re-establish the correct color balance or set the Levels adjustment layer to Luminosity mode.

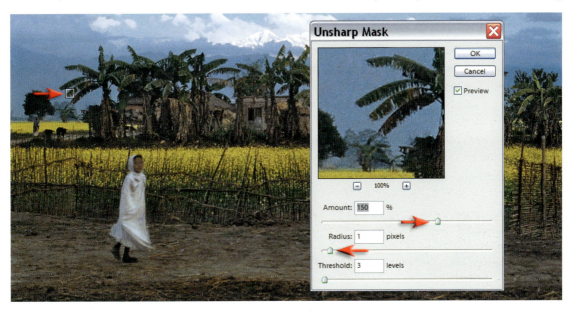

Step 8 - Unsharp Mask

Sharpening is the last step in the image-editing process (unless you intend to create a stroke or border around the edge of the image). If the image is sharpened after a stroke has been added a secondary halo will be created alongside the stroke line. Sharpening amounts often have to be higher on screen so that they look correct in print. It is useful therefore to apply the sharpening to a separate layer so that the final amount of sharpening can be adjusted if required. To create a sharpening layer it is important to merge all of the layers without flattening the file. The keyboard shortcut for this technique is to hold down Ctrl+Alt+Shift modifier keys (Command+Opt+Shift keys on a Mac) and then type the letters N and then E (if using Elements 4 or CS2 you no longer have to type the letter N). The resulting layer should be on top of the layer stack in the layers palette. Switch the blend mode of this layer to Luminosity (this will prevent increased saturation at the sharpened edges) and then select the Unsharp Mask filter from the Filter > Sharpen submenu. It is OK to use a generous Amount of sharpening (100 to 200) but keep the Radius low (typically no higher than 1.5 for print resolution images). Raise the Threshold if the sharpening is having a detrimental effect on noise or subtle detail (3 to 5 will usually suffice for images with a small amount of noise). Lower the layer opacity to reduce the amount of sharpening. You now have a sharpening layer that can be modified to meet the needs of the output device.

Step 9 - Stroke

Adding a stoke line around your image can be a useful technique when creating folio images. The stroke can be added to its own layer above the Unsharp Mask layer. Click on the Create a new layer icon in the Layers palette and then choose Select All from the Select menu. From the Edit menu choose Stroke Selection. In the Stroke dialog box choose the pixel width and the color by clicking on the color swatch and then select the Inside radio button in the Location section. Select OK to complete the image editing process.

Converting images to black and white

When color film arrived over half a century ago the pundits who presumed that black and white film would die a quick death were surprisingly mistaken. Color is all very nice but sometimes the rich tonal qualities that we can see in the black and white work of the photographic artists are something certainly to be savored. Can you imagine an Ansel Adams masterpiece in color? If you can - read no further!

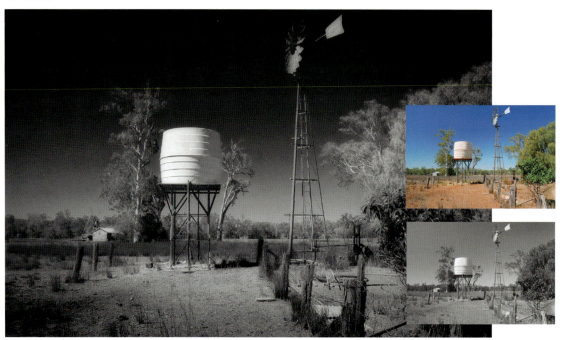

Creating fabulous black and white photographs from your color images is a little more complicated than hitting the 'Convert to Grayscale mode' or 'Desaturate' buttons in your image editing software (or worse still, your camera). Ask any professional photographer who has been raised on the medium and you will discover that crafting tonally rich images requires both a carefully chosen color filter during the capture stage and some dodging and burning in the darkroom.

Color filters for black and white? Now there is an interesting concept! Well as strange as it may seem screwing on a color filter for capturing images on black and white film has traditionally been an essential ingredient to the recipe for success. The most popular color filter in the black and white photographer's kit bag, that is used for the most dramatic effect, is the 'red filter'. The effect of the red filter is to lighten all things that are red and darken all things that are not red in the original scene. The result is a print with considerable tonal differences compared to an image shot without a filter. Is this a big deal? Well yes it is - blue skies are darkened and skin blemishes are lightened. That's a winning combination for most landscape and portrait photographers wanting to create black and white masterpieces.

Note > The more conservative photographers of old (those not big on drama) would typically invest in a yellow or orange filter rather than the 'full-on' effects that the red filter offers.

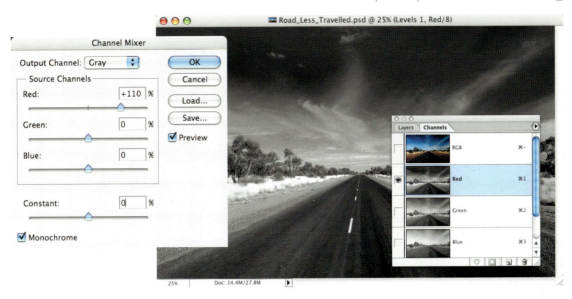

Now just before you run out to purchase your red filter and 'Grayscale image sensor' you should be reminded that neither is required by the digital shooter with access to image editing software. Shooting digitally in RGB (red, green, blue) means that you have already shot the same image using the three different filters. If you were to selectively favour the goodies in the red channel, above those to be found in the mundane green and the notoriously noisy blue channels, when you convert your RGB image to Grayscale, you would, in effect, be creating a Grayscale image that would appear as if it had been shot using the red filter from the 'good old days'. Owners of Photoshop CS/CS2 can see the different information in the individual channels by using the 'Channels Palette', and can then selectively combine the information using the 'Channel Mixer'. For owners of Adobe Elements you are two cans short of a six-pack for this procedure - but take heart. Yes there is no Channels Palette, and no, you don't have a Channel Mixer (but then your bank account probably looks healthier for it). As luck would have it the famous digital Guru 'Russel Preston Brown' has come up with a work-around that is both easier to use than the Channel Mixer and is also available to the software impoverished.

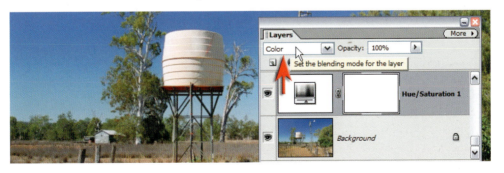

1. Drag the Layers palette from the palette bin (this will be your command centre for this technique). Click on the Adjustment Layer icon in the Layers palette and scroll down the list to select and create a 'Hue/Saturation' adjustment layer. You will make no adjustments for the time being but simply select OK to close the dialog box. Set the blend mode of this adjustment layer to 'Color'.

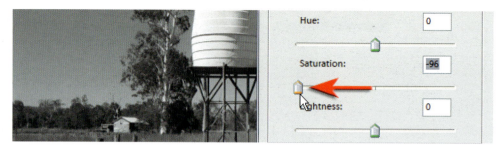

2. Create a second Hue/Saturation adjustment layer. Slide the Saturation slider all the way to the left (-100) to desaturate the image. Select OK. The image will now appear as if you had performed a simple Convert to Grayscale or desaturate (remove color) command.

Note > This second adjustment layer should be sitting on top of the layers stack.

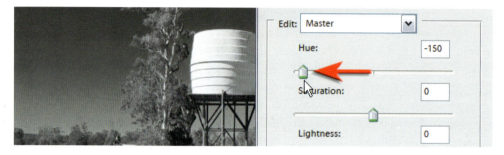

3. Select the first Hue Saturation layer that you created and double-click the layer thumbnail to reopen the Hue/Saturation dialog box. Move the 'Hue' slider in this dialog box to the left. Observe the changes to the tonality of the image as you move the slider. Blues will be darkest when the slider is moved to a position around -150. Select OK. The drama of the image will probably have been improved quite dramatically already but we can take this further with some dodging and burning.

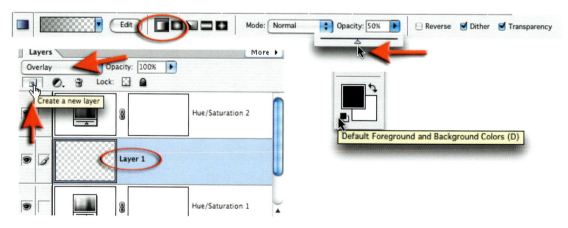

4. Click on the 'New Layer' icon in the Layers palette. Set the blend mode of the layer to 'Overlay'. Set the default 'Foreground and Background Colors' in the Tools palette and then select the 'Gradient' tool. In the options bar select the 'Foreground (black) to Transparent' and 'Linear' gradient options and then lower the Opacity to 50%.

5. Drag one gradient from the base of the image to the horizon line, and a second from the top of the image window to the horizon line. This will have the effect of drawing the viewer into the image and create an increased sense of drama. Lowering the opacity of the layer if the effect is too strong.

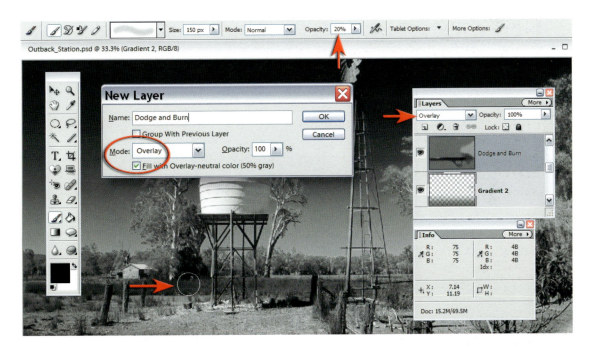

6. Press the 'Alt/Option' key and click on the 'New Layer' icon. In the New Layer dialog box set the blend mode to 'Overlay' and select the 'Fill with Overlay-neutral color' option. Select the Paintbrush Tool and select a soft edged brush from the options bar and lower the Opacity to 10%. A layer that is 50% Gray in Overlay mode is invisible. This gray layer will be used to dodge and burn your image non-destructively, i.e. you are not working on the actual pixels of your image. If any mistakes are made they can either be corrected or the layer can be discarded. Paint onto the gray layer with black selected as the foreground color to burn (darken) the image in localized areas or switch to white to dodge (lighten) localized areas. In the project image the cliffs and the surf were dodged to highlight them.

7. Select the top layer and then create a 'Levels' adjustment layer (one adjustment layer to rule them all) to sit above all of the other layers. Make sure the histogram extends all the way between the black and white sliders. Move the sliders in to meet the histogram if this is not the case.

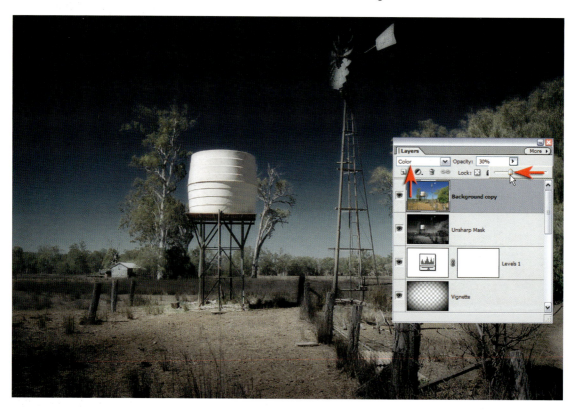

8. Try experimenting with the introduction of some of the original color. Duplicate the background layer by dragging it to the new layer icon. Then drag the background copy further up the layers stack to a position just below the Levels adjustment layer. Reduce the opacity of this layer to let the black and white version introduce the drama once more.

Advanced tone control - part a

A lack of contrast is often just as much of a problem as too much. I remember when Kodak used to place folded pieces of paper in my film boxes as a boy, advising me to photograph with the sun over my shoulder. Being a very good little boy I was then perplexed to discover my family were always squinting in my family snaps and my landscapes looked about as flat and uninteresting as soggy pizzas. Deciding to throw caution, and Kodak's advice, to the wind I then discovered that shooting into the sun created either lens flare or excessive contrast and drama (one out of two isn't bad). In later life I found that judicious use of a good lens hood, a carefully positioned sun (hidden behind someone's head or the branch of conveniently placed tree), the occasional use of a reflector or fill-flash turned my risk-taking habits into something altogether more reliable. I had learnt to see the world in a new light (my own and not Kodak's). Even when you are doing everything right some of our images still fail to live up to our memory of the real thing or our expectations.

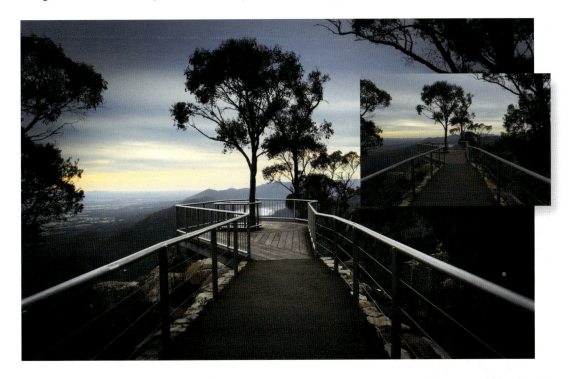

This image was taken at dawn at the Baroka lookout in the Grampians, Victoria (having to dodge a few suicidal kangaroos in the pre-dawn drive to get there). The lighting seemed to be right for the classic low-key image (the sun is behind the subject and strategically positioned behind the horizon line). So why is it still flat? The soft light from the cloud cover is flooding the scene and lowering the contrast excessively. The metal bars that lead us to the central focal point are just not separating sufficiently from the surrounding dark rocks and foliage. A classic low-key image is one where the dark tones dominate the image but where small bright highlights punctuate the shadows to create the characteristic low-key mood. At the moment there is less than 50 levels difference between the bars and the background. Something more than a simple levels adjustment is called for to lift and separate these tones.

1. If you are used to optimizing the histogram using the Levels adjustment feature, the following step might come as a little bit of a surprise. Instead of dragging the black shadow and white highlight sliders that sit directly beneath the histogram in to the start of the histogram, we are going to temporarily clip (render white) the highlights of the sky. Click on the 'Create adjustment layer' icon in the Layers palette and choose 'Levels'. Hold down the Alt key and drag the highlight slider just below the right side of the histogram towards the centre of the histogram. The image window will temporarily look black. As you drag this slider (still holding down the Alt key) you will notice the sky start to appear in the image window. These are all the pixels that are now 255. Do not worry about the sky clipping but focus your attention instead on the foreground. We are expanding the contrast in this region in an attempt to increase the drama.

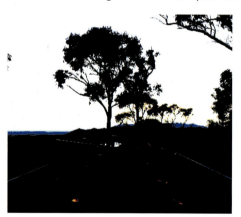

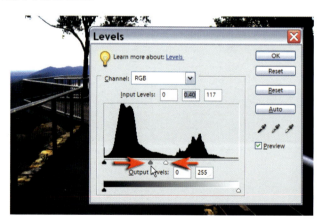

2. As you continue to drag the highlight slider to the left the steel bars will start to appear. Back this slider off to the right until only thin blue lines are apparent (this indicates only the blue channel is clipping). Let go of the Alt key and now drag the central gamma slider (the gray one) to the right to darken the midtones. What you have effectively achieved here is double the contrast in the foreground at the expense of the sky (which is now clipped). Sometimes things have to get worse before they get better so select OK, even if you think things are far from OK, to apply these changes.

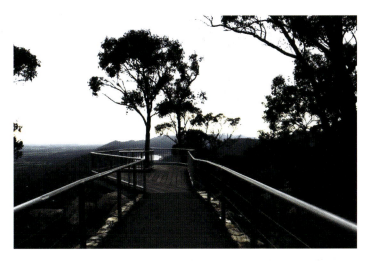

3. Increased contrast brings with it, increased saturation, which in this instance is an unwelcome visitor to the proceedings. We can remove the increase in saturation by simply setting the adjustment layer to Luminosity mode (so long as you do not have a painting tool selected the keyboard shortcut is Alt+Shift+S).

4. Select the Gradient Tool in the Tools palette and in the Options bar choose the 'Black, White' and 'Linear' options. Drag a gradient from a short distance above the horizon line to a short distance below the horizon line. This will effectively shield the sky from the effects of this aggressive adjustment layer and return the tonality of the sky back to 'normal'. 'Normal' does not mean 'dramatic' and seeing as this is an exercise in drama we will set to rectify this situation in the next step.

5. In the Layers palette click on the Create a new layer icon. Set the blending mode of this layer to Soft Light. With the Gradient Tool still selected choose black as your foreground color in the Tools palette and from the Options bar choose the Foreground to Transparent option and that the Transparency box is checked. Drag a gradient from a short distance above the horizon line to a short distance below the horizon line. This will increase the contrast of the sky and increase the color saturation slightly.

Note > The Soft Light bend mode belongs to the 'Contrast' family of blend modes. This blend mode is not as aggressive as the Overlay blend mode that is the most popular blend mode in this grouping.

6. With the image now looking a lot more dramatic all that remains is to put a few finishing touches to the mood masterpiece. To increase the fire in the sky I have decided to add another adjustment layer. This time I have selected a Hue/Saturation adjustment layer. To restrict the adjustment to a localized area I have switched back to the Black, White gradient and chosen the Reflected gradient option and selected the Reverse option. Dragging a gradient from the horizon line to a short distance above or below the horizon line will create a narrow band of adjusted pixels, leaving the sky at the top of the image and the foreground unaffected.

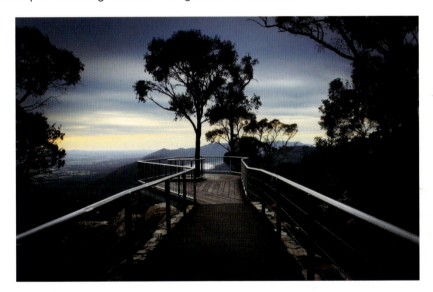

7. The final dramatic touch is to render the highlights pin sharp. My preferred sharpening method is to merge all of the visible elements to a new layer positioned on top of the layers stack. I apply a generous amount (amount but not radius) of sharpening and then produce a test strip. If the print file is too sharp I can lower the opacity of this layer until I strike the correct amount of sharpening. A useful keyboard shortcut to merge all of the visible elements to a new layer is to hold down the Ctrl+Shift+Alt keys and then type the letter N followed by the letter E (whilst still holding down the three modifier keys). The amount I elected to use for this image was 150% at a radius of 0.8. A threshold value of 3 prevents the noise or film grain from becoming an issue.

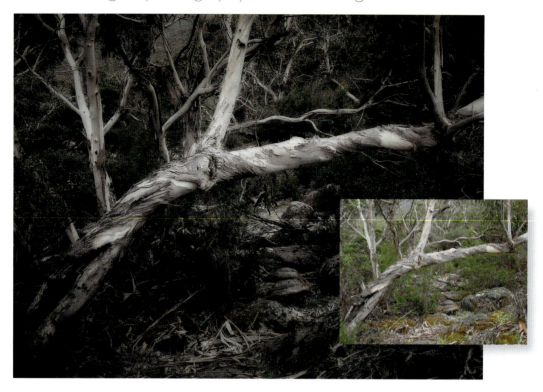

Advanced tone control - part b

In this image the lighting is very flat - cloud cover has removed the useful modelling light usually provided by the sun and all we are left with is a soft diffused light filling the entire landscape. All is not lost however as the image has some useful color and tonal differences that we can exploit. In the previous project we used gradients to limit the adjustments, in this project we must explore alternative techniques to extract the drama.

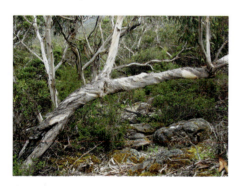

1. To increase the overall contrast in the image create an adjustment layer (any adjustment layer) and set this adjustment layer to Soft Light mode. You do not have to make any adjustment inside the adjustment layer dialog box - simply click OK and change the blend mode of the layer. It is a really fast and economical way (Bits/Channel images only) to increase the overall contrast of an image.

2. In an attempt to isolate the trees from the background we will darken and desaturate the foliage in amongst the trees. Select a Hue/Saturation adjustment layer and from the Edit options choose Yellows. Drag both the Saturation and Lightness sliders to a value of -50. Look at the two ramps at the base of the Hue/Saturation dialog box. The top ramp indicates the range of colors that you are adjusting whilst the bottom ramp indicates the results of the color adjustment, i.e. darker and less saturated.

3. The contrast has already significantly improved but we can change the mood to extract the maximum impact from these battered and wind-swept gum trees by lowering the overall brightness. Use a levels adjustment layer and move the central gamma slider to the right or use the following blend mode technique. Merge the visible layers to a new layer using the technique outlined in Step 7 of part a. Set the blend mode of this layer to Multiply. This is a darkening blend mode that affects predominantly the midtones and shadows. Adjust the Opacity of this layer to strike the right balance of mood that you are looking to create.

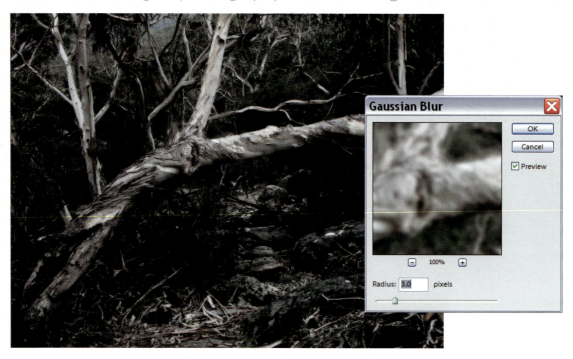

4. The advantage of using the multiply technique over a gamma adjustment in Levels is that we can now apply a small amount of Gaussian Blur (Filter > Blur > Gaussian Blur) to this layer. The Gaussian Blur technique applied to a multiply layer will mainly affect the darker tones. Smoothing out the detail of the background tones (the shadows) will help draw the viewer's attention to the trees (the highlights) resulting in a visual separation between essential and non-essential information. Without a single selection you can see how we are able to massage the tonality of images to create the mood we are looking for. Even when tones or colors are relatively close Photoshop is able to exaggerate these differences to extract the maximum possible impact from our pixels rich resource.

A complete guide to post-production editing can be found in either *Digital Imaging: essential skills* third edition (Elements and CS/CS2 compatible) and *Photoshop CS2: essential skills*.

panoramic photographs

Tamas Elliot

essential skills

~ Develop an understanding of the steps involved in producing panoramic photos.

~ Be aware of the range of stitching software options that is available.

~ Develop skills in the shooting phase of the process using the following techniques:

- Positioning the camera

- Locating and using the nodal point of the lens

- Ensuring image overlap

- Keeping the camera level

- Controlling exposure, contrast and white balance characteristics

- Controlling depth of field, focus and zoom settings

~ Develop skills in the production phase of the process using the following technique:

- Stitching a series of images

The panorama is made by stitching sequentially shot and overlapping images together so that they seamlessly form a single wide vista photo

Introduction

Panoramic images have always been a very inspiring aspect of photography. Until now, making these types of pictures has been restricted to a small set of lucky individuals who are fortunate enough to own the specialized cameras needed to capture the wide images. These wide format cameras come in a variety of designs including spinning lenses or enlarged camera backs that capture the image over several frames of film. With the onset of digital photography image-editing software manufacturers have now started to include features that allow users with standard cameras to create wonderful wide-angle vistas digitally. How is this so?

The new features are sometimes referred to as stitching programs, as their actual function is to combine a series of photographs into a single picture. Whilst in the field the photographer carefully photographs the scene using several exposures making sure that each of the images slightly overlap. When this series of photos is imported into a stitching program the edge details of each successive image are matched and blended so that the join is not detectable. Once all the photographs have been combined, the result is a picture that shows a scene of any angle up to a full 360º.

This 'multi-capture and stitch' approach has taken the ability to create fantastic panoramic photos from the hands of the professionals touting specialized equipment and thrust it into the hands of any photographer with a digital camera and a stitching program. This chapter will look at the steps involved in capturing and producing panoramic photographs.

Panoramic forms

Traditionally photographers have printed their capture images and used this form as a way of presenting their work. Panoramic imaging more so than most other photographic pursuits supports the creation of wonderful printed photographs whilst at the same time providing the opportunity involving the audience in a truly immersive experience. The shooting and stitching stages of the process is pretty much the same for both outcomes but it is in the later production steps that the panoramic image is optimized for one outcome or the other.

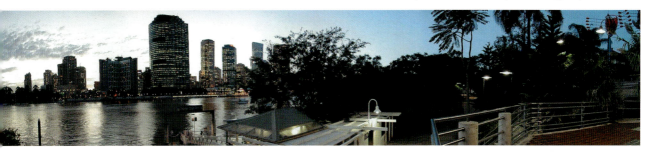

The mighty print

Given the format of most wide vista photographs, printing on standard inkjet paper will result in much of the printing surface being left unused. Printer companies like Epson now produce pre-cut panoramic paper in a photographic finish. These sheets are convenient to use and their proportions are stored as one of the default paper settings on all the latest model printers.

Another approach is to use the roll paper format that is now available as an option on several different models. This option provides the ability to print both long and thin and standard picture formats on the same paper, reducing the need for multiple paper types. Using these special roll holders the printer can output different image formats back to back and edge to edge, providing cutting guidelines between pictures if needed.

Spinning panos

Many wide vista photographers choose to present their work in an interactive spinning format rather than in print form. This way of looking at images is often called Virtual Reality (VR) and is used extensively on the Internet to give viewers the feeling that they are actually standing in the environment they are seeing on screen. Holiday destinations and real estate previews come to life via this technology. When the VR panorama opens you can navigate around the scene looking left and right with nothing more than simple mouse movements.

Although the ability to output your flat panoramic pictures in a VR format is not an integrated function of all stitching programs there are a variety of utility programs available for those who want to get their wide vista pictures spinning. But enough of the output options let's get down to the business of creating panorama photographs.

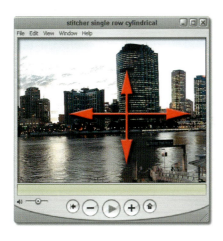

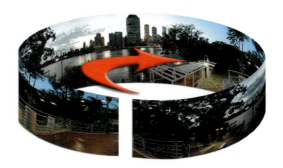

Photographers can easily take their panorama pictures beyond the static print by converting their stitched images to spinning vistas that can be navigated on screen and distributed via the web.

Core steps in creating panoramas

Creating a panorama by stitching together a series of overlapping images is a two part process of **Shooting** and **Producing**.

If your aim is to create high quality wide vista photographs then both phases are just as important as each other. New panorama photographers tend to spend too little time and care in the shooting phase assuming that any problems with capture will be easily overcome with the aid of feature packed software in the production phase. It is true that the software has become increasingly easier to use and more robust as this area of photography has matured but there is still no better way to guarantee seamless blends between stitched panorama parts than by ensuring that they are well captured in the first place. For this reason the majority of this section is dedicated to the steps that you need to take to capture your source photos with the later portion providing a summary of the production phase.

Shooting panoramas

Making wide vista pictures is a photographic activity where careful camera 'set up' and watchful sequence shooting will definitely pay big dividends when it comes time to stitch your source images together. Being attentive to the issues that follow will ensure that the series of photos that you capture will be easily blended back at the desktop. A few extra minutes taken in the setting up and shooting phases will save a lot of time later sitting in front of the computer screen fixing problems.

1. Positioning the camera

Photographers have long prided themselves in their ability to compose the various elements of a scene so that the resultant picture is dynamic, dramatic and balanced. These aims are no less important when creating panoramic images, but the fact that these pictures are constructed of several separate photographs means that a little more thought needs to be given to the positioning of the camera in the scene. For the best results the photographer needs to try and pre-visualize how the final picture will appear once the single images are combined and then select the camera's position.

One common mistake is to move to the centre of the environment, set up the equipment and create a sequence of images with most of the subject detail in the mid or background of the picture. This type of panorama provides a good overview of the whole scene but will have little of the drama and compositional sophistication that a traditional picture with good interaction of foreground, mid ground and background details contains.

When deciding on where to position your camera sweep the area whilst looking through the viewfinder. Ensure that the arc of proposed images contains objects that are close to the camera, contrasted against those subjects that are further into the frame.

Pro tip > Extend this compositional idea further by intentionally positioning the nearest and most dramatic objects in the scene one third (or two thirds) of the way into the sequence of images. This will provide balance to the photograph by positioning this point of focus according to the 'rule of thirds' in the final panorama.

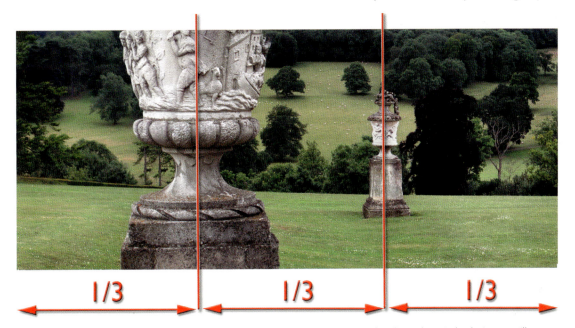

Unlike traditional photography the panoramic image-maker must pre-visualize how the stitched picture will appear when considering where to position the camera

2. Pivot around lens

Though not essential for shooting the odd sequence of images, most panoramic professionals insist on using a tripod coupled with a special panoramic head to capture their pictures. The tripod provides a stable and level base for the camera; the panoramic head positions the camera and lens precisely over the pivot point of the tripod and also contains regular click stops to indicate points in the spin to capture a photograph. Each stop is designed to provide optimum coverage for each frame, taking into account the required edge overlap.

This set up increases the effectiveness of your stitching software's ability to accurately blend the edges of your images. Companies like Kaidan (www.kaidan.com) and Manfrotto (www.manfrotto.com) manufacture VR equipment specifically for particular cameras and lenses. You can purchase a tripod head designed for your camera or choose a head that can be adjusted to suit any camera.

Specialized panoramic or VR (virtual reality) tripod heads are perfect for ensuring that the lens' nodal point is over the pivot point of the tripod. This precision pays dividends at stitching time as panoramic software such as Photoshop's Photomerge will produce much better results when the edges of sequential images can be exactly matched.

(a) Adjustable Manfrotto VR head suitable for a range of cameras.

(b) Camera-specific Kaidan head suitable for a single camera body only

Why all this bother with specialized equipment? The stitching software's main task is to seamlessly blend the edges of overlapping images. This is best achieved when the edge details and perspective of the two pictures are as similar as possible. Slight changes in the relationship of the objects in the scene will cause problems when stitching, often resulting in 'ghosting' of the objects in the final panorama. Now, for the occasional panoramic photographer this is not too big a deal as a little deft work with your Photoshop editing tools and the picture is repaired, but frequent panorama producers will want to use a technique that produces better results faster. Using a special VR or panoramic tripod head produces such results by positioning the 'nodal point' of the lens over the pivot point of the tripod. Images shot with this set up will have edges that match more evenly, which means that Photomerge can blend these overlapping images more successfully and accurately.

Finding the nodal point

If you have a VR head designed specifically for your camera and lens then the hard work is already complete. Simply set up the equipment according to the manufacturer's instruction and you will be taking 'nodal point correct' pictures in no time. If, however, you are using a fully adjustable VR head or you just want to find the nodal point for a specific camera and lens combination you can use the following techniques as a guide.

Left to right adjustment - The lens and tripod should be viewed from the front and the lens position adjusted from left to right until it sits vertically above the tripod's pivot point.

You can check your positioning skills by turning the camera 90 degrees down (so that the lens faces the tripod pivot) and confirming that the pivot point is located centrally in the LCD preview screen. This is the easy part

Back to front adjustment - Move the camera back and forward to find the nodal point of the lens. Set camera and tripod up so that there is a vertical object such as a lamp post or sign very near the camera and a similar vertical object in the distance. The closer the foreground object the more accurate the results of the test will be.

Watching the LCD preview screen (or looking through the viewfinder in an SLR camera) rotate the camera. If the gap between the near and distant verticals increases as the camera is rotated move the camera either forwards or backwards and try again until the gap remains constant

Some camera or lens manufacturers provide details about the nodal points of their products, but on the whole, this type of data is hard to find and it is up to the shooter to determine the nodal point of his/her own equipment. For this the main method is usually referred to as the 'lamp post' test and is based on a two-step process. With the camera set up and levelled on a panoramic head use this step-by-step guide to find the nodal point.

1. Start by adjusting the camera from side to side until the centre of the lens is positioned directly over the pivot point of the tripod. This is the easy part.
2. Next, you need to move the camera back and forwards whilst rotating the camera and comparing the visual distance between foreground and background subjects. When the visual distance is the same the lens nodal point is positioned over the pivot point of the tripod and you are ready to start capturing the source photos for your panorama.

Checking your results

If the lens' nodal point is rotating over the tripod pivot point then the visual distance (gap) will remain the same throughout the movement. If the distance changes then the lens is not positioned correctly and needs to be moved either forward or backwards to compensate.

With a little trial and error you should be able to locate the exact nodal point for each of your lenses, cameras and lens zoom points. VR tripod heads, like those made by Manfrotto, excel in this area. The fine-tuning controls and set up scales enable the user to accurately locate and note the position of the nodal points for a variety of lenses and/or cameras. With the tests complete the results should be recorded and used whenever the same camera set up is required again.

Handy guide to nodal point corrections

Use these rules to help you correct nodal point errors:

1. Moving the lens backward, if rotating the camera away from the foreground object, increases the visual gap, or
2. Moving the lens forward, if rotating the camera away from the foreground object, decreases the visual gap.

Camera assisted hand held

Unless you are a committed panoramic shooter you probably won't have a specialized tripod head handy the next time you want to capture a series of source images. This generally leads to a situation where you attempt to photograph the pictures by simply spinning the camera in your hands. Most stitching software will be able to blend pictures captured in this way but the inaccuracy of the photography process does lead to more editing work back at the desktop. To improve the accuracy of hand-held capture several of the bigger camera companies such as Nikon and Canon include a special 'panorama assist' shooting mode in their mid to high range compact cameras. The mode ghosts the previous shot in the LCD screen so that you can line up the next picture accurately. This saves you from the expense of purchasing a professional panoramic tripod head whilst still ensuring accurate overlap and positioning of the series of photos. As well as helping with correct alignment and positioning these special shooting modes also lock in focus, aperture, contrast and white balance at the beginning of the shooting sequence aiding consistency.

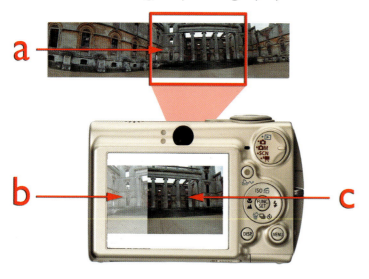

a

b

c

Some mid to high range compact digital cameras now include a panorama assist mode that ghosts the previously taken photo so that the next image in the sequence can be easily aligned. This approach helps ensure that sequential source photos are correctly spaced and positioned.

(a) Area of the scene being framed.

(b) Ghosted section of previous photo to be lined up with current scene.

(c) Current scene in the LCD viewfinder

Pro tip > If you don't have a special panoramic head or a camera model with panorama assist then try rotating the camera around the lens rather than pivoting it around your body. Also if you are shooting 'hand-held' use longer focal lengths rather than wide angle lenses; this will help with stitching later.

Single shot

In recent years a completely new way of capturing and producing panoramas has emerged. With dreams of making life easier for the 'pano shooter' companies like Kaidan have created technology options that allow the user to capture a full 360 degrees worth of information in a single shot. Unlike traditional single shot systems like the Seitz Roundshot camera which captures a full-spin image by rotating the camera during exposure, the new 'donut' technology remains static during exposure whilst still capturing the whole scene.

Kaidan in conjunction with its alliance partner EyeSee360 have produced a single shot technology that is suitable for use with a range of digital cameras. The 360 One VR unit is attached to the lens of a digital camera and the whole unit positioned so that it is photographing vertically. The camera captures a reflected image from the device's mirrored optic. This result in a donut shaped picture which is then manipulated by the supplied software to create either a ready made QuickTime VR movie or a flat panoramic image. This single shot technology is currently the fastest and easiest way to capture and produce a panorama and is only limited by the resolution of the digital camera you attach to the device.

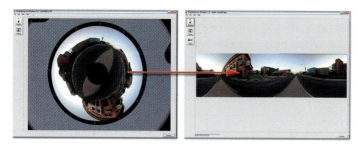

The donut shaped photo captured with the single shot systems is stretched back to a rectangular image using some sophisticated software supplied with the system.

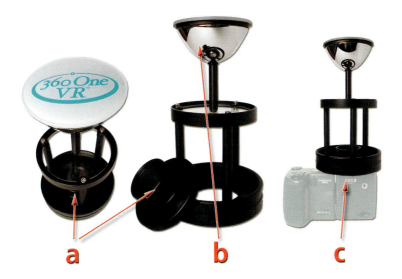

The specially shaped reflective optic is positioned directly in the centre of the camera lens. The camera is then carefully focused (usually in macro mode) before photographing the reflected version of the surrounding environment.

(a) Camera adapter.

(b) Panoramic optic.

(c) Optic positioned on a camera.

3. Image overlap

As you are photographing, ensure that the edges of sequential images are overlapping by between 15 and 40%. The percentage of overlap that works best with a specific stitching program can be usually found in the Help files associated with the software. If you are wanting to create a 360 degree view then the exact number of images needed to complete the sweep of the vista or the full circle will depend on the angle of view of the lens as well as the amount of overlap that you use.

A quick way of calculating the pictures needed for 30% overlap is to count the number of images required to complete a full 360 degree rotation with no overlap and then multiply this value by 3. Or, alternatively, you can use the recommendations detailed in the table aside as a starting point for the number of overlapping portrait images required to construct a 360 degree panorama. Professional VR heads ensure overlap consistency by placing 'click-stops' at regular points on the circumference of the head. On many models this is a variable feature that allows the photographer to change the interval to suit different lenses and/or overlapping amounts. Those on a more modest budget can mark regular intervals on their tripod head using a protractor or use the grid within the camera's viewfinder as a guide.

Focal length in mm (35 mm equivalent)	Number of Images required for 360 degree panorama
14	12
18	12
20	12
24	18
28	18
35	20
42	24
50	28

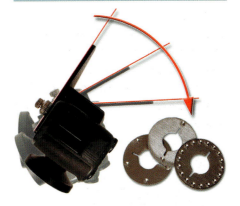

To evenly space sequential image capture points and ensure consistent overlap some companies produce panorama tripod heads with a built-in 'click-stop' system.

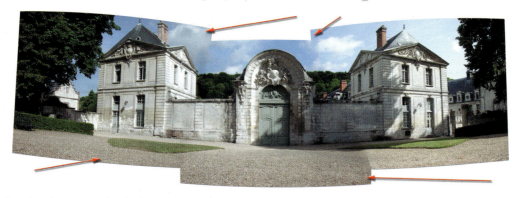

Not keeping the camera level when photographing source images will mean jagged or stepped edges in the final stitched panorama. These edges can be trimmed with the crop tool but in this example that would mean losing important details in the scene so the only answer is to reconstruct the missing areas using features like Photoshop's Clone Stamp and Patch tools.

4. Ensuring the camera is level

Although Photoshop's Photomerge and other stitching programs are designed to adjust images that are slightly rotated, it is far better to ensure that all source images are level to start with. The easiest way to achieve this is by photographing your scene with your camera connected to a level tripod with a rotating head. If you are out shooting and don't have a tripod handy, try to locate a feature in the scene that remains horizontal in all shots and use this as a guide to keep your camera level when photographing your image sequence. Failing to keep the camera level will result in a series of steps at the top and bottom of the stitched photos where the pictures are slightly out of alignment. For the most part these jagged edges can be removed with a simple crop but sometimes this cropping step will loose important scene detail.

5. Keep the exposure constant

As the lighting conditions can change dramatically whilst capturing the sequence of images you need to create a panorama, it is important that the camera's exposure be set manually before commencing the sequence. Leaving the camera set to auto exposure (Program, Aperture priority or Shutter speed priority) will result in changes in brightness of sequential images, especially if you are capturing pictures throughout a full 360 degree sweep of the scene.

Set your camera to manual exposure to ensure consistency across the sequence of images

Take readings from both the shadow and highlight areas in several sections of the environment before selecting an average exposure setting, or one that preserves important highlight or shadow detail. Lock this shutter speed and aperture combination into your camera and use the same settings for all the source images.

If the scene contains massive changes in brightness this will mean that some parts of the picture are rendered pure white or pure black (with no details), then you may want to consider capturing a second sequence using a different set of exposure settings.

The extra shadow or highlight details captured in this additional sequence can be added to the images in the first sequence using layering techniques in your image editing software. These tonal composites can then be used for the stitching process. To ensure that you have sufficient picture data in scenes with extreme brightness changes you may need to capture three complete sequences with varying exposures. The exposure for one sequence should be adjusted to record highlights; one for shadows and if required a third can be used to capture midtones. You can even use your camera's exposure bracketing system to shoot the over-, mid and underexposures automatically.

6. Don't adjust the focus or zoom

A similar problem of differences from image to image can occur when your camera is set to auto-focus. Objects at different distances from the camera in the scene will cause the focus to change from shot to shot, altering the appearance of overlapping images and creating an uneven look in your final panorama. Switching to manual focus will mean that you can keep the point of focus consistent throughout the capture of the source images. In addition to general focus changes, the zoom setting (digital or optical) for the camera should not be changed throughout the shooting sequence either.

Switch your camera to manual focus and then set the distance to encompass the subjects in the scene taking into account 'depth of field' effects as well

7. Determine the 'depth of field'

Despite the fact that cameras can only focus on one part of a scene at a time (the focus point) most of us have seen wonderful landscape images that look sharp from the nearest point in the picture right through to the horizon. Employing a contrasting technique, many contemporary food books are filled with highly polished pictures where little of the shot is sharp. I'm sure that you have seen images where only one tiny basil leaf is defined whilst the rest of the food and indeed the plate is out of focus. Clearly focusing doesn't tell the whole sharpness story.

This phenomenon of changing degrees of sharpness in a picture is referred to as the 'depth of field of acceptable sharpness' or 'DOF'. When shooting panoramas source images it is important to know the factors that control this range of sharpness and, more importantly, how to control them.

Ensure that you consider focus and depth of field at the same time, as both these variables will affect the subject sharpness in your source images.

(a) Sharp foreground detail.

(b) Background unsharp due to shallow DOF

DOF - the three variables:

Aperture - Changing the aperture, or F-Stop number, is the most popular technique for controlling DOF. When a high aperture number like f32 or f22 is used, the picture will contain a large DOF - this means that objects in the foreground, middle ground and background of the image all appear sharp. If, instead, a low aperture number is selected (f1.8 or f2), then only a small section of the image will appear focused, producing a shallow DOF effect.

Focal length - The focal length of the lens that you use to photograph also determines the extent of the DOF in an image. The longer the focal length (more than 50mm on a 35mm camera) the smaller the DOF will be, the shorter the focal length (less than 50mm on a 35mm camera) the greater DOF effect.

Distance from the subject - The distance the camera is from the subject is also an important depth of field factor. Close-up, or macro photos, have very shallow DOF, whereas landscape shots where the main parts of the image are further away have a greater DOF. In other words the closer you are to the subject, despite the aperture or lens you select, the shallower the DOF will be in the photographs you take.

As most panoramic pictures require sharp details in the fore-, mid and background you should practise setting up your camera for the largest depth of field possible. This means selecting a high aperture number, using wide angle lenses and increasing the camera-to-subject distance wherever possible. It is also good practice to take a couple of test shots of sections of the scene and review these on the LCD monitor on the back of the camera (using the magnification option) to ensure that you have sharpness in the areas of the picture that you desire.

Pro tip > After setting the exposure (aperture and shutter speed) and focus on your camera take a couple of test photos of areas within the scene that will be part of the final panorama. Make sure that all important details in the photo are sharp. For the most part this means checking that the closest foreground detail is sharp along with areas in the background that are important. If the DOF doesn't extend far enough into the photo to cover both these extremes then you will need to adjust your aperture, focal length and/or distance to subject to suit.

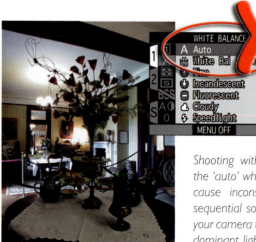

Shooting with your camera set to the 'auto' white balance setting can cause inconsistent color between sequential source images. Switching your camera to a mode that suits the dominant light source for the scene will produce more even results.

8. Watch white balance

The White Balance feature in your digital camera doesn't assess the amount of light entering the camera, but instead it looks at the color of the light. It does this in order to automatically rid your images of color casts that result from mixed light sources. Leaving this feature set to 'auto' can mean drastic color shifts from one frame to the next as the camera attempts to produce the most neutral result. Switching to a manual setting will produce images that are more consistent but you must assess the scene carefully to ensure that you base your white balance settings on the most prominent light source in the environment.

For instance if you are photographing an indoors scene that combines both daylight through a window and domestic lights hanging from the ceiling then the Auto White Balance feature will alter the color of the captured images throughout the sequence to account for one source of the other. Switching to manual will allow you to set the balance to match either of the two light sources or even a combination of both using the preset feature.

9. Control the contrast

Most intermediate to high-end digital cameras contain a series of settings that control how the range of brightness in a scene is recorded to memory. This contrast control feature is one that you should become familiar with if you plan to shoot panoramas where the scene captured moves between bright sunlight and deep shadows. When faced with such a task the difference in brightness between the lightest and darkest areas of the scene can be extremely wide. With the camera set to 'normal' contrast the sensor can loose detail in both the highlight and shadow areas of the scene. Delicate details will either be converted to white or black. Changing the setting to 'less contrast' will increase your camera's ability to capture the extremes of the scene and preserve, otherwise lost, light and dark, details.

Most digital cameras provide some control over how a scene's contrast is recorded by the sensor. Selecting the 'More Contrast' setting will increase the contrast in the recorded image. The 'Normal' setting uses a fixed contrast setting for all images despite the brightness range of the subject. The 'Less Contrast' mode is used to reduce the contrast of the recorded image. Panoramic shooters should avoid using the 'auto' option as switching to this mode will cause the camera to adjust the setting to suit each individual shoot.

In the opposite scenario, sometimes your subject will not contain enough difference between shadows and highlights. This situation results in a low contrast or 'flat' image. Typically pictures made on an overcast winter's day will fall into this category. Altering the camera's setting to 'more contrast' will spread the tonal values of the scene over the whole range of the sensor so that the resultant picture will contain acceptable contrast.

'How do I know that my scene either has too much or too little contrast?' The beauty of shooting digitally is that we can preview our image immediately. There is no waiting around for processing - the results are available straight away. If you are in a situation where you feel that the source images may be enhanced by altering the contrast, shoot a couple of test pictures and assess the results. Check in particular the shadow and highlight areas. Any noticeable loss of detail in either of these two places will warrant a contrast change and a reshoot.

Some cameras have a histogram function that will visually graph the spread of the pixels in the image. This feature takes the guesswork out of determining whether your image is too flat or too contrasty. A bunching of pixels in the centre of the graph usually indicates a need for more contrast, whereas a mass grouping at both ends requires a reduction in contrast.

Along with good exposure control, selecting the right contrast setting is critical if the greatest amount of scene's detail is to be recorded by the sensor and switching to manual contrast control will ensure consistency across the full range of source images.

What about RAW shooters?

It should be noted that image factors such as white balance and contrast are fixed in the picture when the format used for saving 'in camera' is JPEG or TIFF. This is the reason that it is essential to fine tune these settings before commencing to record the image sequence. However this is not the case when using the RAW format as the capture file type. One of the distinct advantages of using this advanced format is that contrast and white balance can be adjusted (losslessly) after capture.

During the process of converting the RAW image to an editable format, programs such as Adobe's Camera RAW provide the ability to make many changes to the original capture. Because of this it is not as critical for RAW shooters to standardize and control the white balance and contrast settings used when capturing. Instead time should be taken during the conversion process to firstly adjust these settings to suit the range of images in the sequence and then to carefully apply the same conversions settings to all the source files.

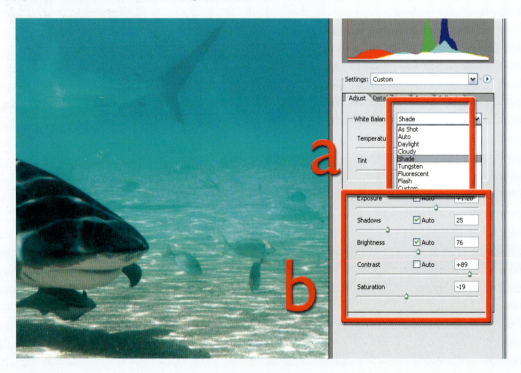

RAW shooters can take advantage of the White Balance (a) and Contrast (b) adjustment options available in conversion software like Adobe Camera RAW to fine tune their source captures

Advantages of Shooting RAW

~ You get to use the full tonal and color range that was captured by the camera.

~ You can remove many of the file processing decisions from the camera to the desktop where more time and care can be taken in their execution. This includes:
 – White balance changes
 – Highlight, shadow and midtone adjustments
 – Applying sharpness
 – Manipulating saturation
 – Color mode (sRGB, Adobe RGB etc.) switches

~ You can make image data changes such as a switching white balance settings without image loss. This is not possible with non-RAW formats as the white balance results are fixed in the processed file.

Disadvantages of Shooting RAW

~ Bigger file sizes to store on you camera's memory card.

~ Having to process the images before use back at the desktop.

~ Needing specialist RAW processing software in addition to your favourite image editing package.

10. Keep an eye on the edges

The edges of the image frame are the most critical part of the source picture. It is important to make sure that moving details such as cars, or pedestrians, are kept out of these areas. Objects that appear in the edge of one frame and not the next cause problems for the stitching program and may need to be removed or repaired later with other tools like the Clone Stamp.

Try to time your exposures so that you limit subject changes at the edges of your pictures

Though not strictly a photographic technique, timing is very important when photographing your sequence of images. The best approach to solving this moving object problem is to wait until the subjects have moved through the frame before capturing the image. A similar solution can be used when photographing in changing lighting conditions. For instance, if you start to capture a sequence of images in full sunshine only to find that halfway through a rouge cloud shadows the scene, then it is best to wait until the sun is shining again before recommencing the capture.

Alternatively if you are photographing in a busy street and there looks to be no reprieve from the hosts moving through your frame then capturing two of more photos for each source image will give you plenty of scope when it comes time to stitch.

Producing panoramas

A variety of specialised stitching software programs are available for both the Mac and Windows environments. The range covers simple entry-level packages like Roxio's PhotoVista through to professional products such as RealViz's Stitcher. Add to these the fact that image manipulation and enhancement packages like Adobe's Photoshop Elements and Photoshop now contain stitching tools and that most new digital cameras come bundled with proprietary panoramic products and you will see that you have plenty of options to play with in the production phase.

Canon PhotoStitch and Nikon (Arcsoft) panorama maker

These panoramic utilities are supplied as part of the software that comes with most Canon and Nikon digital cameras. They offer simple step-by-step processes for acquiring, adjusting, stitching and saving panoramic images. Although specifically designed for the production of wide images for print there is also the option to save pictures as QuickTime VR movies.

The resultant images are well aligned and blended and generally give good results. These packages are typical of the 'included' software titles that are now frequently bundled with new digital cameras. Although not a major purchasing reason itself, having a piece of software like this included 'free of charge' does make some camera deals more attractive.

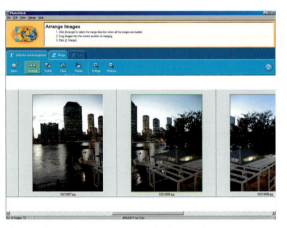

Canon PhotoStitch is supplied free with most Canon cameras

Adobe Photomerge

Not to be left behind Adobe has included a stitching feature called Photomerge in both their entry level offering - Photoshop Elements and the king of photo editing - Photoshop. The automated process acquires and matches edge details of separate files before making a new single panoramic picture. A variety of tools are available for manual adjustment of positioning of source images within the panorama and there are also options for perspective correction and advanced edge blending. Having a stitching feature as part of your favourite imaging program seems to make sense especially if you only produce panoramas infrequently. And it's included free.

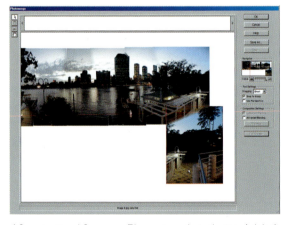

After starting life as an Elements only inclusion Adobe's Photomerge now comes standard with both Photoshop Elements and Photoshop

Panavue ImageAssembler

This stitching package allows users to 'flag' precise details in the edges of overlapping images so that the stitches can be made more efficiently and effectively. It allows for slight 'tilts' or horizontal inaccuracies in the shooting process. Instead of requiring you to crop the unwanted stairs that appear on the edge of a panorama made with such images it allows for the whole image to be realigned giving a more realistic and usable result.

Interestingly Panavue has also included a flat 'image stitcher' in the package for all those times when you try to scan an image larger than your scanner.

Panavue Image Assembler matches edge areas using flagged details that are common to the edges of sequential photos

iSee Photovista Panorama

Available for both Macintosh and Windows platforms this product allows a series of images to be stitched together to form a complete zoomable 360 degree image. The software takes into account that most such panoramas will be viewed on line by optimizing file size for limited bandwidth applications. For those of you who aren't lucky enough to already have a stitching utility this could be your first step to creating panoramic images.

Previously released by MGI Photovista Panorama is now being marketed and developed by iSeeMedia.

RealViz Stitcher

RealViz Stitcher is one of the most powerful panorama makers out there. It is a professional program whose strength comes from the sophistication of a stitching engine that is capable of producing cubic as well as cylindrical panoramas, the vast range of input formats it can use and the variety of output files it can create which includes Shockwave 3D, VRML as well as QuickTimeVR. Unlike some of the other packages Stitcher doesn't require for the user to input lens lengths or angles of view. The individual images are 'dragged and dropped' into the work area where they are adjusted and blended with a few simple clicks.

RealViz Stitcher is the professional's choice when it comes to a dedicated panorama creation program

Stitching the photos

Now that the source photos have been successfully captured let's set about stitching them together to form a panorama. Adobe's Photomerge (available in both Photoshop and Photoshop Elements) was used to join the images but the other programs mentioned above could have been used just as easily.

1. The process is started by selecting the source files. You can multi-select the images from inside Bridge or Element's Photo Browser or use the Photomerge add files window which is displayed when the feature is selected from the File menu.

2. The simple add files dialog contains Browse/Open and Remove options which prompt the user to nominate the picture files that will be used to make up the panorama. Preselected files will already be entered into the dialog, other suitable images are 'browsed' for and 'opened' into the Source Files section of the box. Any of the files listed here can be removed if incorrectly added by highlighting the file name and clicking the Remove button.

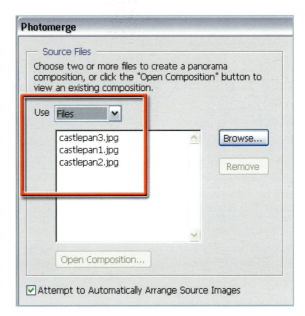

3. Clicking OK exits the dialog and starts the initial opening and arranging steps in Photomerge. You will see the program load, match and stitch the image pieces together. For the most part, Photomerge will be able to correctly identify overlapping sequential images and will place them side by side in the editing workspace. In some instances, a few of the source files might not be able to be automatically placed and Photomerge will then display a pop-up dialog telling you this has occurred. Don't be concerned about this as a little fine-tuning is needed even with the best panoramic projects and the pictures that haven't been placed can be manually moved into position in the main Photomerge workspace.

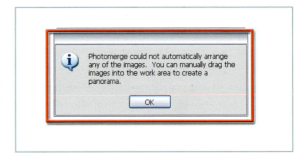

4. Whilst in the Photomerge workspace you can use the Select Image tool to move any of the individual parts of the

panorama around the composition or from the layout to the light box area. Click and drag to move image parts. Holding down the Shift key will constrain movements to horizontal, vertical or 45° adjustments only. The Hand or Move View tool can be used in conjunction with the Navigator window to move your way around the picture. For finer control use the Rotate Image tool to make adjustments to the orientation of selected image parts.

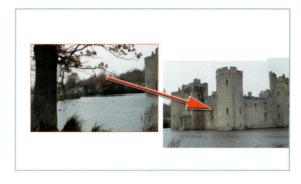

5. The 'Use Perspective' option, together with the Set Vanishing Point tool, manipulate the perspective of your panorama and its various parts. Keep in mind when using the perspective tools that the first image that is positioned in the Composition area is the base image (light green border), which determines the perspective of all other image parts (red border). To change the base image, click on another image part with the Set Vanishing Point tool.

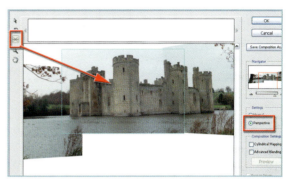

6. To correct some of the 'bow-tie'-like distortion that can occur when using these tools, check the Cylindrical Mapping option in the Composition area of the dialog.

7. The Advanced Blending feature, also available here, can be used to help minimize color inconsistencies or exposure differences between sequential images. It is not possible to use the perspective correction tools for images with an angle of view greater than 120°, so make sure that these options are turned off.

8. After making the final adjustments, the panorama can be completed by clicking the OK button in the Photomerge dialog box. This action creates a stitched file that no longer contains the individual images.

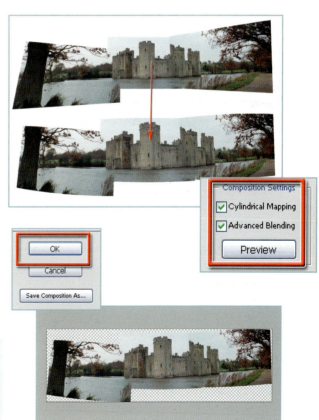

Accessing Adobe's Photomerge

Photoshop – File > Automate > Photomerge
Bridge – Tools > Photoshop > Photomerge
Elements – File > New > Photomerge

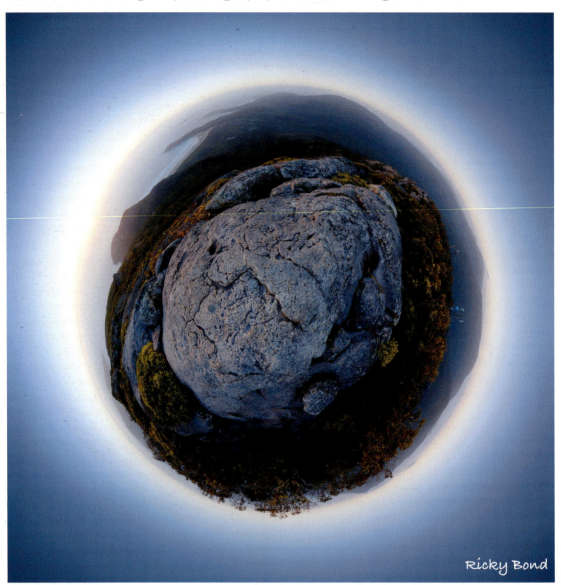

Ricky Bond

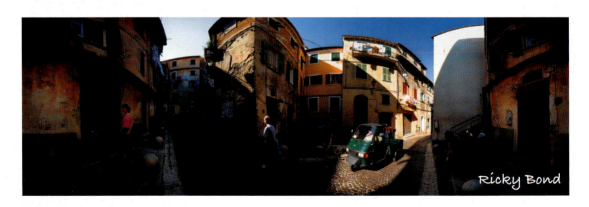

Ricky Bond

landscape

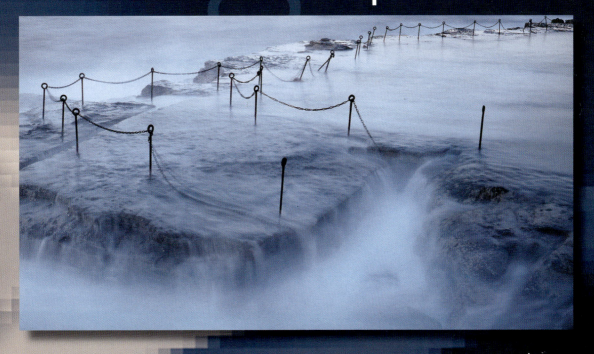

Rod Owen

essential skills

~ Increase knowledge of the historical development of the landscape image.

~ Express ideas, convictions or emotions through landscape images.

~ Develop an understanding of how different techniques can be employed to aid personal expression.

~ Produce photographic images exploring expressive landscape photography in response to the activity and assignment briefs in this chapter.

Introduction

Picture postcards, calendars and travel brochures show us glimpses of romantic, majestic and idyllic locations to be admired and appreciated. The beautiful and wonderful are identified, observed, recorded and labelled repeatedly by professionals, tourists and travellers. Mankind is responding to the basic social needs and expectations to capture, document and appreciate. I came, I saw, I photographed. Photography allows the individual to pay homage to beauty and achievement as if in some religious ritual. We mark the occasion of our endeavour and our emotional response by taking a photograph.

> 'Most tourists feel compelled to put the camera between themselves and whatever is remarkable that they encounter. Unsure of other responses they take a picture. This gives shape to experience: stop, take a photograph, and move on.'
>
> *Susan Sontag - On Photography*

In order to avoid a stereotypical representation it is important to connect emotionally with the environment in order to express something personal. How do you as an individual feel about the location and what do you want to say about it?

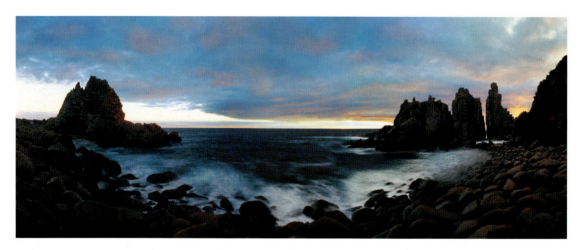

Orien Harvey

History

Early landscape images were either created as factual records or looked to the world of painting for guidance in such things as composition and choice of content. Fox Talbot described his early photographs as being created by the 'pencil of nature'. On the one hand the medium was highly valued because of the great respect for nature at this time. On the other hand the medium was rejected as art because many perceived photography as a purely objective and mechanical medium. The question was asked: 'Can photography be considered as an artistic medium?'

Although it is the camera that creates the image, it is the photographer who decides what to take and how to represent the subject. This subjective approach enables individuals to express themselves in unique ways whether they use a brush or a camera.

Pictorial photography

The practice of recording the environment as the principal subject matter for an image is a fairly modern concept. Prior to the 'Romantic Era' in the late 18th century, the landscape was merely painted as a setting or backdrop for the principal subject. Eventually the environment and in particular the natural environment began to be idealized and romanticized. The picturesque aesthetic of beauty, unity and social harmony was established by painters such as John Constable and William Turner working just prior to the invention of photography. The first photographic movement was born and was known as 'pictorial photography'.

Pictorial photographers believed that the camera could do more than simply document or record objectively. The pictorial approach was not so much about information as about effect, mood and technique.

Pictorial photographers often felt, however, that the photographic lens recorded too much detail. This led to photographers employing techniques to soften the final look of the image. These techniques included taking the images slightly out of focus or using print manipulation to remove detail. The aim was to create an image which looked more like a drawing or painting and less like a photograph.

Pictorial style image - Itti Karuson

Naturalism

Dr Peter Henry Emerson promoted photographic 'Naturalism' in 1889 in his book *Naturalistic Photography for Students of Art*. Emerson believed that photographers shouldn't emulate the themes and techniques of the painters but treat photography as an independent art form. He encouraged photographers to look directly at nature for their guidance rather than painting. He believed that photography should be both true to nature and human vision. Emerson promoted the concept that each photographer could strive to communicate something personal through their work.

Realism

In 1902 a photographer named Alfred Stieglitz exhibited under the title 'Photo-Secessionists' with nonconformist pictorial photographs, choosing everyday subject matter taken with a hand-held camera. These images helped promote photography as an aesthetic medium.

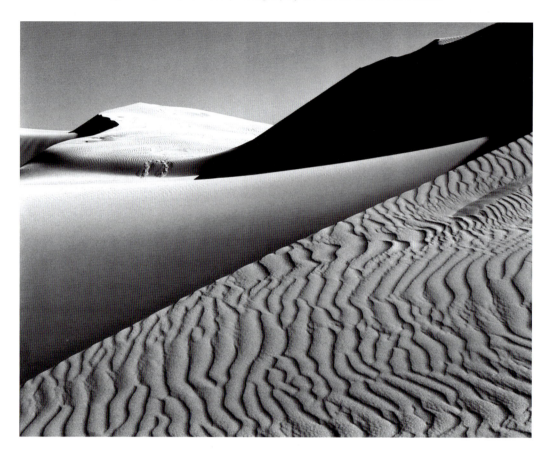

Dunes, Oceano, California 1963 - Ansel Adams © Ansel Adams Publishing Rights Trust/Corbis

F64

Another member of the group, Paul Strand, pioneered 'straight photography', fully exploring the medium's strengths and careful observation of subject matter. Strand believed that the emphasis should lie in the 'seeing' and not the later manipulation in order to communicate the artist's feelings. The work and ideas influenced photographers such as Edward Weston and Ansel Adams who decided to take up this new 'Realism'. They formed the group F64 and produced images using the smallest possible apertures on large format cameras for maximum sharpness and detail.

Straight photography heralded the final break from the pursuit of painterly qualities by photographers. Sharp imagery was now seen as a major strength rather than a weakness of the medium. Photographers were soon to realize this use of sharp focus did not inhibit the ability of the medium to express emotion and feeling.

Documentary

Photography was invented at a time when the exploration of new lands was being undertaken by western cultures. Photography was seen as an excellent medium by survey teams to categorize, order and document the grandeur of the natural environment. A sense of the vast scale was often established by the inclusion of small figures looking in awe at the majestic view. These majestic views and their treatment by American photographers contrasted greatly with European landscape photographs. Landscape painters and photographers in Europe did not seek isolation. Indeed seeking out a sense of isolation is problematic in an industrialized and densely populated land.

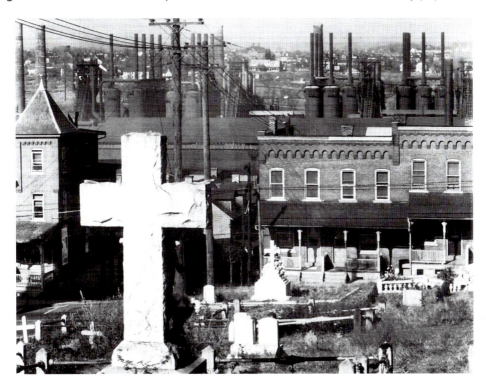

Bethlehem, Graveyard and Steel Mill - Walker Evans 1935 © Walker Evans Archive, 1994, The Metropolitan Museum of Art

In the 1930s Roy Stryker of the Farm Security Administration (FSA) commissioned many photographers to document life in America during the depression. Photographers such as Arthur Rothstein, Dorothea Lange and Walker Evans produced images which not only documented the life of the people and their environment but were also subjective in nature.

ACTIVITY 1

View the image by Walker Evans on this page and describe what you can actually see (objective analysis) and what you think the image is about (subjective analysis).

Discuss how effective Walker Evans has been in using a landscape image to communicate a point of view.

Can this photograph be considered as Art? Give two reasons to support your answer.

Personal expression

The image can act as more than a simple record of a particular landscape at a particular moment in time. The landscape can be used as a vehicle or as a metaphor for something personal the photographer wishes to communicate. The American photographer Alfred Stieglitz called a series of photographs he produced of cloud formations 'equivalents', each image representing an equivalent emotion, idea or concept. The British landscape photographer John Blakemore is quoted as saying:

'The camera produces an intense delineation of an external reality, but the camera also transforms what it "sees". I seek to make images which function both as fact and as metaphor, reflecting both the external world and my inner response to, and connection with it.'

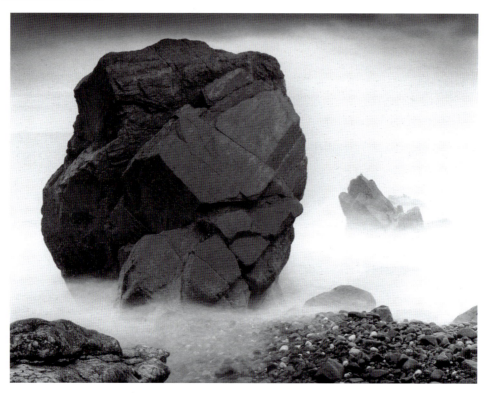

Rocks and Tide, Wales - John Blakemore

'Since 1974, with the stream and seascapes, I had been seeking ways of extending the photographic moment. Through multiple exposures the making of a photograph becomes itself a process, a mapping of time produced by the energy of light, an equivalent to the process of the landscape itself.' John Blakemore, 1991

Communication of personal ideas through considered use of design, technique, light and symbolic reference is now a major goal of many landscape photographers working without the constraints of a commercial brief. Much of the art world now recognizes the capacity of the photographic medium to hold an emotional charge and convey self expression.

Alternative realities

There is now a broad spectrum of aesthetics, concepts and ideologies currently being expressed by photographers. The camera is far from a purely objective recording medium. It is capable of recording a photographer's personal vision and can be turned on the familiar and exotic, the real and surreal. This discriminating and questioning eye is frequently turned towards the urban and suburban landscapes the majority of us now live in. It is used to question the traditional portrayal of the rural landscape (romantic and idyllic) as a mythical cliché. It explores the depiction of the natural landscape for many urban dwellers as a mysterious location, viewed primarily through the windscreen of the car and from carefully selected vantage points. Photographers such as Martin Parr now present different views of familiar locations and offer alternative realities. Landscape is used frequently as a political tool, reflecting the values of society. The landscape traditionally portrayed as being unified and harmonious may now be portrayed as confused and cluttered and in turn express the conflict between expectation and reality.

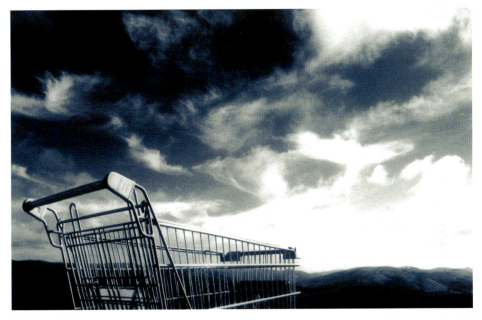

Dreams will come true - Matthew Orchard

Photographers also explore their personal relationship with their environment using the camera as a tool of discovery and revelation. To make a photograph is to interact and respond to the external stimuli that surround us. We may respond by creating images that conform to current values and expectations or we may create images that question these values. To question the type of response we make and the type of image we produce defines who we are and what we believe in.

ACTIVITY 2

Find two landscape photographs that question social values or act as a metaphor for personal issues that the photographer is trying to express. Discuss whether the communication is clear or ambiguous and how this communication is conveyed.

Expressive techniques

Sweeping panoramas are not caught by the frame of a standard lens. When a wide angle lens is attached to include more of the panorama the resulting images may be filled with large areas of empty sky and foreground. This does little for the composition and can make the subject of interest seem far away and insignificant. The lens does not discriminate, recording everything within its field of vision. Painters recording a landscape have the option of eliminating information that would clutter the canvas or detract from the main subject matter. Unlike the painter, a photographer can only remove superfluous detail by using a carefully chosen vantage point or by moving in closer to reduce the information that is contained within the frame. If the photographer moves in too close, the feeling of the broader landscape is lost.

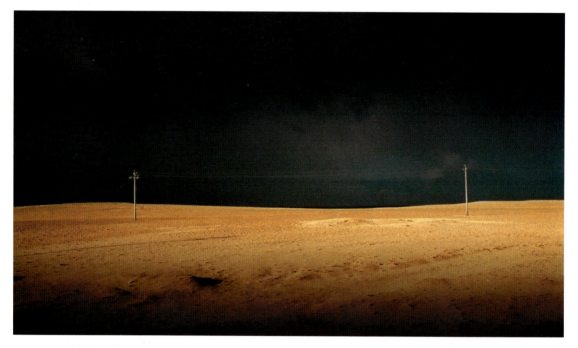

The Apostles - Mark Galer

Although it is difficult to communicate personal ideas or feelings and capture the mood of a location it is nevertheless possible and, when achieved, can be one of the most rewarding photographic experiences. Through increased awareness, careful observation and knowledge of the elements that create a successful landscape photograph the photographer can learn to achieve expressive and effective results consistently.

ACTIVITY 3

Compare and contrast a landscape photograph with a landscape painting.

Discuss the expressive possibilities of each medium using your examples to illustrate your argument.

Choose your examples carefully as representative of the medium.

Light

As previously stated in the chapter on light the use of low light is essential to increase the range of moods. The changes in contrast, hue and color saturation found in low light conditions can all be used to extend the expressive possibilities for the photographer.

Extreme brightness range

With an extreme brightness range the exposure between land and sky is often a compromise. Sky may become overexposed when detail is required in the land, land may become underexposed when detail is required in the sky. The brightness range can be controlled by filtration, shooting at an appropriate time of day and by using the camera RAW format. It is also possible to bracket exposures and merge the images in post-production (see *Photoshop CS2: essential skills* or *Digital Imaging: essential skills*).

Note > It is recommended to capture in RAW mode to exploit the full dynamic range that your image sensor is capable of as JPEG or TIFF processing in-camera may clip the shadow and highlight detail.

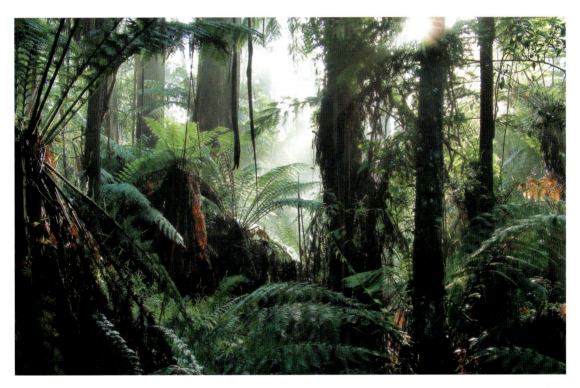

Mark Galer

Merge to HDR

New to Photoshop CS2 is the merge to HDR (High Dynamic Range) automated feature. A series of bracketed exposures can be selected and the Merge to HDR feature then aligns the images automatically. It is recommended that the photographer brackets the exposures using the shutter speed rather than the aperture for optimum results.

Composition

Composing subject matter is more than an aesthetic consideration. It controls the way we read an image and the effectiveness of the photographer's communication.

Format and horizon line

The most powerful design elements landscape photographers have to work with are choice of format and positioning of the horizon line. Most landscape images are horizontal or landscape format. The use of this format emulates the way we typically view the landscape. To further emulate the human vision we can crop to a wider image to reduce the viewer's sensation of viewing a truncated image. Many photographers make the mistake of over using the vertical or portrait format when faced with tall subject matter. The placement of the horizon line within the frame is also critical to the final design. A central horizon line dividing the frame into two halves is usually best avoided. The photographer should consider whether the sky or foreground is the more interesting element and construct a composition according to visual weight and balance.

Mark Galer

Open or closed landscape

By removing the horizon line from the image (through vantage point or camera angle) the photographer creates a closed landscape. In a closed landscape a sense of depth or scale may be difficult for the viewer to establish.

ACTIVITY 4

Create two photographs in a location with tall buildings or trees using both formats.
Create a closed and open landscape at one location.
Discuss the different ways we read the resulting images.

Depth

Including foreground subject matter introduces the illusion of depth through perspective and the image starts to work on different planes. Where the photographer is able to exploit lines found in the foreground the viewer's eye can be led into the picture. Rivers, roads, walls and fences are often used for this purpose.

By lowering the vantage point or angling the camera down, the foreground seems to meet the camera. A sense of the photographer in, or experiencing the landscape can be established. In the photograph below the beach and cliff walls are included along with the author's own footsteps to establish a sense of place.

Mark Galer

Mark Galer

ACTIVITY 5

Create a landscape utilizing foreground subject matter to create a sense of depth.
Discuss how the resulting image is likely to be read by the viewer.

Scale

Where the photographer is unable to exploit foreground interest it is common to include subject matter of known size. This gives the viewer a sense of scale which can often be lost in images that seemingly exist on only one plane. The lone figure on the summit of an active volcano in the photograph below adds not only a focal point of interest but also scale.

Mark Galer

Focal length

A wide angle lens is a favourite tool of the landscape photographer. It has the potential to create images with exaggerated perspective and greater depth of field. Foreground detail is vital to prevent empty images.

The telephoto lens is often overlooked when photographing landscape images. The photographer Andreas Feininger made a series of dramatic images of New York using very long telephoto lenses. Feininger did not like the distortion of scale when using wide angle lenses close to the subject matter. He preferred to photograph the correct relationship of scale by shooting at a distance with a longer lens.

Where a high vantage point has been found the compression of detail and subject matter can be used to create dramatic designs. Photographers working at a distance with long lenses should take precautions against overexposure due to excessive UV light. Slight underexposure and use of UV or Skylight filters is strongly recommended.

ACTIVITY 6

Create a landscape image with a wide-angle lens or telephoto lens.

Discuss the differences in communication and design compared to an image that would have been created using a standard lens.

Detail

The photographer can communicate more about the natural environment than just with images of the broad landscape. With more than one image cable of being stored on a memory card the photographer is not restricted to making a single carefully chosen statement about a natural landscape on a particular day. With keen visual awareness and close observation the photographer is able to move in close, isolate particular features, and build a more detailed impression of a location. By moving in close, depth of field is reduced, so aiding the photographer's attempt to isolate single features within a complex environment.

Mark Galer

Macro

Very small features may be photographed with the aid of a macro lens or a relatively inexpensive close-up lens. The close-up lens is screwed onto the front of an existing lens like a filter and is available in a range of dioptres. The photographer using macro capabilities to capture nature should be aware of the very shallow depth of field when shooting at wide apertures. Photographers using the smaller apertures can incur a number of problems. Extended shutter speeds may require the use of a tripod or monopod and any wind may cause the subject to blur.

Monopods are preferred by many who find the speed advantage over a tripod invaluable. An insect visiting a flower is often gone by the time the legs of a tripod are positioned. Many photographers specializing in this area of photography often resort to using wind breaks to ensure that the subject remains perfectly still during an extended exposure. These wind breaks can be constructed out of clear polythene attached to three or four wooden stakes so that a natural background can be retained. One or more of the sides can be a white translucent material that can act as a reflector or a diffuser to lower the contrast of harsh direct sunlight.

Night photography

One of the best times to take night photographs is not in the middle of the night but at dusk, before the sky has lost all of its light. The remaining light at this time of day helps to delineate the buildings and trees from the night sky.

Night photography is often seen as a technically demanding exercise. With a little extra equipment and a little knowledge however the pitfalls can easily be avoided. Use a tripod to brace the camera, a cable release to release the shutter (optional if using the self timer) and a flashlight to set controls of the camera. Raising the ISO and the use of very long exposures (over 1 second) can present 'noise' problems for prosumer cameras using smaller CCD sensors and some of the budget DSLRs.

Michael Wennrich

Using the camera's meter and histogram to calculate exposure

Set the camera to manual exposure mode. Frame part of the scene where the artificial lights will not overly influence the meter (avoid lights directed towards the camera and/or in the centre of the frame). If the reading is off the meter's scale try opening the aperture ('stopping up') or extending the shutter speed to establish a reading. Review the preliminary exposures using the camera's LCD screen and histogram. Bracket several exposures using the shutter speed. This will allow you to merge separate exposures using Photoshop's merge to HDR feature if the contrast exceeds the latitude or dynamic range of the sensor.

ACTIVITY 7

Create an image at an urban location during the twilight hour. Bracket your exposures.
Create an image where the twilight delineates the buildings and trees from the night sky.
Discuss your technique and the resulting communication.

The constructed environment

When Arthur Rothstein, FSA photographer, moved a skull a few metres for effect he, and the FSA, were accused of fabricating evidence and being dishonest. A photograph however is not reality. It is only one person's interpretation of reality. Rothstein perceived the skull and the broken earth at the same time and so he included them in the same physical space and photograph to express his emotional response to what he was seeing. Is this dishonest?

The photograph can act as both a document and as a medium for self expression. Truth lies in the intention of the photographer to communicate visual facts or emotional feelings. Sometimes it is difficult for a photograph to do both at the same time.

Andy Goldsworthy

The majority of photographers are content with responding to and recording the landscape as they find it. A few photographers however like to interact with the landscape in a more concrete and active way. Artists such as Andy Goldsworthy use photography to record these ephemeral interactions. Goldsworthy moves into a location without preconceived ideas and uses only the natural elements within the location to construct or rearrange them into a shape or structure that he finds meaningful. The day after the work has been completed the photographs are often all that remain of Goldsworthy's work. The photograph becomes both the record of art and a piece of art in its own right.

ACTIVITY 8

Make a construction or arrangement using found objects within a carefully selected public location. Create an image showing this structure or arrangement in context with its surroundings. Consider framing, camera technique and lighting in your approach.

What do you think your construction communicates about your environment?

Assignments

Produce six images that express your emotions and feelings towards a given landscape.

Each of the six images must be part of a single theme or concept and should be viewed as a whole rather than individually.

People may be included to represent humankind and their interaction with the landscape. The people may become the focal point of the image, but this is not a character study or environmental portrait where the location becomes merely the backdrop.

1. Wilderness.
2. Seascape.
3. Suburbia.
4. Sandscape.
5. Inclement weather.
6. The city or city at night.
7. Mountain.
8. Industry.
9. Arable land.

RESOURCES

A Collaboration with Nature - Andy Goldsworthy. Abrams. New York. 1990.

Ansel Adams: Classic images. New York Graphic Society. 1986.

On Photography - Susan Sontag. Picador. 2001.

Inscape - John Blakemore. Art Books Intl. Ltd. 1991.

In This Proud Land - Roy Emerson Stryker. New York Graphic Society. New York. 1973.

Land - Faye Godwin. Heinemann. London. 1985.

Naturalistic Photography for Students of the Art - P. H. Emerson. Arno Press. NY. 1973.

Small World - Martin Parr. Dewi Lewis Publications. 1995.

The History of Photography: an overview - Alma Davenport. Focal Press. 1991.

The Photograph - Graham Clarke. Oxford University Press. 1997.

The Story of Photography - Michael Langford. Focal Press. Oxford. 1997.

Walker Evans: Masters of Photography (2nd edition). Aperture. 1997.

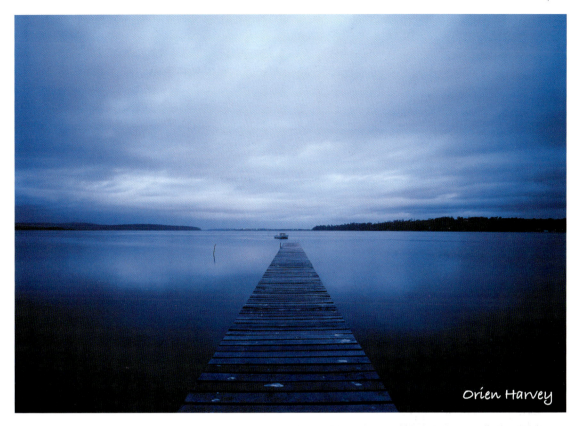

Orien Harvey

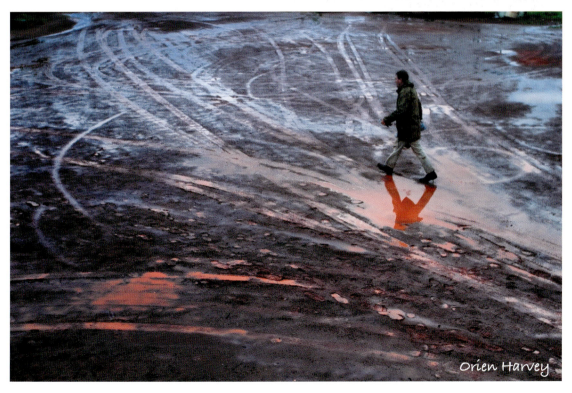

Orien Harvey

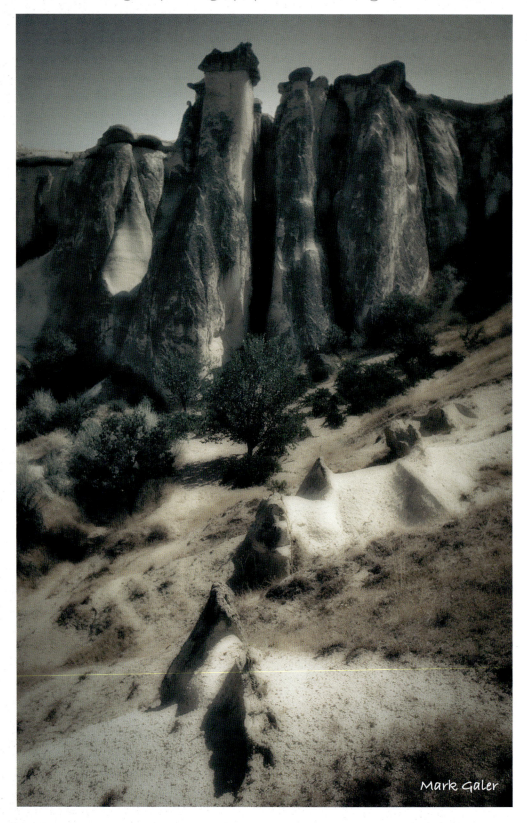

Mark Galer

digital

environmental portraits

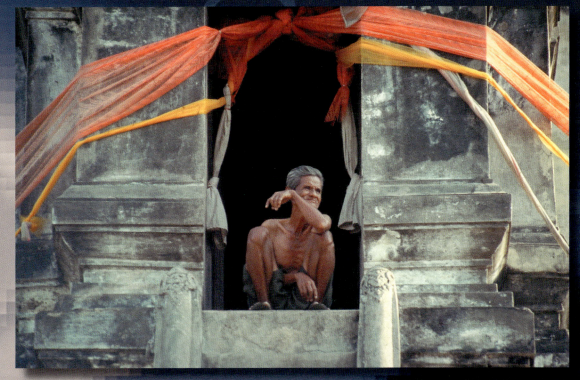

Mark Galer

essential skills

~ Develop an increased awareness of the actions and interactions of a broad spectrum of people.

~ Develop personal skills in directing people.

~ Develop essential technical skills to work confidently and fluently.

~ Produce images through close observation and selection that demonstrate both a comfortable working relationship with people at close range and appropriate design and technique.

Introduction

The craft of representing a person in a single still image or 'portrait' is to be considered a skilled and complex task. The photographic portrait (just as the painted portrait that influenced the genre) is not a candid or captured moment of the active person but a crafted image to reveal character. The person being photographed for a portrait should be made aware of the camera's presence even if they are not necessarily looking at the camera when the photograph is made. This requires that the photographer connects and communicates with any individual if the resulting images are to be considered portraits. Portraits therefore should be seen as a collaborative effort on the part of the photographer and subject. A good photographic portrait is one where the subject no longer appears a stranger.

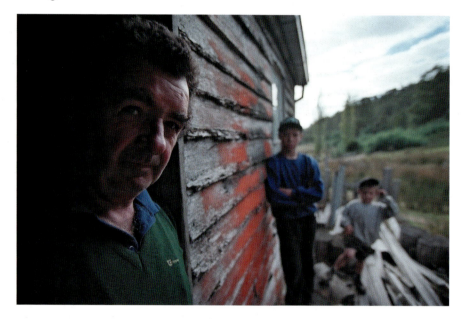

Orien Harvey

The physical surroundings and conditions encountered on location whilst making a portrait image offer enormous potential to extend or enhance the communication. Just as facial expression, body posture and dress are important factors, the environment plays a major role in revealing the identity of the individual. The environmental portrait for this reason has become a genre in its own right. Environmental portraits are produced commercially for a number of reasons. The environmental portrait may be produced to stand alone to illustrate an article about a person that is of public interest. It may also be the central or key image of a collection of images that together form a photo-essay or social documentary.

ACTIVITY 1

Look through assorted publications and collect two images where the environment plays an important role in determining an aspect of the subject's character or identity.
Discuss how the subject relates to the environment in each image.

Design

In order for the photographer to reveal the connection between the subject and the environment the photographer must carefully position or frame the two elements together. Vantage point, cropping and choice of scale become critical factors in the design. The relationship and connection between foreground and background becomes a major design consideration for an environmental portrait.

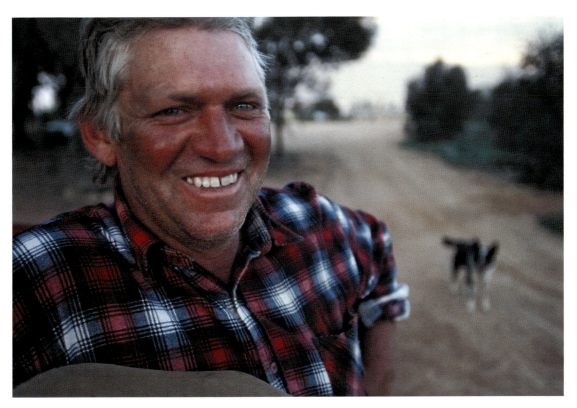

Orien Harvey

Format

The choice of vertical or horizontal framing and the placement of the subject within the frame will affect the quantity of environmental information that can be viewed in the resulting image. A centrally placed subject close to the camera will marginalize the environmental information. This framing technique is more difficult to utilize but should not be ruled out for creating successful environmental portraits. Using the portrait format for environmental portraits usually requires the photographer to move further back from the subject so that background information is revealed.

ACTIVITY 2

Find two environmental portraits that demonstrate the different ways a photographer has framed the image to alter meaning or content. Discuss the photographer's vantage point, use of scale, depth of field and subject placement in all of the images.

Composing two or more people

Composing two or more people within the frame for an environmental portrait can take considerable skill. People will now relate with each other as well as with the environment. The physical space between people can become very significant in the way we read the image. For a close-up portrait of two people the space between them can become an uncomfortable design element. Careful choice of vantage point or placement of the subjects is often required to achieve a tight composition making optimum use of the space within the frame.

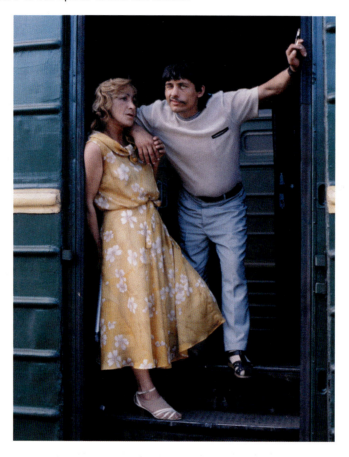

Mark Galer

The situation most often encountered is where two people sit or stand side by side, shoulder to shoulder. If approached face on (from the front) the space between the two people can seem great. This can be overcome by shooting off to one side or staggering the individuals from the camera. The considerations for design are changed with additional subjects.

ACTIVITY 3

Collect two environmental portrait images with two to five subjects.
In at least one image the subject should have been placed in the foreground.
Comment on the arrangement of the subjects in relation to the camera and the effectiveness of the design.

Depth of field

Sophisticated digital cameras usually provide a 'Portrait Mode'. When this program mode is selected a combination of shutter speed and aperture is selected to give the correct exposure and a visual effect deemed suitable for portrait photography by the camera manufacturers. The visual effect aimed for is one where the background is rendered out of focus, i.e. shallow depth of field. This effect allows the subject to stand out from the background, reducing background information to a blur. Although this effect may be pleasing for some portrait images it is not suitable for most environmental portraits where more information is required about the physical surroundings and environment. The photographer intending to shoot environmental portraits is recommended to use aperture priority or manual in most situations so that maximum control is maintained.

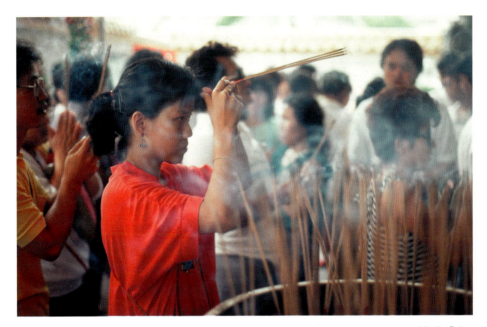

Mark Galer

Portrait lenses

Some lenses of a certain focal length are often referred to as 'portrait lenses'. The 'ideal' portrait lens is considered by the manufacturers to be a medium telephoto lens such as a 135mm lens (or equivalent) for a DSLR camera. This lens provides a visual perspective that does not distort the human face when recording head and shoulder portraits. The problem of distortion however is not encountered with shorter focal length lenses if the photographer is not working quite so close to the subject. To record environmental portraits with a telephoto lens would require the photographer to move further away from the subject and possibly lose the connection with the subject that is required. Standard and wide angle lenses are suitable for environmental portraiture.

ACTIVITY 4

Photograph the same subject varying both the depth of field and focal length of lens.
Discuss the visual effects of each image.

Revealing character

Significant and informative details can be included within the frame with the subject. These details may naturally occur in the environment or be introduced for the specific purpose of strengthening the communication. Connections may be made through the 'tools of the trade' associated with the individual's occupation. Informative artifacts such as works of art or literature may be chosen to reflect the individual's character. Environments and the lighting may be chosen to reflect the mood or state of mind of the subject.

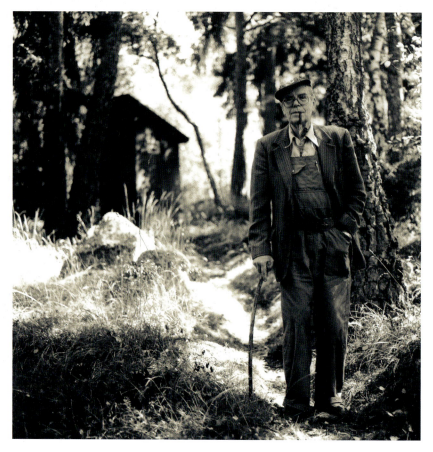

Ann Ouchterlony

The objects or subject matter chosen may have symbolic rather than direct connection to the subject. In the above image the bent walking stick of the old man and the path travelled could be seen to represent the journey of life.

ACTIVITY 5

Compose one image considering carefully the inclusion or juxtaposition of significant or informative detail.
Describe the importance of the additional information and how it is likely to be read by the viewer.

Connecting with new people

The shift from receptive observer to active participant can sometimes be awkward and difficult for both the potential subject and the photographer. These feelings of awkwardness, embarrassment or even hostility may arise out of the subject's confusion or misinterpretation over the intent or motive behind the photographer's actions. The photographer's awkwardness or reticence to connect often comes from the fear of rejection.

Stephen Rooke

The initial connection with the subject is crucial for a successful environmental portrait. If the photographer is taking images at an event or activity the photographer must be very aware when someone within the frame makes eye contact with the camera. At this decisive moment the posture and facial expression usually remains unchanged from where the subject's attention was previously engaged. The photographer should be able to capture a single frame at this moment before lowering the camera. There is no time for re-focusing, re-framing and adjusting exposure. The camera should be lowered and a friendly and open response offered by the photographer. If the photographer continues to observe the subject after having been noticed the subject's sense of privacy can be invaded and the photographer's chance for an amicable contact can be lost. Most people will gladly cooperate if a friendly connection has first been established.

Contact

The first verbal connection with the subject should be considered carefully. Asking people for their permission to be photographed requires a considered response on the subject's behalf ('What are they selling?' and 'Who will see the picture?' etc.). Unsure of the implications of consenting to be photographed many people will refuse their permission. Once refused it is not always possible to persuade someone that their acceptance to be photographed would have no further implications, i.e. they would not be required to purchase the photograph, give consent for publication etc. The first verbal connection should simply be who you are.

Familiarity

Many photographers will arrange a preliminary visit to a location if there is time available. This will afford individuals present at the location to get used to the photographer's presence and feel comfortable being photographed. This is especially useful at small or enclosed events, as it may be difficult for the photographer to work unnoticed. If introductions haven't first been made the photographer may cause some disruption at the event or activity. Successful environmental portraits are often dependent on the initial interactions the photographer has with the potential subject.

Interaction

Putting a subject at ease in front of the camera is dependent on two main factors.

> 1. The subject is clear about the photographer's motive.

> 2. The subject sees value in the photographs being made.

Motive

Many people view an unknown photographer with curiosity or suspicion. Who is the photographer and why are they taking photographs? It is essential that the photographer learns to have empathy with the people he/she intends to photograph. A brief explanation is therefore necessary to help people understand that the photographer's intentions are harmless.

Value

Many people see the activity or job that they are doing as uninteresting or mundane. They may view their physical appearance as non photogenic. The photographer needs to explain to the subject what it is that he/she finds interesting or of value and why. If the activity the subject has been engaged in appears difficult or demanding and requires skill, patience or physical effort, the photographer should put this view forward. The photographer should continue to ask questions whilst photographing so that the subject is reassured that the interest is genuine.

Directing the subject

The photographer should display an air of confidence and friendliness whilst directing subjects. Subjects will feel more comfortable if the photographer clearly indicates what is expected of them. There can be a tendency for inexperienced photographers to rush an environmental portrait. The photographer may feel embarrassed, or feel that the subject is being inconvenienced by being asked to pose. The photographer should clarify that the subject does have time for the photograph to be made and indicate that it may involve more than one image being created. A subject may hear the camera shutter and presume that one image is all that is required.

Passive subject

Subjects should be directed to pause from the activity that they were engaged in. The photographer can remain receptive to the potential photographic opportunities by keeping the conversation focused on the subject and not oneself.

Expression and posture

Often a subject will need reminding that a smile may not be necessary. Subjects may need guidance on how to sit or stand, what they should do with their hands and where to look. It may be a simple case of just reminding them how they were standing or sitting when you first observed them.

Shooting decisively

As a photographer takes longer to take the picture the subject will often feel more and more uncomfortable about their expression and posture. To freeze human expression is essentially an unnatural act. Exposure, framing and focus should all be considered before raising the camera to the eye.

Stephen Rooke

ACTIVITY 6

Connect with someone new and create three environmental portraits.
At least one image should demonstrate how you have directed them towards a relaxed expression and body posture.
Discuss the process of direction.

Character study

Environmental portraits often stand alone in editorial work but can also form part of a larger body of work. A series of environmental portraits may be taken around a single character, or characters, connected by profession, common interest or theme.

With additional images the photographer is able to vary the content and the style in which the subject is photographed to define their character within the study. The photographer may choose to include detail shots such as hands or clothing to increase the quality of information to the viewer. The study may also include images which focus more on the individual (such as a straight head and shoulders portrait) or the environment to establish a sense of place.

Sean Killen

The images above show the diversity of approach to present the character of a single individual. The images are of Martin, a homeless individual who lived under a bridge in Melbourne and who sold copies of *The Big Issue* to support himself.

ACTIVITY 7

Collect one photographic essay where the photographer has varied the content of the images to define the character or characters of the individual or individuals.

Describe the effectiveness of the additional images that are not environmental portraits.

Assignments

Produce six environmental portraits giving careful consideration to design, technique and communication of character. At least one of the images should include more than one person. Choose one category from the list below.

1. Manual labourers dockers, builders, mechanics, bakers etc.
2. Professional people...................................... doctors, nurses, lawyers etc.
3. Craftsmanship............................ potters, woodworkers, violin makers etc.
4. Club or team members footballers, golfers, scouts etc.
5. Corporate image................................. business consultants, bankers etc.
 This study should include three environmental portraits,
 two images of close-up detail and one portrait.
6. Character study .. celebrity, politician, busker etc.
 This study should include three environmental portraits,
 two images of close-up detail and one close-up portrait.

RESOURCES

Editorial:
National Geographic
Newspapers and magazines

Books:
Arnold Newman - TASCHEN America Llc. 2000.
August Sander: 1876-1964. TASCHEN America Llc. 1999.
Brandt: The Photography of Bill Brandt. Harry N Abrams. 1999.
East 100th Street - Bruce Davidson. St Ann's Press. 2003.
Immediate Family - Sally Mann. Aperture. 1992.
Karsh: A Biography in Images. MFA Publications. 2004.
Portraits - Steve McCurry. Phaidon Press Inc. 1999.
Pictures of People - Nicholas Nixon. Museum of Modern Art. New York. 1988.
Richard Avedon Portraits. Harry N Abrams. 2002.
The Brown Sisters - Nicholas Nixon. Museum of Modern Art. New York. 2002.
The Photographs of Dorothea Lange. Hallmark Cards. 1996.
Women - Annie Liebowitz and Susan Sontag. Random House. 1999.

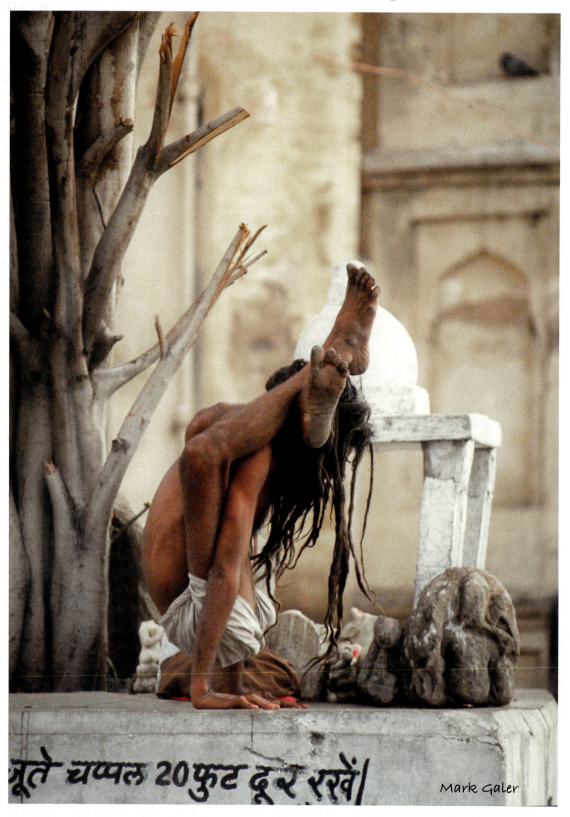

Mark Galer

the photographic essay

Andrew Goldie

essential skills

- ~ Increase knowledge of the historical development of the photographic essay.
- ~ Understand visual communication through narrative techniques.
- ~ Develop an awareness of receptive and projective styles of photography.
- ~ Understand the process of editing to clarify or manipulate communication.
- ~ Increase awareness of commercial, ethical and legal considerations.
- ~ Capture and/or create images to communicate a specific narrative and edit the work collaboratively.

Introduction

The purpose of constructing a photographic essay is to communicate a story through a sequence of images to a viewer. Just as in writing a book, a short story or a poem the photographer must first have an idea of what they want to say. In a photographic essay it is the images instead of words that must be organized to tell the story. Individual images are like descriptive and informative sentences. When the images are carefully assembled they create a greater understanding of the individual, event or activity being recorded than a single image could hope to achieve. Words should be seen as secondary to the image and are often only used to clarify the content.

The Vet - Michael Mullan

The first stories

In 1890 the photographer Jacob Riis working in New York produced one of the earliest photographic essays titled 'How the other half lives'. *National Geographic* magazine began using photographs in 1903 and by 1905 they had published an eleven-page photographically illustrated piece on the city of Lhassa in Tibet. In 1908 the freelance photographer Lewis W. Hine produced a body of work for a publication called *Charities and the Commons*. The photographs documented immigrants in the New York slums. Due to the concerned efforts of many photographers working at this time to document the 'human condition' and the public's growing appetite for the medium, photography gradually became accepted. The first 'tabloid newspaper' (the *Illustrated Daily News*) appeared in the USA in 1919. By this time press cameras were commonly hand-held and flash powder made it possible to take images in all lighting conditions.

'I saw and approached the hungry and desperate mother, as if drawn by a magnet. I do not remember how I explained my presence or my camera to her, but I do remember she asked me no questions. I made five exposures, working closer and closer from the same direction. I did not ask her name or her history. She told me her age, that she was thirty-two. She said that they had been living on frozen vegetables from the surrounding fields, and birds that the children killed. She had just sold the tires from her car to buy food. There she sat in that lean-to tent with her children huddled around her, and seemed to know that my pictures might help her, and so she helped me. There was a sort of equality about it.' Dorothea Lange from: Popular Photography, Feb. 1960.

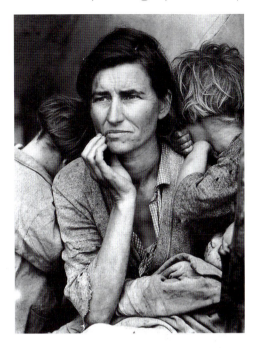

Migrant Mother - Dorothea Lange

FSA

The 1930s saw a rapid growth in the development of the photographic story. During this decade the Farm Security Administration (FSA) commissioned photographers to document America in the grip of a major depression. Photographers including Russell Lee, Dorothea Lange, Walker Evans and Arthur Rothstein took thousands of images over many years. This project provides an invaluable historical record of culture and society whilst developing the craft of documentary photography.

The photo agencies

In the same decade *Life magazine* was born along with a host of like-minded magazines. These publications dedicated themselves to showing 'life as it is'. Photographic agencies were formed in the 1930s and 1940s to help feed the public's voracious appetite for news and entertainment. The greatest of these agencies Magnum was formed in 1947 by Henri Cartier-Bresson, Robert Capa, Chim (David Seymour) and George Rodger. Magnum grew rapidly with talented young photographers being recruited to their ranks. The standards for honesty, sympathetic understanding and in-depth coverage were set by such photographers as W. Eugene Smith. Smith was a Life photographer who produced extended essays staying with the story until he felt it was an honest portrayal of the people he photographed. He went on to produce the book *Minamata* about a small community in Japan who were being poisoned by toxic waste being dumped into the waterways where the people fished. This was and remains today an inspirational photo-essay.

ACTIVITY 1

Research a photographic story that was captured by either an FSA photographer or a photographer working for the Magnum photo agency.
What do the images communicate about the human condition?

Visual communication

Photographic stories are the visual communication of personal experience, as such each story is potentially unique and is the ideal vehicle for personal expression. To communicate coherently and honestly the photographer must connect with what is happening. To connect the photographer should research, observe carefully, ask questions and clarify the photographer's personal understanding of what is happening. Unless the photographer intends to make the communication ambiguous it is important to establish a point of view or have an 'angle' for the story. This can be achieved by acknowledging feelings or emotions experienced whilst observing and recording the subject matter. All images communicate and most photographers aim to retain control of this communication. Photography can be used as a powerful tool for persuasion and propaganda and the communication of content should always be the primary consideration of the photographer.

Kim Noakes

Choosing a subject

The most popular subject for the photographic story has always been the 'human condition'. This is communicated through experience-based discovery. The aim is to select one individual or group of individuals and relate their story or life experience to the viewer. The story may relate the experience of a brief or extended period of time.

Finding a story, gaining permission to take images and connecting with the individuals once permission has been granted are some of the essential skills required to produce a successful story. Tracking down a story often requires curiosity, perseverance, motivation and patience. These skills are required by the majority of professional photojournalists who are freelance. Freelance photographers find, document and sell their own stories.

The comfort zone

The 'comfort zone' is a term used to describe the familiar surroundings, experiences and people that each of us feel comfortable in and with. They are both familiar and undemanding of us as individuals. Photography is an ideal tool of exploration which allows us to explore environments, experiences and cultures other than our own. For professional photojournalists this could be attending the scene of a famine or a Tupperware party.

Orien Harvey

A photographer may feel they have to travel great distances in order to find an exotic or unusual story. Stories are, however, much closer at hand than most people realize. Interesting stories surround us. Dig beneath the surface of any seemingly bland suburban population and the stories will surface. People's triumphs, tragedies and traumas are evolving every day, in every walk of life. The interrelationships between people and their environment and their journey between birth and death are the never ending, constantly evolving resource for the documentary photographer. The photographer's challenge is to find and connect in a non-threatening and sympathetic way to record this. The photojournalist should strive to leave their personal 'comfort zone' in order to explore, understand and document the other. The photographer should aim to become proactive rather than waiting to become inspired and find out what is happening around them.

ACTIVITY 2

Find two meaningful photographic stories containing at least four images.
What is being communicated in each story?
Have the captions influenced your opinion about what is happening?
Could a different selection of images alter the possible communication?
Make a list of five photo-essays you could make in your own home town.
Describe briefly what you would hope to find out and communicate with your images.

Capturing a story

How many movies have you seen where the opening scene begins with a long and high shot of a town or city and moves steadily closer to isolate a single street or building and then a single individual. This gives the viewer a sense of the place or location that the character inhabits. A story constructed from still images often exploits the same technique. To extend and increase the communication of a series of images the photographer should seek to vary the way in which each image communicates. There is a limit to the communication a photographer can achieve by remaining static, recording people from only one vantage point. It is essential that the photographer moves amongst the people exploring a variety of distances from the subject. Only in this way will the photographer and the viewer of the story fully appreciate and understand what is happening.

The photographer should aim to be a witness or participant at an activity or event rather than a spectator.

Vietnam Vet Motorcycle Club at the Shrine of Remembrance, Melbourne

The images that create a well-crafted photographic story can usually be divided or grouped into four main categories. Not all stories contain images from all four categories but many editors expect to see them. The categories are:

1. Establishing image.
2. Action image.
3. Portraits.
4. Close-up or detail image.

Establishing image

In order to place an event, activity or people in context with their environment it is important to step back and get an overview. If the photographer's essay is about a small coal-mining community in a valley, the viewer needs to see the valley to get a feeling for the location. This image is often referred to as the establishing image but this does not necessarily mean that it is taken or appears first in the story. Often the establishing image is recorded from a high vantage point and this technique sets the stage for the subsequent shots. In many stories it can be very challenging to create an interesting establishing image. An establishing image for a story about an animal refuge needs to be more than just a sign in front of the building declaring this fact. The photographer may instead seek out an urban wasteland with stray dogs and the dog catcher to set the scene or create a particular mood.

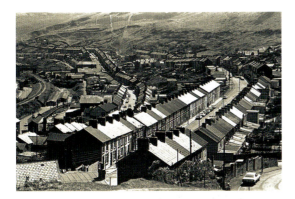

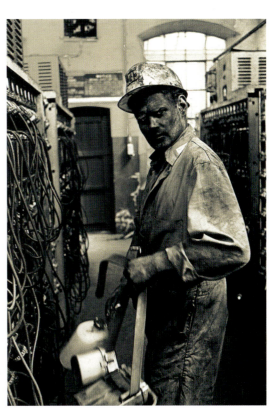

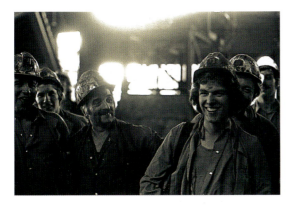

Coal mine in the Rhondda valley

Action image

This category refers to a medium-distance image capturing the action and interaction of the people or animals involved in the story. Many of the images the photographer captures may fall into this category, especially if there is a lot happening. It is, however, very easy to get carried away and shoot much more than is actually required for a story to be effective. Unless the activity is unfolding quickly and a sequence is required the photographer should look to change the vantage point frequently. Too many images of the same activity from the same vantage point are visually repetitive and will usually be removed by an editor.

Portraits

Portraits are essential to any story because people are interested in people and the viewer will want to identify with the key characters of the story. Unless the activity the characters are engaging in is visually unusual, bizarre, dramatic or exciting the viewer is going to be drawn primarily to the portraits. The portraits and environmental portraits will often be the deciding factor as to the degree of success the story achieves. The viewer will expect the photographer to have connected with the characters in the story and the photographs must illustrate this connection. Portraits may be made utilizing a variety of different camera distances. This will ensure visual interest is maintained. Environmental portraits differ from straight head and shoulder portraits in that the character is seen in the location of the story. The interaction between the character and their environment may extend the communication beyond making images of the character and location separately.

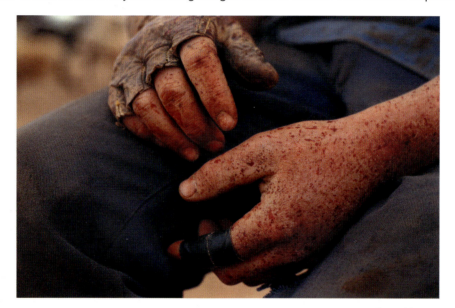

Orien Harvey

Close-up or detail image

The final category requires the photographer to identify significant detail within the overall scene. The detail is enlarged either to draw the viewer's attention to it or to increase the amount or quality of this information. The detail image may be required to enable the viewer to read an inscription or clarify small detail. The detail image in a story about a craftsperson who works with their hands may be the hands at work, the fine detail of the artifact they have made or an image of a vital tool required for the process. When the detail image is included with images from the other three categories visual repetition is avoided and the content is clearly communicated.

ACTIVITY 3

Find one photographic story that contains images from all four categories listed.

How does each image contribute to the story?

Describe alternative images for each of the categories in the story you have chosen?

Working styles

The photographer working on a story often has to switch between creating images (portraits, overall and detail images) and capturing images (action or decisive images). The styles of working are very different, each requiring a different mind-set, and photographers can find the switch between the two uncomfortable. Many photographers tackle the different images required for a photographic essay separately rather than alternating between the two styles of work.

Receptive

Decisive images and action shots require a receptive approach where the photographer is focused solely on the environment and the activities, facial expressions or mannerisms of the characters. The photographer working receptively is not looking for specific images but is accepting circumstances 'as they are'. The photographer aims to increase their awareness of the activities and their surroundings as they change or unfold, many of the resulting images being photographed 'intuitively'.

The ability to photograph intuitively rests on the degree of familiarity photographers have with their equipment. Many professional photojournalists are able to operate their cameras instinctively without even looking to change shutter, aperture and exposure compensation controls. The camera becomes an extension of the hand and eye and the photographer is primarily concerned with seeing images rather than with the equipment necessary to capture them.

Moving in close

The standard equipment for a photojournalist is a DSLR camera equipped with a wide angle lens. Many photographers choose a fixed focal length lens rather than a zoom for the advantage that the wider maximum apertures afford in low light. Wide angle lenses are chosen above standard and telephoto lenses due to the steep or dramatic perspective they give the images when working very close to the subject (see page 90). The steep perspective and the relative position of the photographer to the action has the effect of involving the viewer. Viewers feel like participants rather than spectators.

ACTIVITY 4

Research a photographic essay where the photographer has made extensive use of a wide angle lens.
Discuss the composition and communication of each image.
Without resorting to the use of telephoto lenses, take ten images of people engaged in a group activity.
Create depth by the use of foreground, middle distance and distant subject matter.
Make use of edge of frame detail to create the feeling of involvement.

The photographer's presence

When the photographer is working at close range it is worth considering the impact this presence has on the event or activity being photographed. Most photojournalists practice the art of working unobtrusively to minimize the effect on their surroundings. This can be achieved in the following ways:

~ Raise the camera to take the image not to find the image.
~ Be decisive, don't procrastinate.
~ Minimize the amount of equipment being carried - two bodies and three lenses is sufficient.
~ Carry the camera in the hand rather than around the neck - use a wrist strap or the neck strap wrapped around the wrist.
~ Reduce the size of the camera bag and do not advertise the cameras that are inside.
~ Use the available light present - use a high ISO, image stabilization and fast lenses rather than flash.
~ Choose appropriate clothing for the location or company that you are in.
~ Move with the activity.
~ Familiarize yourself with the location and/or the people prior to capturing the images.

Shooting ratios

A photographer capturing images spontaneously should not expect to contribute all of the images to the final story. This will lead to undershooting and missed opportunities. The photographer cannot hope to wait for the single most dramatic moment of the event or activity before releasing the shutter. This would lead to a projective approach that is used when a photographer is creating rather than capturing images. The photographer cannot control events only predict them as they are about to happen. Recording images as an event unfolds or as the photographer changes vantage point means that many images will be captured that will be not be used. This is called a 'shooting ratio'. For every image used, ten may be discarded as unnecessary to the narrative of the story (a shooting ratio of 1:10). The value of each image is not assessed as it is captured but later during the editing process. The unused images are not to be seen as wasted or failed images but as part of the working process of photojournalism.

ACTIVITY 5

Make a list of the ideal range of equipment you would take to record a crowded event in a foreign country where spontaneous and decisive images are required.
List brand names and the cost of each item new or second-hand.
List the cost of insuring these items against 'all risks' and theft from a locked room or vehicle.
Indicate how you would review the images on location at the end of each day to monitor your progress.

Projective

In creating images the photographer is able to plan and arrange either the timing, the subject matter or location so that the resulting imagery fits the photographer's requirements for communication of content. Photographers illustrate what is often in their mind's-eye.

To create images in collaboration with the characters of the story a connection must be made. For this to happen the photographer must overcome the fear that most people have about talking to strangers. It is a little like door to door sales. The first contact is always the most nerve racking. The more you connect, the easier it becomes.

Shane Bell

An honest document

Some people find the projective approach (used by many photojournalists) controversial, and do not like the degree of manipulation involved in assembling a story which is claiming to be an accurate and honest record or document. On the other hand all photographs are a manipulation of reality to some degree. The selection of timing and framing is a manipulation in itself. As soon as a character within a story makes eye contact with the photographer the event has been changed or manipulated. Without manipulation and interaction the resulting stories can appear detached and shallow. Each individual photographer must weigh up the advantages and disadvantages of working in a projective style. The photographer must personally feel comfortable that the story being created is an accurate translation of events, people and circumstances. Photographs are however just that, a translation, and each story teller will tell their tale differently.

Editing a story

The aim of editing work is to select a series of images from the total production to narrate an effective story. Editing can be the most demanding aspect of the process requiring focus and energy. The process is a compromise between what the photographer originally wanted to communicate and what can actually be said with the images available.

Editorial objective

The task of editing is often not the sole responsibility of the photographer. The task is usually conducted by an editor or in collaboration with an editor. The editor considers the requirements of the viewer or potential audience whilst selecting images for publication.

The editor often has the advantage over the photographer in that they are less emotionally connected to the content of the images captured. The editor's detachment allows them to focus on the ability of the images to narrate the story, the effectiveness of the communication and the suitability of the content to the intended audience.

The process

Images are viewed initially as a collective. A typical process is listed as follows:

- ~ All images are viewed as thumbnails in the image editing software
- ~ All of the visually interesting images and informative linking images are selected or ranked and the rest are hidden from view.
- ~ Similar images are grouped together and the categories (establishing, action, portrait and detail) are formed.
- ~ Images and groups of images are placed in sequence in a variety of ways to explore possible narratives.
- ~ The strength of each sequence is discussed and the communication is established.
- ~ Images are selected from each category that reinforce the chosen communication.
- ~ Images that contradict the chosen communication are removed.
- ~ Cropping and linking images are discussed and the final sequence established.

ACTIVITY 6

Create at least 20 images of a chosen activity or event taking care to include images from all of the four categories discussed in this chapter.

Edit the work with someone who can take on the role of an editor.

Edit and sequence the images to the preference of the photographer and then again to the preference of the editor.

Discuss the editing process and the differences in outcome of both the photographer's and editor's final edit.

Ethics and law

Will the photograph of a car crash victim promote greater awareness of road safety, satisfy morbid curiosity or just exploit the family of the victim? If you do not feel comfortable photographing something, question why you are doing it. A simple ethical code of practice used by many photographers is: 'The greatest good for the greatest number of people.'

Paparazzi photographers hassle celebrities to satisfy public curiosity and for personal financial gain. Is the photographer or the public to blame for the invasion of privacy?

The first legal case for invasion of privacy was filed against a photographer in 1858. The law usually states that a photographer has the right to take a picture of any person whilst in a public place so long as the photograph:

~ is not used to advertise a product or service;
~ does not portray the person in a damaging light (called defamation of character).

If the photographer and subject are on private property the photographer must seek the permission of the owner. If the photograph is to be used for advertising purposes a model release should be signed.

Other legal implications usually involve the sensitivity of the information recorded (military, political, sexually explicit etc.) and the legal ownership of copyright. The legal ownership of photographic material may lie with the person who commissioned the photographs, published the photographs or the photographer who created them. Legal ownership may be influenced by country or state law and legally binding contracts signed by the various parties when the photographs were created, sold or published.

Digital manipulation

Images are often distributed digitally which allows the photographer or agency to alter the images subtly in order to increase their commercial potential. Original image files may never be sighted by an editor. A photographer, agency or often the publication itself may enhance the sharpness, increase the contrast, remove distracting backgrounds, remove information or combine several images to create a new image. What is legally and ethically acceptable is still being established in the courts of law. The limits for manipulation often rests with the personal ethics of the people involved.

ACTIVITY 7

Discuss the ethical considerations of the following:

~ Photographing a house fire where there is the potential for loss of life.
~ Photographing a celebrity, who is on private property, from public property.
~ Manipulating a news image to increase its commercial viability.

Distribution and sale of photo-essays

The majority of photojournalists are either freelance or work for agencies. Freelance photographers are commissioned to cover stories for a wide variety of media and corporate publications. Photojournalists also self assign. They seek out and research possible commercial stories and then sell the finished piece to a publication. Many photographers contact publications with the idea or concept for a story before taking the images. They complete the story when they find a publication interested in the idea. Newspapers cannot hope to cover all world news and feature stories using staff photographers only. They therefore rely heavily on input from freelance photographers. The material is brought in from photo and news agencies, wire services, stock libraries and through direct contact with photographers.

In order to succeed a freelance photojournalist usually requires the following skills:

- ~ Curiosity, self motivation and patience to find and complete a story.
- ~ Knowledge of publications currently buying photographic material (a media directory with contact names, addresses and circulation is usually available in large libraries).
- ~ Commercial requirements for stories (these include image format, publication deadlines, content, length, style and copy).

Titles and copy

All images require an image description prior to submission. This can be achieved by entering Metadata into the image files using your editing software. Metadata should include the following information:

- ~ Location and date.
- ~ A brief description of the content including names of people.
- ~ Photographer's name.
- ~ Contact details and copyright information

Accompanying copy is sometimes prepared by a staff writer working from the factual information provided by the photographer or is submitted by the photographer along with the images. Photographers often team up with a writer on projects and submit the work as a team effort. The average length of each story and the style for written copy (humorous, factual etc.) needs to be researched prior to submission.

ACTIVITY 8

Research possible distribution and sale of a photo-essay.

Locate one local photo-agency, one stock library and one photographic archive.

Research the possibility of submitting one essay or image to a magazine to which you currently subscribe.

Assignments

Produce a ten image photo-essay giving careful consideration to communication and narrative technique. For each of the five assignments it is strongly recommended that you:

~ Treat each assignment as an extended project.
~ Choose activities, events or social groups that are repeatedly accessible.
~ Avoid choosing events that happen only once or run for a short period of time.
~ Approach owners of private property in advance to gain relevant permission.
~ Have a back-up plan should permission be denied.
~ Introduce yourself to organisers, key members or central characters of the story.

1. Document manual labour or a profession.
2. Document a minority, ethnic or fringe group in society.
3. Document an aspect of modern culture.
4. Document an aspect of care in the community.
5. Document a political or religious group.

RESOURCES

Books:

American Photographers of the Depression - Charles Hagen. Thames and Hudson. 1991.
Don McCullin. Jonathon Cape. 2003.
Farewell to Bosnia - Gilles Peress. Scalo. New York. 1994.
In This Proud Land - Stryker and Wood. New York Graphic Society. New York. 1973.
Minamata - W. Eugene and Aileen Smith. Chatto and Windus. London. 1975.
Sleeping with Ghosts - Don McCullin. Vintage. London. 1995.
Terra: Struggle of the Landless. Phaidon Press. 1998.
The Concerned Photographer 2 - Cornell Capa. Viking Press. 1973.
The Photographs of Dorothea Lange. Hallmark Cards. 1996.
Workers - Sebastião Salgado. Phaidon Press. London. 1993.

Magazine:
National Geographic magazine.

Websites:
Black Star photo agency - http://www.blackstar.com
FSA - http://lcweb2.loc.gov/ammem/fsowhome.html
Magnum Photo Agency - http://www.magnumphotos.com

Mark Galer

glossary

Adjustment layer — Image adjustment placed on a layer above the background layer.
Ambient — Available or existing light.
Analyse — To examine in detail.
Aperture — Lens opening controlling intensity of light entering camera.
Aspect ratio — The ratio of height to width.
Auto focus — Automatic focusing system.
Available — Ambient or existing light.

Background — Area behind main subject matter.
Backlight — Light source directed at the subject from behind.
Backlit — A subject illuminated from behind.
Balance — A harmonious relationship between elements within the frame.
Banding — Visible steps of tone or color in the final image due to a lack of tonal information in a digital image file.
Bit — Short for binary digit, the basic unit of the binary language.
Bit depth — Number of bits (memory) assigned to recording color or tonal information.
Blend mode — The formula used for defining the mixing of a layer with those beneath it.
Blurred — Unsharp image, caused by inaccurate focus, shallow depth of field, slow shutter speed, camera vibration or subject movement.
Body copy — Written word, main content of advertisement.
Bounce — Reflected light.
Bracketing — Overexposure and underexposure either side of MIE.
Brightness value — The value assigned to a pixel to define the relative lightness of a pixel.
Byte — Eight bits. Standard unit of data storage containing a value between 0 and 255.

Cable release — Device to release shutter, reduces camera vibration.
Camera — Image capturing device.
Camera RAW — Unprocessed image data from a camera's image sensor.
Camera shake — Blurred image caused by camera vibration during exposure.
CCD — Charge coupled device. A solid state sensor used in digital image capture.
Channel — A division of color or luminance data.
Cloning Tool — A tool used for replicating pixels.
Close down — Decrease in aperture size.

Closest point of focus	Minimum distance at which sharp focus is obtained.
CMOS	A type of image sensor used in digital cameras.
CMYK	Cyan, Magenta, Yellow and black (K). The inks used in four color printing.
Color balance	Photoshop adjustment feature for correcting a color cast in a digital image file.
Color fringing	Bands of color on the edges of lines within an image.
Color gamut	The range of colors provided by a hardware device, or a set of pigments.
Color Picker	Dialog box used for the selection of colors.
Compensation	Variation in exposure from MIE to obtain appropriate exposure.
Complementary	Color - see Primary and Secondary.
Composition	The arrangement of shape, tone, line and color within the boundaries of the image area.
Compression	A method for reducing the file size of a digital image.
Concept	Idea or meaning.
Context	Circumstances relevant to subject under consideration.
Continuous tone	An image containing the illusion of smooth gradations between highlights and shadows.
Contrast	The difference in brightness between the darkest and lightest areas of the image or subject.
CPU	Central processing unit of a camera used to compute exposure.
Crop	Alter image format to enhance composition.
Curves	Control in the full version of Adobe Photoshop for adjusting tonality and color.
Dedicated flash	Flash regulated by camera's exposure meter.
Depth of field (DOF)	Area of sharpness variable by aperture or focal length.
Design	Basis of visual composition.
Diagonal	A line neither horizontal nor vertical.
Differential focusing	Use of focus to highlight subject areas.
Diffuse	Dispersion of light (spread out) and not focused.
Diffuser	Material used to disperse light.
Digital	Images recorded in the form of binary numbers.
Digital image	Computer generated image created with pixels, not film.
Dioptres	Close-up lenses.
Direct light	Light direct from source to subject without interference.
Distortion	Lens aberration or apparent change in perspective.
DOF	Area of sharpness variable by aperture or focal length.
DNG	A camera RAW file format developed by Adobe.
DPI	Dots per inch. A measurement of resolution.
DSLR camera	Digital Single Lens Reflex camera.
Dynamic	Visual energy.

Dynamic range	The ability of the image sensor to record image detail across the subject brightness range. This is often expressed in f-stops.
Edit	To select images from a larger collection to form a sequence or theme or to optimize, enhance or manipulate an image using editing software.
Electronic flash	Mobile 5800K light source of high intensity and short duration.
Evaluate	Estimate the value or quality of a piece of work.
EVF	Electronic ViewFinder
Exposure	Combined effect of intensity and duration of light on light-sensitive material.
Exposure compensation	To increase or decrease the exposure from a meter-indicated exposure to obtain an appropriate exposure.
Exposure meter	Device for the measurement of light.
Exposure value	Numerical values used in exposure evaluation without reference to aperture or time.
Extreme contrast	Subject brightness range that exceeds the image sensor's ability to record all detail.
F-stop	Numerical system indicating aperture diameter.
Fast lens	Lens with a large lens opening (small f-stop).
Feather	The action of softening the edge of a digital selection.
Figure and ground	Relationship between subject and background.
File format	The code used to store digital data, e.g. TIFF or JPEG.
File size	The memory required to store digital data in a file.
Fill	Use of light to increase detail in shadow area.
Fill-flash	Flash used to lower the subject brightness range.
Filter	Optical device used to modify transmitted light.
Fixed lens camera	Non DSLR camera where the lens cannot be removed.
Flare	Unwanted light entering the camera and falling on image plane.
Flash	Mobile 5800K light source, high intensity, short duration.
Focal plane shutter	Shutter mechanism next to image plane.
Focal point	Point of focus at the image plane or point of interest in the image.
Focusing	Creating a sharp image by adjustment of the lens to sensor distance.
Foreground	Area in front of subject matter.
Format	Image area or orientation of camera.
Frame	Boundary of composed area.
Front light	Light from camera to subject.

Gaussian Blur	A filter used for defocusing a digital image.
Genre	Style or category of photography.
Gigabyte	A unit of measurement for digital files, 1024 megabytes.
Gray card	Contrast and exposure reference, reflects 18% of light.
Grayscale	An 8-bit image used to describe monochrome (black and white) images.
Guide number	Measurement of flash power relative to ISO and flash to subject distance.

Halftone	Commercial printing process, reproduces tone using a pattern of dots printed by offset litho.
Hard/harsh light	Directional light with defined shadows.
High Dynamic Range (HDR):	An image created from multiple exposures where the subject brightness range exceeded the latitude of the image sensor.
High key	Dominant light tones and highlight densities.
Highlight	Area of subject giving highest exposure value.
Histogram	A graphical representation of a digital image indicating the pixels allocated to each level of brightness.
Hot shoe	Mounting position for on-camera flash.
Hue	The name of a color, e.g. red or green.
Hyperfocal distance	Nearest distance in focus when lens is set to infinity.

ICC profile	A color profile embedded into the digital image file to ensure color consistency.
Image sensor	Light-sensitive digital chip used in digital cameras.
Image size	The pixel dimensions, output dimensions and resolution used to define a digital image.
Incandescent	Tungsten light source.
Infinity	Point of focus where bellows extension equals focal length.
Infrared	Wavelengths of light longer than 720nm invisible to the human eye.

Interpolation	A method of resampling the image to alter its pixel dimensions.
Inverse square law	Mathematical formula for measuring the fall-off (reduced intensity) of light over a given distance.
Iris	Aperture/diaphragm.
IPTC	Metadata information standard designed by the International Press and Telecommunications Council.
ISO	Sensitivity rating - International Standards Organization.

JPEG (.jpg)	Joint Photographic Experts Group. Popular image compression file format used for images destined for the World Wide Web.
Key light	Main light source relative to lighting ratio.
Landscape	Horizontal format.
Latitude	Image sensor's ability to record the brightness range of a subject.
Layer	A feature in digital editing software that allows a composite digital image where each element is on a separate layer.
Layer mask	A mask attached to an adjustment layer that is used to define the visibility of the adjustment. It can also be used to limit the visibility of pixels on the layer above if that layer is grouped or clipped with the adjustment layer.
LCD	Liquid Crystal Display.
LED	Light Emitting Diode. Often used in the camera's viewfinder to inform the photographer of the camera's settings.
Lens	Optical device used to bring an image to focus at the image plane.
Lens angle	Angle of lens to subject.
Lens hood	Device to stop excess light entering the lens.
Levels	Shades of lightness or brightness assigned to pixels.
Light	The essence of photography.
Light meter	Device for the measurement of light.
Lighting contrast	Difference between highlights and shadows.
Lighting ratio	Balance and relationship between light falling on subject.
Long lens	Lens with a reduced field of view compared to normal.
Low key	Dominant dark tones and shadow densities.
Luminance range	Range of light intensity falling on subject.
Macro	Extreme close-up.
Magic Wand Tool	Selection tool used in digital editing.
Matrix metering	Reflected meter reading averaged from segments within the image area. Preprogrammed bias given to differing segments.
Maximum aperture	Largest lens opening, smallest f-stop.
Megapixels	More than a million pixels.
Memory card	A removable storage device about the size of a small card.
Meter	Light meter.
MIE	Meter indicated exposure.
Minimum aperture	Smallest lens opening, largest f-stop.
Movement Blur	Blur created by using a slow shutter speed.

Multiple exposure	More than one exposure in the same image file.
ND filter	Neutral density filter.
Neutral density	Filter to reduce exposure without affecting color.
Noise	Electronic interference producing speckles in the image.
Normal lens	Perspective and angle of view approximately equivalent to the human eye.
Objective	Factual and non-subjective analysis of information.
Opaque	Does not transmit light.
Open up	Increase lens aperture size.
Optimize	The process of fine-tuning the file size and display quality of an image.
Out of gamut	Beyond the scope of colors that a particular device can create, reproduce or display.
Overall focus	Image where everything appears sharp.
Overexposure	Exposure greater than meter indicated exposure.
Panning	Camera follows moving subject during exposure.
Perspective	The illusion of depth and distance in two dimensions. The relationship between near and far imaged objects.
Photograph	Image created by the action of light and chemistry.
Pixel	The smallest square picture element in a digital image.
Pixelated	An image where the pixels are visible to the human eye and curved or diagonal lines appear jagged or stepped.
Plane	Focal plane.
Polarizing filter	A filter used to remove polarized light.
Portrait	Type of photograph or vertical image format.
Post-production editing	Image enhancement or manipulation in editing software.
Posterization	Visible steps of tone or color in the final image due to a lack of tonal information in a digital image file.
Preview	Observing image at exposure aperture.
Previsualize	The ability to decide what the photographic image will look like before the exposure.
Primary colors	The colors, red, green and blue.
RAW	The unprocessed data recorded by a digital image sensor. Sometimes referred to as camera RAW or the 'digital negative'.
Reflected	Light coming from a reflective surface.
Reflection	Specular image from a reflective surface.

Reflector	Material used to reflect light.
Refraction	Deviation of light.
Resample	To alter the total number of pixels describing a digital image.
Resolution	Optical measure of definition, also called sharpness.
RGB	Red, green and blue. The three primary colors used to display images on a color monitor.
Sample	To select a color value for analysis or use.
Saturation	Intensity or richness of color.
SBR	Subject brightness range, a measurement of subject contrast.
Scale	Size relationship within subject matter.
Secondary colors	Complementary to primary colors, yellow, magenta, cyan.
Selective focus	Use of focus and depth of field to emphasize subject areas.
Shadow	Unlit area within the image.
Sharp	In focus.
Shutter	Device controlling the duration (time) of exposure.
Shutter-priority	Semi-automatic exposure mode. The photographer selects the shutter and the camera sets the aperture automatically.
Shutter speed	Specific time selected for correct exposure.
Side light	Light from side to subject.
Silhouette	Object with no detail against background with detail.
SLR	Single lens reflex camera; viewfinder image is an optical view of the framed image.
Softbox	Heavily diffuse light source.
Soft light	Diffuse light source with ill-defined shadows.
Specular	Highly reflective surfaces.
Speed	ISO rating, exposure time relative to shutter speed.
Spot meter	Reflective light meter capable of reading small selected areas.
Standard lens	Perspective and angle of view equivalent to the eye.
Stop	Selected lens aperture relative to exposure.
Stop down	Decrease in aperture size.
Subject	Main emphasis within image area.
Subject reflectance	Amount of light reflected from the subject.
Subjective	Interpretative and non-objective analysis of information.
Symmetrical	Image balance and visual harmony.
Sync	Flash sychronization.
Sync lead	Cable used to synchronize flash.
Sync speed	Shutter speed designated to flash.
System software	Computer operating program, e.g. Windows or Mac OS.
Thyristor	Electronic switch used to control electronic flash discharge.
TIFF	Tagged Image File Format. Popular digital image file format for desktop publishing applications.
Time	Shutter speed, measure of duration of light.

Tonal range	Difference between highlights and shadows.
Tone	A tint of color or shade of gray.
Transmitted light	Light that passes through another medium.
Transparent	Allowing light to pass through.
Tripod	Camera support.
TTL	Through the lens light metering system.
Tungsten light	3200K light source.
Unsharp Mask	See USM.
URL	Unifrom Resource Locator. A unique web address given to each web page.
USB	Universal Serial bus. A computer interface for connecting peripheral devices such as cameras.
USM	Unsharp Mask. A software filter used to sharpen images.
UV	Ultraviolet radiation invisible to the human vision.
Vertical	At right angles to the horizontal plane.
Viewpoint	Camera to subject position.
Visualize	Ability to exercise visual imagination.
Wide angle	Lens with a greater field of view than normal.
Workflow	Series of repeatable steps required to achieve a particular result within a digital imaging environment.
X-sync.	Synchronization setting for electronic flash.
X-sync. socket	Co-axial socket on lens or camera for external flash cable.
Zoom Tool	A tool used for magnifying a digital image on the monitor.

index